CW00751838

SARNATH

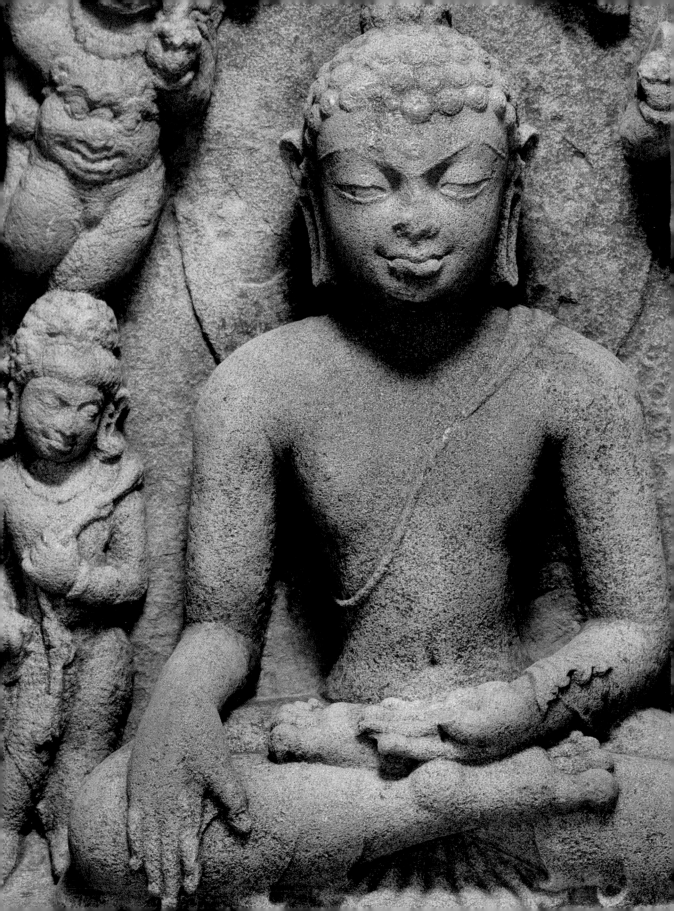

SARNATH

A CRITICAL HISTORY OF THE PLACE WHERE BUDDHISM BEGAN

FREDERICK M. ASHER

PUBLISHED BY THE GETTY RESEARCH INSTITUTE | LOS ANGELES

THE GETTY RESEARCH INSTITUTE PUBLICATIONS PROGRAM

Mary Miller, *Director, Getty Research Institute*
Gail Feigenbaum, *Associate Director*

© 2020 J. Paul Getty Trust
Published by the Getty Research Institute, Los Angeles
Getty Publications
1200 Getty Center Drive, Suite 500
Los Angeles, California 90049-1682
www.getty.edu/publications

Lauren Edson, *Editor*
Amy McFarland, *Designer*
Amita Molloy, *Production*
Karen Ehrmann, *Image and Rights Acquisition*

Type composed in Janson and Flama

Distributed in the United States and Canada by the University of Chicago Press
Distributed outside the United States and Canada by Yale University Press, London

Printed in Singapore

LIBRARY OF CONGRESS CATALOGING-IN-PUBLICATION DATA

Names: Asher, Frederick M., author. | Getty Research Institute, issuing
 body.
Title: Sarnath : a critical history of the place where Buddhism began /
 Frederick M. Asher.
Description: Los Angeles : Getty Research Institute, [2020] | Includes
 bibliographical references and index. | Summary: "This volume provides
 an analytical history of Sarnath, the place where the Buddha preached
 his first sermon and established the Buddhist monastic order.
 Excavations at Sarnath have yielded the foundations of temples and
 monastic dwellings, two stupas, and some of the most important
 sculptures in the history of Indian art"-- Provided by publisher.
Identifiers: LCCN 2019019885 (print) | LCCN 2019981362 (ebook) | ISBN
 9781606066164 | ISBN 9781606066386 (ebook other)
Subjects: LCSH: Buddhist antiquities--India--Sārnāth Site. | Excavations
 (Archaeology)--India--Sārnāth Site. | Sārnāth Site (India)
Classification: LCC DS486.S3 A84 2020 (print) | LCC DS486.S3 (ebook) |
 DDC 934/.2--dc23
LC record available at https://lccn.loc.gov/2019019885
LC ebook record available at https://lccn.loc.gov/2019981362

Contents

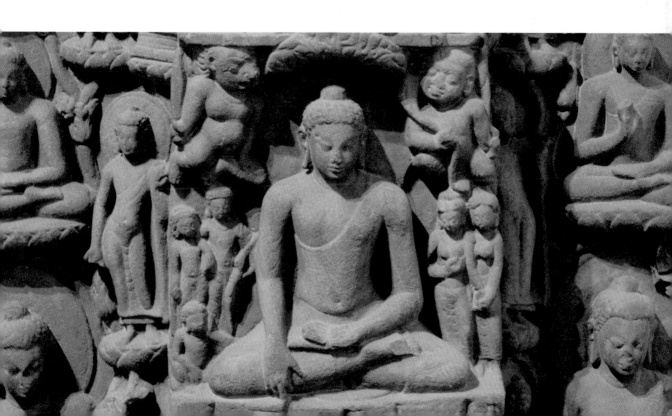

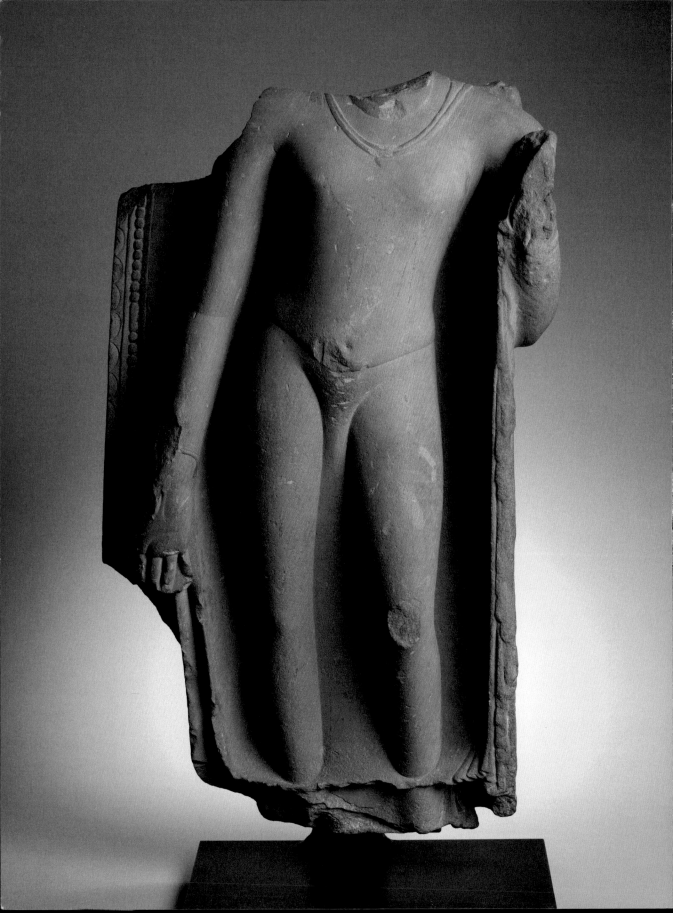

Preface

While reading a massive biography of Ludwig van Beethoven, which I'll prob-
ably still be plodding through long after this book is in circulation, I thought
about writing a biography of a place. But it would be quite unlike Jan Swafford's
approach to the Beethoven biography, in which he argues, "When it comes to his-
tory and biography, I believe submission to objective fact is, for all its limitations,
what the discipline is about."[1] The commitment to objectivity reminds me of Sgt.
Joe Friday on that old radio and TV show *Dragnet:* "Just the facts, ma'am." I am
not convinced that there is such a thing as objective fact. Rather, I am taken with
Paul Brass's presentation of the diverse perceptions of a single event in his *Theft
of an Idol* (1997), by his recognition that memory clouds and shapes witnessing,
that "facts" can represent hope as much as objectivity, and that distance in time,
place, and culture can bring new but meaningful realities.[2] So, as I thought and
wrote about Sarnath, I treated it as more than a physical locus, a site charged with
history and meanings. (Note that my use of *meanings*, plural, is intentional.)

That recognition of multiple realities explains the watercolor on the cover of
this book. The two stupas it shows are easily recognizable: the Dhamekh stupa and
the Chaukhandi. They are separated by a distance of about 755 meters, and even
without modern construction and recent landscape growth, there is no way one
could have been seen from the other, as the artist has depicted in this work. The
rendering, like much I discuss in this book, is a construction, a way of giving a simul-
taneous view of two works that on the ground could not be viewed simultaneously.

This book started simply with a wish to write about a place that I had often
visited and considered something of an art historical treasure trove, a site that

OPPOSITE:
Standing Buddha image. Cleveland, The Cleveland Museum of Art.
See fig. 3.64, p. 132.

yielded an immense collection of sculptures—many of them so important that I invariably teach them in undergraduate courses and others that I use in my own scholarship. I had largely seen the architectural remains within the excavated site as an obligatory prelude to time spent in the Archaeological Museum Sarnath. So what could I do with Sarnath that might be different from the ways I had thought about it and the ways in which it had been reported by earlier scholars? I began to ask myself what I would do with the site if I could design the visitor's experience there. That led to the following questions: What do I mean by Sarnath? Where is it? And *when* was it? —I had always thought of Sarnath in the past tense.

I had never imagined a Sarnath flourishing with monks who lived and studied there. When I encountered people on my visits to the site, they felt like an obstruction to my own looking. So I have set out to view Sarnath as an ever-changing institution, one not confined by a fenced-in, ticketed site and one that can be seen through more than a twenty-first-century lens. I have tried to think about Sarnath populated by monks in antiquity, by archaeologists in the nineteenth and twentieth centuries, and by tourists and pilgrims in more recent times.

As I read and reread the archaeological reports of excavations and exploration at Sarnath, I found myself confronted by dull descriptive narratives, measurements, and monuments; noticeably absent were accounts of the people who had lived at and visited the site. One of the few connections to a lived past was the terse account of Xuanzang, the seventh-century pilgrim who came to India to study the Buddhist texts in the original language.

But what if, rather than work to match Xuanzang's description of Sarnath with the remains visible above the surface or those revealed by the archaeologist's spade, we instead considered Xuanzang as a witness? As Brass has shown in *Theft of an Idol*, multiple witnesses to an event recall and tell dramatically different stories. Are there then multiple truths, or do we concede that memory is fragile, particularly when the description is written, as Xuanzang's was, many years after that which has been witnessed? We need to remember—and perhaps be excited by—why the structures were important to Xuanzang. They were physical remains of a past associated with two figures who mattered profoundly to him: the Buddha and Ashoka.

Jane Blocker, my colleague at the University of Minnesota, writes insightfully about witnessing through works of art.[3] Archaeologists, too, witness as they remove dirt in order to uncover things of the past, and art historians engage in the process of witnessing as they seek to give context to things of the past. What are they trying to understand? Are we, as specialists in South Asia's past, so focused on the object that we forget its function then and now?

So where is Sarnath: In the imagination? At geographic coordinates? During what time? Is Sarnath the past?

The idea for this book was germinated by Thomas Gaehtgens, then director of the Getty Research Institute and one of the most broadly curious and interested scholars in our discipline. Because he, Jim Cuno, president and CEO of the J. Paul Getty Trust, and others associated with the Getty sought to extend the institution's global impact to India, they conferred with the Archaeological Survey of India and were permitted to focus on ways of developing Sarnath, particularly the Archaeological Museum Sarnath. To begin, they called together a small group of scholars to inform them about Sarnath; I was privileged to be among them. While most of us had written about Sarnath, though never as the principal focus of our scholarship, I realized that there was no good comprehensive book on the site to which we could refer the Getty leadership staff.

This process led me to reflect on my time living in Varanasi during the 1974–75 academic year, when Sarnath was very much on my radar. I frequently visited Sarnath, though always just the excavated site and the museum. I was often joined by my wife, Cathy, who always pushed me to see at least one more thing, whatever that might be. I returned many times subsequently on trips to Varanasi, particularly during a long engagement with the American Institute of Indian Studies Center for Art and Archaeology. There, Sarnath was the topic of a great many conversations: with M. A. Dhaky, Krishna Deva, Mr. Hingorani, and even the wonderful director, Mr. Nambiar. To younger readers, these names may feel like an ancient past.

My working title for the manuscript was simply *Sarnath;* I liked the ambiguity that the one-word title might suggest. But the press is probably right in noting that it's something of an insider's title, meaningful to specialists but not to a larger audience. Still, adding the subtitle, *A Critical History of the Place Where Buddhism Began,* may suggest a sort of certainty that I do not intend. Yes, this is a critical history—or critical art history—of a place. And if the site that today we call Sarnath is the very place where the Buddha preached his first sermon, turning the Wheel of the Law, then it is where the *sangha*—that is, the Buddhist order—was formed. But is there a moment when a religion begins? Is it with the birth of the founder, in this case his final birth? Is it the moment when Siddhartha achieved enlightenment? Or is it when he developed a following? This is yet another example of the ambiguity that I have enjoyed projecting in the book.

While writing, I made some editorial choices. I'm no fan of diacritical marks. In most cases, they are unnecessary. Why, for instance, should Sarnath be written as Sārnāth? Isn't it perfectly clear what place we're talking about in the absence of a pair of long *a*'s? Therefore, in this book, as in much of my other writing, I've avoided diacritical marks except in quotations, in the hope that the book will be somewhat more accessible than it would be with a field of diacritics over words, even common ones. So for transliteration, I've used *sh* for both *ś* and *ṣ, ri* for *ṛ,* and *t* for *ṭ.*

I am, however, a fan of metric measurements and hope the United States can someday join the rest of the world in using them. For consistency, then, I've reported all measurements in metric unless the measurement is part of a direct quote.

As I complete my manuscript, there are people who deserve my gratitude. I should start with Thomas Gaehtgens and Jim Cuno. Even though the Getty project at Sarnath was never realized—no fault of the Getty's—the book is one material result of their commitment to India and to this site in particular. Thanks, too, are due to Gail Feigenbaum, associate director of publications, who provided encouragement from the outset of this project and made the link to Michele Ciaccio, managing editor; Lauren Edson, senior editor; and Karen Ehrmann, image and rights coordinator. The book's fine design is thanks to Amy McFarland, and its realization as a finished product is the work of Amita Molloy, senior production coordinator. What a privilege it has been to work with these people.

Administrators of museums who permitted me to take photographs, the ones that, for the most part, compose the figures of this book, were most generous. Ellen Raven, university lecturer at Leiden University, was so kind in responding to my requests for images from the Kern collection. Vandana Sinha, director (academic) of the American Institute of Indian Studies Center for Art and Archaeology in Gurgaon, and Purnima Mehta, director-general of the American Institute of Indian Studies, were immensely helpful and invariably responsive to questions and to requests, not all of them entirely reasonable. Thank you, Vandana and Purnima.

M. B. Rajani, a scholar at the National Institute of Advanced Studies, Bangalore, merits special mention for her engagement with this project and the limitless help she gave me. The plans in the book are all thanks to her. She made them from satellite imagery, but she did so much more: trekked the site with me, sent me plans she discovered, made observations that I never could have made. I'm deeply grateful for all that she did to make this work possible.

Had it not been for the enormously helpful comments of a scholar who read the initial draft of this book, it would have been very different and much duller. The reader was anonymous but subsequently identified herself as Janice Leoshko, associate professor of art history at the University of Texas at Austin. She could have written this book and would have produced a more insightful volume. This is not the last word on Sarnath by any means. Keep that in mind, Janice.

My newest granddaughter, Imi, is young, just two years old as this book enters publication, but already she's a world traveler. She's made a couple of trips to Asia and gotten close to Sarnath but not quite there. She'll make that visit someday, I'm sure, and as stimulus to do so, I dedicate this book to her with the hope that her obvious curiosity will lead her to interesting places, Sarnath among them.

OPPOSITE:
Temple doorway lintel (detail). Findspot not recorded. Sarnath, Archaeological Museum Sarnath. See fig. 3.48, p. 117.

NOTES

1. Jan Swafford, *Beethoven: Anguish and Triumph* (New York: Houghton, Mifflin Harcourt, 2014), xv. I'm indebted to my long-time friends, Dorina and Piero Morawetz, for this book, the outcome of a discussion on which composer's work we'd wish to have if marooned on a desert island. I opted for Beethoven with the proviso that I'd rather not be forever on a desert island.

2. Paul Brass, *Theft of an Idol* (Princeton: Princeton University Press, 1997), 58–96.

3. Jane Blocker, *Seeing Witness: Visuality and the Ethics of Testimony* (Minneapolis: University of Minnesota, 2008), see esp. xvii–xix.

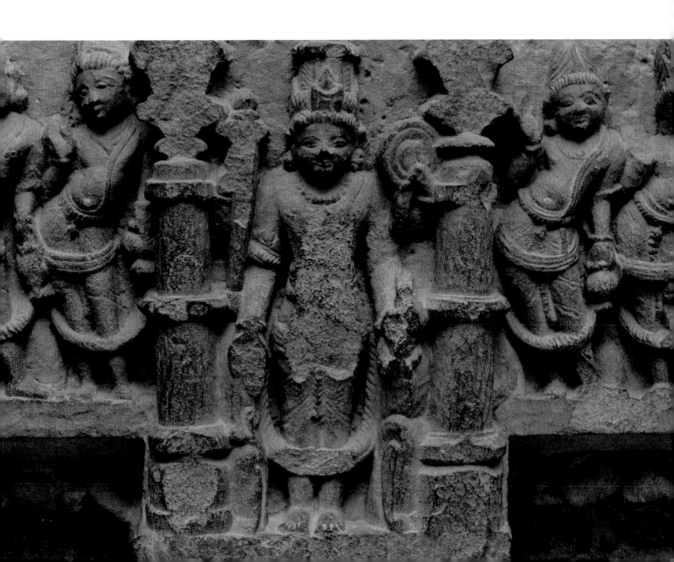

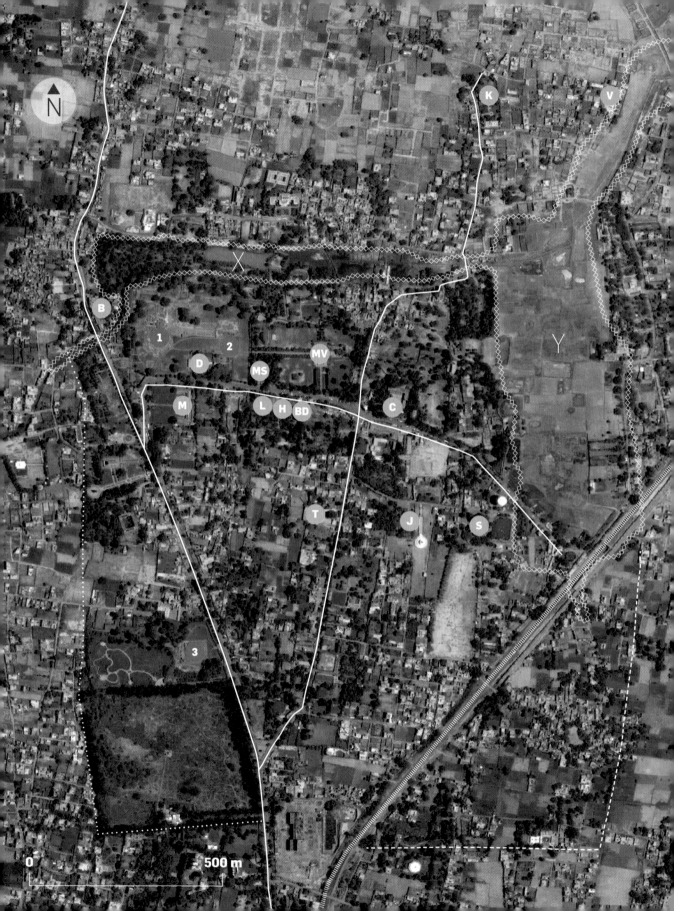

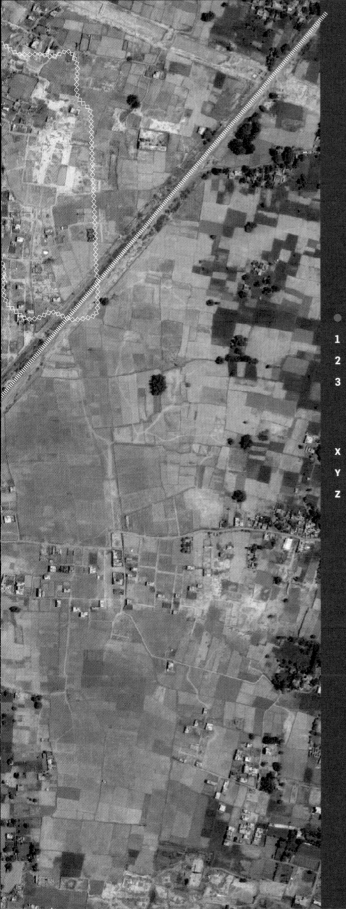

·············	Western extent
- - - - - - - -	Eastern extent
◇◇◇◇◇◇◇◇◇◇◇	Bodies of water
═══════════	Extent of Chandra Tal
───────────	Roads
⊪⊪⊪⊪⊪⊪⊪⊪⊪⊪⊪	Railway line

● **STUPA STRUCTURES**

1 Dharmarajika

2 Dhamekh

3 Chaukhandi

BODIES OF WATER

X Naya Tal

Y Narohar or Sarang Tal

Z Chandra Tal

● **OTHER LOCATIONS**

B Burmese monastery

BD Birla Dharmsala

C Chinese temple

D Digambara Jain temple

H Maha Bodhi Hospital

J Japanese temple

K Korean temple

L Maha Bodhi Library

M Archaeological Museum Sarnath

MS Maha Bodhi Society

MV Mulagandhakuti Vihara

S Saranganatha temple

T Tibetan monastery

V Vietnamese monastery

FIGURE 1
Satellite view showing excavated site and environs, 20 January 2017. Plan by M. B. Rajani and Sonia Das, National Institute of Advanced Studies, Bangalore.

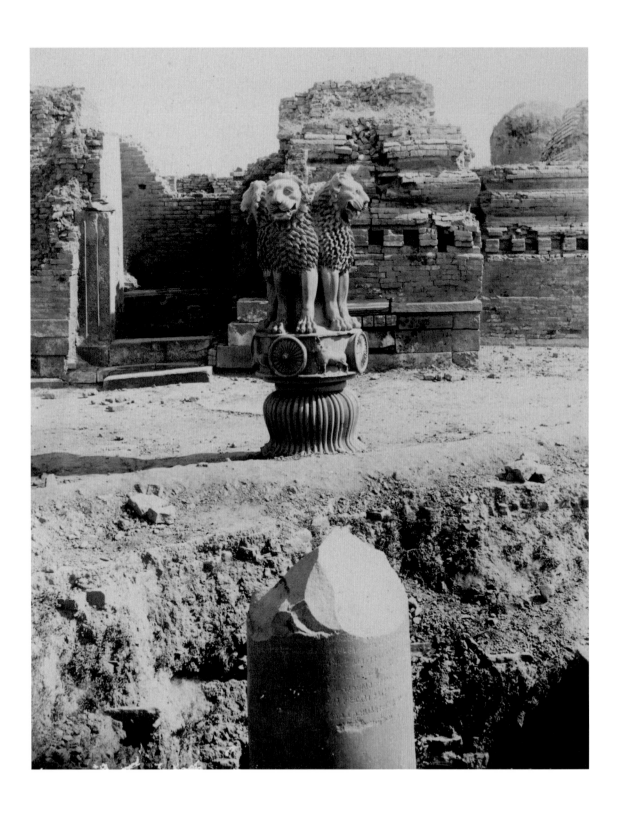

Introduction

Sarnath has not always been Sarnath. In ancient texts, the site of the Buddha's first sermon is called either Mrigadava or Rishipatana. These texts, however, give little sense of the site's geography, as they are concerned instead with the momentous event that took place there, probably sometime during the fifth century BCE: the Buddha's first sermon and the establishment of the Buddhist order—that is, the *sangha*. When the Buddha left the vicinity of the Bodhi tree, he headed toward Kashi, as Varanasi was called then, and, more specifically, to the Deer Park (Mrigadava) at Rishipatanam (or Ishipatanam), which was located on the outskirts of Kashi (FIGURE 1).[1]

None of the ancient texts gives a precise or even approximate location for this place; they were not meant to serve as a kind of guide to the faithful who might embark on a pilgrimage. For example, the *Buddhacharita*, a biography of the Buddha roughly datable to the second century CE, implies that after a long meditation under the Bodhi tree, "Gautama [Buddha] proceeded to the blessed city, which was beloved of Bhīmaratha, and whose various forests are ornamented by the Varanasi."[2] Although it gives

little more information, the *Lalitavistara*, a text composed about the third century CE that includes considerable biographical information, states that after meditation at Bodhgaya, "the four gods of the Bodhi tree . . . asked: 'Where will the Blessed One turn the wheel of Dharma?'" To this, the Buddha replied simply, "At the Deer Park by the Hill of the Fallen Sages, outside of Varanasi."[3] And then in the next chapter, it simply notes, "He then proceeded to the Hill of the Fallen Sages at the Deer Park."[4]

No Buddhist text, however, is intended as a presentation of the physical world, the geographic realities of space. These texts are spiritual in nature and, however old, were all written centuries after the Buddha's life. So how did the site of the Buddha's first sermon come to be associated with present-day Sarnath, or, conversely, how did present-day Sarnath come to be accepted as the site of the Buddha's first sermon? Certainly, oral tradition, critically important in premodern India, played a significant role.

When pilgrims following the Buddha's admonition recorded in the *Mahaparinirvana Sutra* (in Pali, called the *Mahaparinibbana Sutta*)—a text from

FIGURE 2
Ashokan pillar and capital, 1905. Photo by Madho Prasad.

about the fourth century CE on the Buddha's death and attainment of nirvana—to visit the sites associated with his life came to Varanasi, they likely were directed to a particular spot, very possibly today's Sarnath.[5] But there is no evidence of any permanent structures there prior to the third century BCE. That is when the Maurya dynasty emperor Ashoka (circa 269–32 BCE) erected his magnificent lion pillar at Sarnath, the one with four addorsed lions that today serve as the emblem of the Republic of India. Although he does not say so explicitly in the pillar's inscription, as he does at the site he designated as Lumbini, the place of the Buddha's birth, the very act of erecting the lion pillar probably was intended to mark the place as the location of the Buddha's first sermon. In other words, here as elsewhere, we see Ashoka assuming responsibility for shaping an important facet of Buddhism: the pilgrimage sites. The circulation of monks among these sites would have been essential to the stability of Ashoka's vast empire, and the permanent settlement of monks at sites associated with the Buddha's life, as well as at other sites distant from his capital, Pataliputra, would have ensured a Magadhan presence even in places far from the capital. Speaking Ashoka's language and sharing his culture, the monks would have helped shape a unified empire and been able to ensure a flow of critical information back to Pataliputra.

The pillar bearing Ashoka's inscription and its capital, detached from each other when they were excavated in 1904–5 (FIGURE 2), serve as an effective metaphor for Sarnath today. When the German archaeologist F. O. Oertel reported the pillar's discovery during his excavation, he did so with remarkable detachment, surely unaware of the subsequent history that capital would have.[6] The archaeologist simply notes that the capital was unearthed "close to the western wall of the [Main] shrine," a short distance from the remains of the pillar on which it once stood (a distance exaggerated today by the capital's placement in the Archaeological Museum Sarnath). *Detachment*, however, is

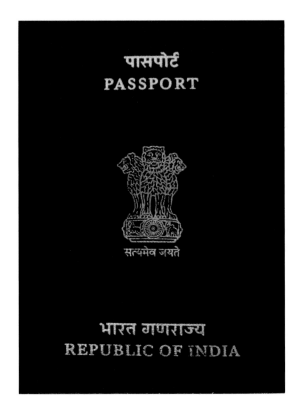

FIGURE 3
Indian passport cover bearing the capital with addorsed lions, the symbol of the Republic of India, 2015. Photo by A. Sulthan.

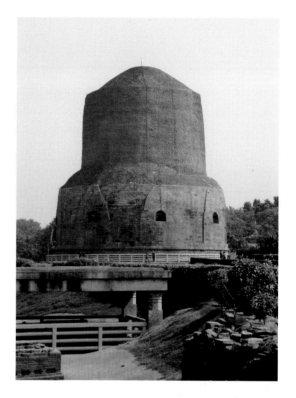

precisely the right term to use for more than Oertel's report. The pillar remains broken in several pieces at the site and is now protected by a glass enclosure that separates the pillar from visitors. The pedestal for the capital lowers it to eye level from its previously far more elevated position. The museum also makes it an art object, dissociating the capital from its powerful symbolism. The fence around the perimeter of the excavated area disconnects the ticketed portion of the site from the larger area that once comprised the monastic site. And the many two-dimensional reproductions of the capital as the emblem of the Republic of India (FIGURE 3) are detached from the finely sculptured original work.

In the eighteenth and nineteenth centuries, the name Sarnath applied only to the stupa today known as the Dhamekh stupa, which is often considered the site where the Buddha preached his first sermon (FIGURE 4). But before Sarnath became an archaeological site replete with signs identifying the names of places within the excavated area and sometimes providing bits of historical information (or speculation), the name Sarnath belonged "properly to a small Brahmanical temple on the western bank of the lake."[7] Which temple and which lake is not clear. The temple is probably what is known today as the Saranganatha temple, a Shiva temple (FIGURE 5). The lake is likely what was called, in the time of Alexander Cunningham (the first archaeologist to systematically explore Sarnath), the Naya Tal (New Tank or New Lake); it is one of three fairly large bodies of water to the east, northeast, and north. These lakes probably demarcated the monastic site

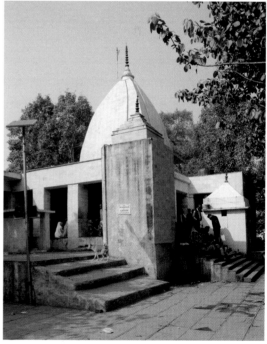

FIGURE 4
Dhamekh stupa, ca. 800 (in its present form), 43.5 meters above the original base.

FIGURE 5
Saranganatha temple, 20th century (in its present form).

much as the bodies of water at Nalanda likely did. The Saranganatha temple is now a prominent structure elevated from the plain close to the nearly dry body of water that corresponds on Cunningham's map to the Naya Tal (FIGURE 6). I asked several people if this is the Naya Tal. Repeatedly, I was told that it is not new at all; it is very old.

As visitors—tourists, pilgrims, even the occasional scholar—walk through the excavated site as it appears today, many must imagine that this is the way it was, as if the past were an undifferentiated thing, a discrete time period. That is not the case,

of course. Even when it was in daily use as a monastic establishment, the place constantly changed not only with the addition of new structures, the renovation of older ones, and the total disintegration of still others but also with the changing population of monks themselves, who held new and evolving beliefs or practices. Although here we can use monuments to document some of that instability, they reveal more about additions than decay, while sculptures and inscriptions can, to a limited extent, reveal changes of practice. What the sculptures do not disclose, however, is the extent

FIGURE 6
Naya Tal, the lake north of the excavated site, probably defining the northern border of the monastery.

SITE OF THE BUDDHA'S FIRST SERMON

Was Sarnath the site of the Buddha's first sermon, his discourse on the Middle Way and the Eightfold Path? Maybe that is not a reasonable question to ask because no one can be certain precisely where the Buddha sat when he delivered the sermon to the five disciples who had previously abandoned him, even though signage at the Dhamekh stupa suggests the possibility that the sermon was delivered there.[8] But oral tradition and the practice of pilgrimage must have focused on the site we today call Sarnath.

Excavations at Sarnath indicate that the oldest levels date to the Maurya period, specifically to the reign of Ashoka. Even though an inscription on Ashoka's column at Sarnath admonishes the monks and nuns resident there to avoid schism (denoting to some that a Buddhist monastery had long been established there), it is perfectly possible that the monarch wished to ensure, even to demand, a sort of unity among monks who had arrived relatively recently. In other words, there is a compelling reason to speculate that Ashoka, by patronizing a monastery and placing his edict pillar at the site, sought to identify the location of the Buddha's first sermon, much as Ashoka assumed a role in identifying other sites associated with the life of the Buddha.[9]

That first sermon established a community: the sangha. At the time of the Buddha, there was only a single mode of practice, not the multiple schools that have since developed, probably as a result of the very dissent that Ashoka admonished against. In India today, a *community* is a group that is still generally called a *caste* in the West. A community may be

to which older practices persisted alongside the acceptance, at least by some, of newer ones. Nor do they or the architectural remains divulge the ways in which monks interacted daily with the architecture in which they lived, worshipped, and studied, much less the sounds and smells that were so much part of any establishment. Finally, I worry that by focusing, as I do, on each of Sarnath's monuments separately, I give little sense of the whole, the ensemble that at any one point of time in the past constituted the monastic establishment.

one of the four *varnas* or a more limited group (sub-caste) within one of those four *varnas*—a *jati*, a word whose etymology indicates a birth group. That sense of community, of belonging, has in traditional India invariably referred to a birth group. In Buddhism, which eschewed caste and still does, the sangha provides a sense of belonging, a community of brotherhood and sisterhood that substitutes for the sense of a birth community. And it was at Sarnath—or wherever the Buddha preached his first sermon—that the sangha was first formed.

Let us assume, as Buddhists did from Ashoka's time forward, that the Buddha's first sermon was delivered at the place we now know as Sarnath. Pilgrimage to the site, then, creates a connection both to the Buddha's words and to those who initially spread them, thus expanding the sangha and creating the faith that, despite the diverse ways it is practiced, is called Buddhism. This explains the Chinese pilgrims' visits to Sarnath, even though the place features almost marginally in their accounts. It also explains the present-day pilgrims who come to Sarnath as well as the monasteries that now are located in close proximity to the excavated site.

SARNATH'S PATRONAGE

The records of patronage for Sarnath are exclusively in the form of inscriptions, mostly on sculptures, that for the most part register donations of the sculptures by individual monks, not the laity and certainly not royal sponsors of the monastery. That fits a pattern at other sites associated with the life of the Buddha—that is, initial recognition of the site by Ashoka but not patronage by any king. Monasteries not associated with the life of the Buddha, however, did receive royal patronage. Nalanda, for example, almost certainly had direct support from the Gupta dynasty if the several imperial Gupta seals or seal impressions found there were once attached to royal charters. And by the time of the Pala dynasty—that is, by the ninth century—Pala patronage of Buddhist monastic complexes in eastern India is well documented, not only at Nalanda but also at Vikramashila, which probably was established by the Pala king Dharmapala (circa 783–820) and Paharpur, properly called Dharmapala Mahavihara. It may have been the support of Dharmapala that served as a stimulus for late royal patronage at Sarnath, as evidenced, for example, by the inscription dated the equivalent of 1026 recording the repair of two monuments and the construction of a perfumed chamber (*gandhakuti*) by two Pala princes, Sthirapala and Vasantapala.[10] And in the last known premodern inscription at Sarnath, Kumaradevi, queen to the Gahadavala king Govindachandra (circa 1114–54), takes credit for restoring the "Lord of the Turning of the Wheel," possibly an image of the Buddha, to the way it was in the time of Ashoka and for the construction of a monastic dwelling, a *vihara* (FIGURE 7).[11] Though those gifts are noted only in the last few lines of this long inscription, much has been made of it. The Indian archaeologist Daya Ram Sahni, for example, claims that the inscription tells us that Kumaradevi built her vihara at Dharmachakra, one of the names for the site of the Buddha's first sermon.[12] It doesn't

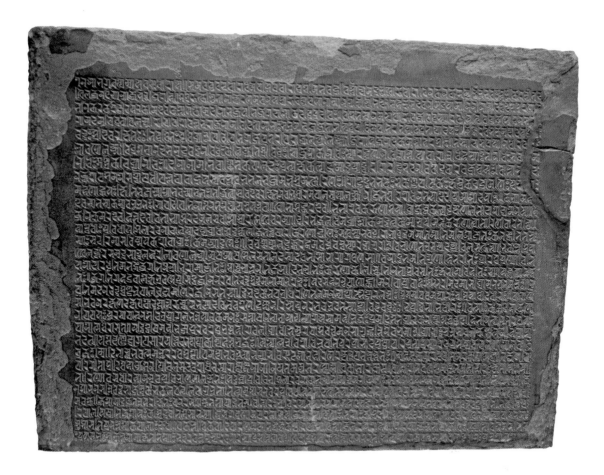

actually say that. Sukumar Dutt goes much further, stating that "the remains of Kumaradevi's imposing monastery . . . which bore the name Dharmachakra-jinavihara, measures 760 feet [231.6 meters] from east to west . . . and encompasses several ruined *viharas.*"[13] The inscription, found just north of the Dhamekh stupa, gives no indication of the name of the vihara that Kumaradevi established or which of the surviving monasteries at Sarnath may have been hers, and therefore it is unknown whether her monastery survives in any form today. The point is that all too often information about the site is presented uncritically, perhaps in an effort to give historical substance to a place for which we have little written documentation.

But the site is enormous, probably about three-quarters of a kilometer in length, extending from the Chaukhandi stupa to the Dhamekh stupa. If we add the many mounds beyond the excavated area to the east, the monastery and its monuments extended over an area of at least a kilometer from east to west. Beside the Dhamekh and Chaukhandi stupas, there is the base of one other huge stupa at the site, the Dharmarajika stupa; at least eight monastic dwellings; a large temple commonly called the Main Shrine; and many much smaller monuments. While one can imagine some of this resulting from a collective enterprise—like the many individual donations recorded on stupa railings, such as the ones at Bharhut and Sanchi—there must have been some

FIGURE 7
Inscription of Queen Kumaradevi, queen to the Gahadavala king Govindachandra (ca. 1114–54). Sarnath, Archaeological Museum Sarnath.

major gifts to generate a site as large as Sarnath prior to the twelfth century.

In 2014, the Archaeological Survey of India (ASI) began excavations just west of the pillar bearing Ashoka's edicts. A *Times of India* news story reports, "According to ASI officials, the known history of Sarnath dates back to 3rd Century BC to 12th Century AD. The excavation aims to ascertain the actual age of Sarnath."[14] And confirmation of a pre-Ashokan date they did find: the ASI discovered something organic with a carbon-14 date that has been estimated at 395 BCE, almost a century prior to Ashoka.[15] Does that, however, prove that a monastery existed there at the time? All it really means is that something—not necessarily a monastery, not even necessarily a site recognized as Buddhist—was there.[16]

Despite the effort to determine an originating moment for Sarnath, the most significant and extensive patronage for the site was provided during the time of Ashoka and again during the reigns of the Kushana and Gupta kings. While Ashoka himself is generally given credit for the establishment of the monastic site and the provision of funds for the foundation of many of the monuments there, the Kushana and Gupta dynasties seem not to have provided any direct patronage. Nonetheless, a large number of sculptures were produced during the reign of these two dynasties, especially during the time of Gupta rule, suggesting substantial new building activity and, therefore, structures that required sculptural imagery.

Ashoka's reign certainly extended over the greatest territory ever ruled by a single dynasty in India, greater even than British India or the modern Republic of India. But the extent of Kushana and Gupta territory was also enormous and, like the extent of the Maurya dynasty domain, extended from coast to coast, providing ports for international trade and thus wealth that was distributed well beyond the king and his nobles. Because Buddhism attracted so many merchants, it is not at all surprising that they would have the disposable resources to provide patronage at Sarnath and other Buddhist sites. But it was not just the ports that supported trade. The fact that a single ruling house presided over territory extending from the Arabian Sea to the Bay of Bengal meant that merchants could move goods from inland places of production to the ports without frequent taxation as they crossed each new realm.

The patronage at Sarnath was in no way confined to these three periods—that is, the time of Ashoka, the Kushana period, and the reign of the Gupta dynasty. The remains, both architectural and sculptural, document an almost continuous history up to the twelfth century.

ASHOKA AND SARNATH

Ashoka is credited with so many pious acts, many of them associated with specific sites, that he, almost as much as the Buddha himself, might be seen as a founder of the faith. As the Buddha told his disciple Ananda, as recounted in the *Mahaparinirvana Sutra* (5.8), the faithful should visit four places whose sight should arouse emotion: where the Buddha was born (Lumbini), where

he achieved enlightenment (Bodhgaya), where he set the Wheel of the Law in motion (Sarnath), and the place where he attained nirvana (Kushinagar). Ashoka went on just such a pilgrimage, if the account in the *Ashokavadana*, a text dating earlier than 300 CE, is accurate. Together with the "most excellent of preachers," the monk Upagupta, Ashoka traveled to the thirty-two sites associated with the Buddha's life and marked them with signs as a guide for future pilgrims.[17] He made gifts of gold to these sites and at each of them built a prayer hall (*chaitya*), perhaps signifying a constructed permanence at a place that had previously been just an unmarked spot, a locus that was not necessarily geographically established. The *Ashokavadana* says nothing about the king's construction at Sarnath (called Rishipatana in the text), but the pillar Ashoka erected there is a stronger testament to his presence at the site than a written text subject to subsequent interpolations might be. His inscription on the pillar, discussed in chapter 2, carries an admonition to monks and nuns, suggesting that there was a resident monastic community at Sarnath (unlike some of the other sites he visited on this pilgrimage), which is not surprising because this is where the order was founded.

Other accounts, particularly that of the seventh-century Chinese pilgrim Xuanzang, attribute considerably more construction to Ashoka. At Sarnath—though he does not refer to it by any of the common names, such as Deer Park or Rishipatana—Xuanzang records a stupa built by Ashoka with a brilliantly shining pillar in front of it that marks the spot where the Buddha set the Wheel of the Law in motion. Ashoka designated this specific place for an event in the Buddha's life, as was done at other sites. Throughout Xuanzang's writing, Ashoka is given a role almost as prominent as that of the Buddha himself.

So, was there a monastic establishment at Sarnath—or at any other site—prior to Ashoka's time? Even though the accounts in the *Ashokavadana* and Xuanzang's records imply that Ashoka designated this as the place of the Buddha's first sermon, and even though excavations show no structures at Sarnath dating before Ashoka's time, the pillar inscription indicates the likelihood of a pre-Ashokan monastic order there. Or might that pillar edict refer to a schism among Buddhists in general and not specifically to those resident at Sarnath?

As at so many Buddhist sites in India, Sarnath's earliest monuments date to the time of Ashoka, not to the time of the Buddha. The evidence is largely archaeological and art historical, just as it is, for example, at Bodhgaya and at Kushinagar.[18] Elsewhere, however, the evidence is inscriptional. At Lumbini, a pillar inscription declares the site to be that of the Buddha's birth, as if to resolve a controversy or legitimize a place of pilgrimage. At Sarnath, no inscription identifies the site as the place of the Buddha's first sermon, but, in a pillar inscription, Ashoka explicitly addresses monks and nuns resident at the site, although it is not clear that monks and nuns had been there long or that

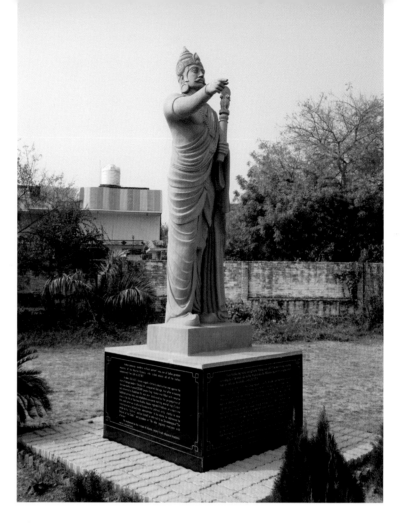

they acknowledged their monastery as the site of the Buddha's first sermon. Nonetheless, it seems that during Ashoka's time, if not with his personal intervention, sites associated with the Buddha's life were explicitly identified and that permanent structures constructed in brick and stone were built at these sites.

Why might the identification of these sites and the construction of structures there matter to a ruler such as Ashoka? Many might say that it was because he was a devout Buddhist and that is reason enough. But it seems more likely that he was a pragmatic ruler for whom Buddhism could become a unifying force in his far-flung empire, a way of extending a local Magadhan faith and practice. Moreover, the establishment of permanent monastic structures must have facilitated pilgrimage, and with the movement of people, both monks and the laity, would come economic advantage, including a stimulus to spend, for example, in support of the monasteries and the sculptural adornment of structures such as stupa railings. The movement of people, of course, also facilitated other sorts of expenditure—for example, daily needs such as food and lodging and also the exchange of goods. So deeply enmeshed is Ashoka with Sarnath that a statue in the modern Vietnamese monastery there depicts Ashoka holding his lion pillar (FIGURE 8).

FIGURE 8
Modern statue of Ashoka, ca. 2009. Sarnath, Vietnamese monastery.

THE "END" OF SARNATH

Something happened that brought premodern construction at Sarnath to an end after the twelfth century and, in all probability, caused the resident monks to desert the monastery. That was about the same time that other monasteries in India seem to have been abandoned. Generally, the blame is placed on invaders, almost invariably identified by their religion, Islam, rather than their geographic or cultural identity, Afghans.

But Sarnath may have also suffered devastation by Hindus, not just by invading Afghan armies. An intriguing explanation for this, and also for possible interruptions in the long life of the site, is offered by Giovanni Verardi and, at greater length, by Federica Barba in an appendix to Verardi's book.[19] They make a strong case, based on both literature and archaeology, that Brahmanical hostility toward Buddhists resulted in the destruction of Sarnath and other sites. For example, at Bodhgaya, during the Gupta period, modifications were made to the architecture of several structures—changes, Barba says, that would not have been made by Buddhists; and there are three Brahmanical sculptures dating to the same period. If this is so, then the many fifth-century Buddhist sculptures would have resulted from the Buddhists' return to Sarnath and the reappropriation of the monuments that had been taken over by Brahmanical powers hostile to Buddhists. Late in Sarnath's history, Barba argues, the Gahadavala dynasty, which provided many temples at Varanasi, was responsible for taking over Sarnath and building a very large temple at the site identified as Monastery I, a temple closely related to the twelfth-century Duladeo temple at Khajuraho. At the same time, she suggests, they converted several other Buddhist structures to Brahmanical shrines.[20] And then, in 1193, Qutb-ud-din Aibek, the military commander of Muhammad of Ghor's army, marched toward Varanasi, where he is said to have destroyed idols in a thousand temples. Sarnath very likely was among the casualties of this invasion, one all too often seen as a Muslim invasion whose primary purpose was iconoclasm. It was, of course, like any premodern military invasion, intended to acquire land and wealth. Iconoclasm is largely a trope used in reporting military success in Arabic texts rather than an account of what actually transpired, although the account of the invasion of Varanasi does add that Aibek carted away some fourteen hundred camel loads of treasure.[21] In addition, we must assume that his troops—not all of them necessarily Muslim—were given license to rape and pillage, to take compensation in the form of plunder. I would suggest that just as the temples of Varanasi were believed to hold goods of considerable value rivaling the value of the Gahadavala dynasty treasury in Varanasi, so Sarnath must have been expected to house great treasure, as probably it did. We should not imagine a Buddhist monastery as being so austere that it and the monks who resided there lacked material possessions. This invasion may have so seriously damaged Sarnath and so terrified the resident monks that it could not be salvaged, transforming the monastery to a ruin, an archaeological relic. But as the final chapter of this book shows, it did not mark the lasting end of Sarnath.

WHY SARNATH?

Before anyone paid much attention to the other sites associated with the life of the Buddha (such as Lumbini, Bodhgaya, Kushinagar, Shravasti, and Sankasya) or major Buddhist sites like Nalanda and Vikramashila, Sarnath struck the curiosity of a great many beginning in the late eighteenth century. That is probably because the site is located on the outskirts of Varanasi, where there was a strong British presence. European drawings of the Dhamekh stupa date as early as 1785 (FIGURE 9), and a report on the site presented to the Asiatic Society of Bengal dates to 1799.[22] By 1835–36, Alexander Cunningham, then a British army engineer and the subsequent founder of the ASI, had determined Sarnath's identity as the site of the Buddha's first sermon, and even done some preliminary excavation there. By contrast, Bodhgaya, though a site of equal or greater importance in the history of Buddhism, commanded little official attention until 1861–62, and funds to support the excavation of the most important monastery in ancient India, Nalanda, were not granted until 1915. Before that, Bodhgaya was treated as a ruin, not a historical monument worthy of scholarly attention. It was not until 1854 that Cunningham turned his attention to Sanchi, a site he managed to explore thanks to his brother Joseph, then a political agent to the state of Bhopal. And still later, in 1879, Alexander Cunningham explored Bharhut.

But even before Cunningham was at Sarnath, the Scottish physician, botanist, and explorer Francis

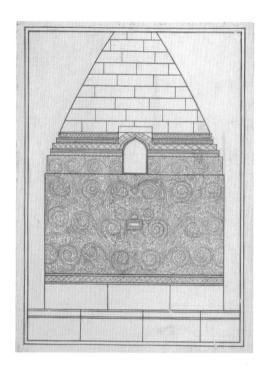

Buchanan-Hamilton was there, probably in 1813, when he traveled up the Ganges from Shahabad District in Bihar to Allahabad and then onward to Agra.[23] Although he left detailed accounts of his travels in eastern India, he provided no record of this trip, although he made a plan of Sarnath, which he called Buddha Kashi (FIGURE 10). The plan certainly would date prior to 1814, when Buchanan-Hamilton assumed the role of superintendent of the botanical garden in Kolkata, a position he held only for a year prior to leaving India for England.

FIGURE 9
Pen-and-ink drawing of the north niche of the Dhamekh stupa at Sarnath. One of a series of four drawings depicting details of carvings on the Dhamekh stupa by an anonymous artist, ca. 1785. London, British Library.

FIGURE 10
Francis Buchanan-Hamilton's plan of Sarnath. From an album of 246 drawings of sculpture and architecture, with plans of sites made during Buchanan-Hamilton's surveys in the Bengal Presidency, 1807–14. London, British Library.

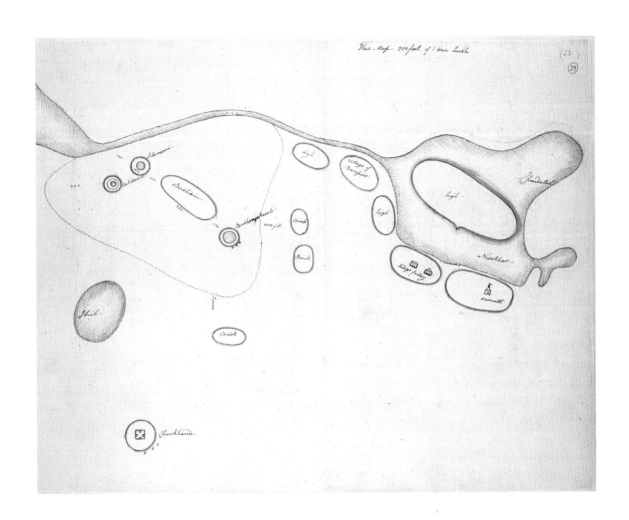

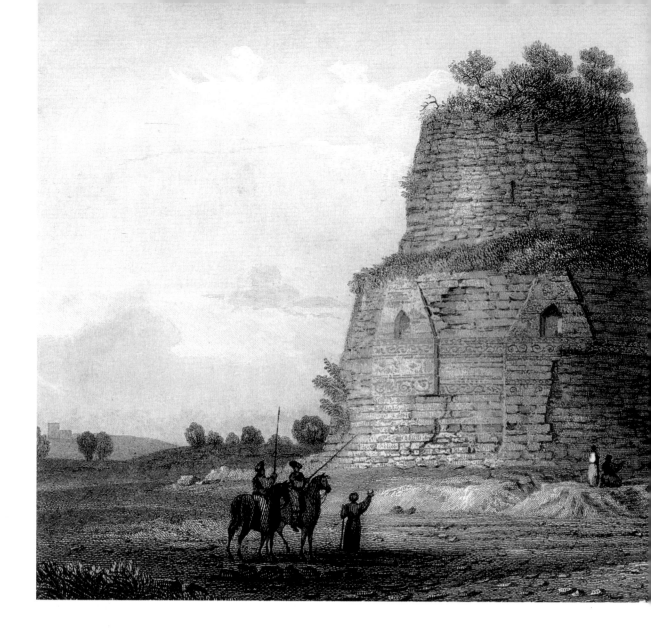

Why then the attention to Sarnath? In large measure, its proximity to Varanasi made it easily accessible to those in the town with official responsibilities. During much of the nineteenth century, Varanasi — Benares as it was then called — was a cantonment town — that is, a city with a military presence. Other British were drawn there because Sanskrit College had been established in the town in 1791. The site was easily accessible and a matter of considerable curiosity. So, well before the establishment of the ASI in 1861, amateur archaeologists dug at the site, explored it, and removed newly found antiquities; while about that same time, the Dhamekh stupa there was the subject of artistic interest and treated as the marker of a ruin (FIGURE 11).

FIGURE 11
Drawing of the Dhamekh stupa, ca. 1832. From R. Montgomery Martin, *The Indian Empire*, vol. 3 (ca. 1860), unnumbered plate preceding p. 47.

site's products in context was not part of the scientific approach of the time, just as the habits and habitats of a particular butterfly mattered little to those who sought to determine its genus and species. Sarnath's sculptural remains were sent to Calcutta and London, where they could serve as examples of Indian culture or document the role of the British East India Company. The products were, to the British in both India and London, more important than the place that had yielded them. Sarnath never caught the care and imagination of non-Indian Buddhists in the way that Bodhgaya, for example, came to be so important to the Burmese and Sri Lankans. In fact, regular pilgrimage to Bodhgaya is recorded almost without break, even when the site of the Buddha's enlightenment largely fell to ruins. But pilgrimage to Sarnath, however central it was to the formation of the Buddhist sangha, failed to attract visitors from about the twelfth century until the very end of the eighteenth century. There are, at least, no inscriptional records of pilgrims during those six hundred years. And until modern times, there were no copies of Sarnath's principal monuments as there were of the Maha Bodhi temple at Bodhgaya. Thus, despite the Buddha's admonition to visit the sites of four key events in his life, three of them were largely neglected.

IN COMES THE ARCHAEOLOGICAL SURVEY

While Cunningham might be credited as the first European explorer to present Sarnath as a site of antiquarian interest — not just a source of building material — the first serious, successful, and

REMOVING ANTIQUITIES

Even before Cunningham's exploration of Sarnath and his recognition of it as marking the site of the Buddha's first sermon, it was identified as a source for collecting antiquities that might be sent to Calcutta and elsewhere, where they could be examined like biological specimens, stimulating the curiosity of amateur Indologists. The notion of examining a

well-documented excavations there were conducted near the beginning of the twentieth century, in 1904–5, by F. O. Oertel, an engineer with the Public Works Department. Although Oertel's was the first of several controlled excavations of the site, and the one that yielded some of Sarnath's most famous discoveries, others followed, all under the aegis of the ASI. They were carefully reported in the volumes of the Survey's annual reports, and the works housed in the fledgling museum at Sarnath, where they could be related to the excavated area almost immediately adjacent to the museum. The reports and the extant remains, both those at the site itself and those housed in the museum, form much of the knowledge base for this book and are discussed in much greater detail in chapter 1.

IN ADDITION TO THE MATERIAL REMAINS

Like many at that time who considered the written records of the indigenous people to be largely mythological fantasy, Cunningham turned to external sources for an understanding of India's past. Of primary interest to him was the recently published French translation of Xuanzang's travels in India during the seventh century.[25] Xuanzang, who wrote the account after he had returned to China and settled at the monastery in Xian (today called the Great Wild Goose Monastery), visited most of the sites associated with the life of the Buddha as well as a great many other places in India. He comments on some in detail, but his account of Sarnath, like that of an earlier fifth-century Chinese Buddhist pilgrim, Faxian, is surprisingly cursory.[26]

WHAT IS NOT AT SARNATH?

Two things many people often associate with ancient Buddhist monasteries in India are curiously absent at Sarnath. One is bronze images. Simply stated, there are no metal sculptures found in the excavations as there were at Nalanda, and indeed all across Bihar and Bengal, and in Chattisgarh at Sirpur.[27] One explanation may be the absence of bronze casting workshops in the area or the lack of copper close by. In all of present-day Uttar Pradesh, I know of only three ancient bronze sculptures: the three from the site of Dhanesar Khera. But there may be something special about sites associated with the life of the Buddha, for even at Bodhgaya, no bronze sculptures have been found, although large caches of bronzes come from places as close as Kurkihar and Nalanda. Similarly, no bronze sculptures were found at Lumbini or Kushinagar.

The other thing that apparently was not at Sarnath was a scriptorium, where a group of scribes and possibly painters would produce Buddhist manuscripts. There are manuscripts recording the place of production at other Buddhist monasteries—for example, Nalanda and Vikramashila—but there is no manuscript that notes the place of production as one of the sites associated with the Buddha's life. Does that mean, then, that the monasteries at those places were in some way different from the monasteries associated with distinguished teachers? If so, there is a lack of any meaningful insight into the life of Sarnath's monastery. Or should monasteries be considered as separate from one another and with little interaction, much like the modern monasteries

in close proximity to the excavated site, including the Tibetan monastery, the Thai and Vietnamese monasteries, the Burmese one, and those representing the presence of China and Japan? In other words, should Sarnath be thought of as a unified monastic establishment or a cluster of largely unrelated monasteries?

There may be two other explanations for the absence of bronze images and a scriptorium at Sarnath. One is the possibility that there was a difference between a pilgrimage site and a residential monastery such as Nalanda and Vikramashila. I am not suggesting that monks were not resident at Sarnath. They were, as both pilgrims' accounts and the excavation of monastic dwellings indicate. But bronze images, as we know from those excavated at Nalanda, were used by monks in their residences, not in temples or as part of stupa complexes. If there was not a long-term residential community at Sarnath, then perhaps bronze images might be less common. The more temporary nature of residence at a pilgrimage site might have made a scriptorium tangential to the purpose of that site.

It also may be that the production of bronze sculpture and the establishment of scriptoria were simply later developments. Sarnath seems to have flourished through the fifth century, with a notable diminution of sculptural production and architectural expansion after that. Bronze came to be used extensively only from the eighth century onward, both in eastern India and in the south of India. The earliest surviving illustrated Buddhist manuscripts date to the eleventh century. So it may simply be that by the time bronze sculptures were extensively made and manuscripts were produced, there was little artistic activity of any sort at Sarnath, though certainly not none at all.

WHAT IS AT SARNATH?

What remains from antiquity are the foundations of structures, both monastic dwellings and temples as well as stupas, and a large number of sculptures and inscribed slabs. One account notes some 6,832 antiquities in the Sarnath site museum,[28] and this book considers others of certain or likely origin at Sarnath that are distributed in museums in other parts of India as well as across the globe. These form the subject of chapter 3, while chapter 2 considers the structures, though not just the structures within the excavated site. In antiquity, as today, Sarnath extended well beyond the excavated area. The structures composing greater Sarnath are, for the most part, religious, but just as today the institutions of Sarnath depend on the surrounding area to provide support—food and other goods and services—so, too, in antiquity we must imagine that the residents of Sarnath, who likely generated relatively little income, nonetheless had sufficient resources in the form of endowments and gifts to make the surrounding area on which they were dependent viable, perhaps even prosperous.

NOTES

1. Textual sources generally locate the Deer Park within Rishipatana. See, for example, Sutta 26 of the *Majjhima Nikaya*, in *The Middle Length Discourses of the Buddha,* trans. Bhikku Nanamoli and Bikkhu Bodhi (Boston: Wisdom Publications, 1995), 264. The *Mahavastu* also refers to the Mrigadava at Rishipatana. See J. J. Jones, trans., *The Mahavastu* (London: Luzac, 1949), 311, https://archive.org/stream /sacredbooksofbud16londuoft/sacred booksofbud16londuoft_djvu.txt. Vidula Jayaswal, however, has argued that the site we today call Sarnath was ancient Mrigadava, while a recently excavated site, Aktha, about five kilometers southwest of Sarnath, was the older Rishipatana. See Vidula Jayaswal, *The Buddhist Landscape of Varanasi* (New Delhi: Aryan Books, 2015). John C. Huntington offers the interesting suggestion that the word *mriga* is derived from the verb *mrig,* meaning "to seek or strive," but he then suggests that *mriga* literally means "those who are afraid to die" and concludes that the Buddha conquers death through his insights and travels to the park of those who are afraid to die. See John C. Huntington, "Sowing the Seeds of the Lotus: A Journey to the Great Pilgrimage Sites of Buddhism, Part II: The Ṛṣipatana Mṛgadāva ('Deer Park') Near Vārāṇasī," *Orientations* 17, no. 2 (1986): 28–29. Huntington doesn't cite a Sanskrit source for this interpretation, and the *Monier Williams Sanskrit-English Dictionary,* the standard Sanskrit etymological resource, offers no meaning of *mriga* that might suggest "those who are afraid to die."

2. *Buddhacharita,* book 1, 107, https://www.ancient-buddhist-texts.net /Texts-and-Translations/Buddhacarita /14-Book-XIV.htm. See also Max Müller, ed., *Sacred Books of the East* (Oxford: Clarendon, 1894), 169, 171.

3. *Lalitavistara,* chap. 25.54, http:// read.84000.co/translation/toh95.html. See also Bijoya Goswami, trans., *Lalitavistara* (Kolkata: Asiatic Society, 2001), 366, and https://aryanthought.files.wordpress.com /2014/05/lalitavistara-sutra.pdf, 311.

4. *Lalitavistara,* chap. 26.8. Hill of the Fallen Sages (Rishipatana, in Sanskrit; or Isipatana, in Pali) is probably better translated as Hill Where Sages Landed. Deer Park is English for Mrigadava.

5. *Mahaparinibbana Sutta* 5.8. See *Dialogues of the Buddha,* trans. T. W. [Thomas William] Rhys Davids and Caroline A. F. Rhys Davids (London: H. Frowde, 1910), 153–54. Note, however, that Toni Huber effectively argues that there is not really a canonical group of four sites, or eight sites, for that matter. Toni Huber, *The Holy Land Reborn: Pilgrimage and the Tibetan Reinvention of Buddhist India* (Chicago: University of Chicago Press, 2008), 15–39.

6. F. O. [Friedrich Oscar] Oertel, "Excavations at Sārnāth," in *Archaeological Survey of India, Annual Report, 1904–5* (Calcutta: Superintendent of Government Printing, India, 1908), 68–69; hereafter, this report is cited as *ASIAR*. With characteristic admiration for the written word, Oertel devoted much more space to the pillar and its inscription than to the capital with its four addorsed lions and remarkable abacus.

7. Alexander Cunningham, *Four Reports Made during the Years 1862-63-64- 65 (Archaeological Survey of India Report)* (Simla: The Government Central Press, 1871), 1:105.

8. A. Foucher even wonders whether the Buddha actually preached his first sermon on the outskirts of Kashi. It is far from the site of his enlightenment, notes Foucher, and he returned soon after preaching it to Bodhgaya, as the site of his enlightenment is called today. Alfred Foucher, *The Life of the Buddha, according to the Texts and Monuments of India,* trans. Simone Brangier Boas (Middletown, CT: Wesleyan University Press, 1963), 135.

9. Ashoka's Lumbini pillar inscription, for example, declares, "Here the Buddha was born."

10. E. Hultzsch, "The Sarnath Inscription of Mahipala," *Indian Antiquary* 14 (1885): 139–40.

11. Sten Konow, "Excavations at Sārnāth," *ASIAR, 1907–8* (Calcutta: Superintendent of Government Printing, India, 1911), 76–80; and Sten Konow, "Sarnath Inscription of Kumaradevi," *Epigraphia Indica* 9 (1907–8): 319–28.

12. Daya Ram Sahni, *Catalogue of the Museum of Archaeology at Sārnāth* (Calcutta: Superintendent of Government Printing, India, 1914), 276.

13. Sukumar Dutt, *Buddhist Monks and Monasteries of India* (London: George Allen & Unwin, 1962), 208.

14. "ASI Launches Excavation to Ascertain Sarnath's Actual Age," *Times of India,* 20 February 2014, http://timesofindia. indiatimes.com/city/varanasi/ASI-launches -excavation-to-ascertain-Sarnaths-actual -age/articleshow/30713151.cms.

15. "Carbon Samples from Sarnath Could Be from 395 BC," *Indian Express,* 5 May 2014, http://indianexpress.com/article /technology/science/carbon-samples-from -sarnath-could-be-from-395-bc/. See also B. R. Mani, Sachin Kr. Tiwari, and S. Krishnamurthy, "Evidence of Stone Sculpturing Workshop at Sarnath in the Light of Recent Archaeological Investigations," *Puratattva,* no. 45 (2015): 197–203.

16. As so eloquently stated by Herbert Härtel, "Considering the function of the place, an open-air grove situated outside the city of Banaras … nothing else than a 'silent soil' is predictable here for the time before Aśoka." Herbert Härtel, "Archaeological Research on Ancient Buddhist Sites," in *The Dating of the Historical Buddha=Die Datierung des historischen Buddha,* Part I, ed. Heinz Bechert (Göttingen: Vandenhoeck & Ruprecht, 1991), 66.

17. John S. Strong, *The Legend of King Aśoka: A Study and Translation of the Aśokāvadāna* (Princeton: Princeton University Press, 1983), 244.

18. At Bodhgaya, the earliest surviving monument is a slab regarded as the seat on which the Buddha sat in the course of his meditation leading to enlightenment. The pecking geese and acanthus motif recall the subject and style of the abacus on several Ashokan pillars. For Kushinagar, see Jean Ph. Vogel, "Note on Excavations at Kasia," *ASIAR, 1904–5,* 43–58, esp. 58.

19. Federica Barba, "Sarnath: A Reassessment of the Archaeological Evidence with Particular Reference to the Final Phase of the Site," in Giovanni Verardi, *Hardships and Downfall of Buddhism in India* (New Delhi: Mahohar, 2011), app. 2, 417–35.

20. The suggestion that Sarnath became a Hindu site under the Gahadavala dynasty would have to be reconciled with the Gahadavala queen Kumaradevi's gift for the "Lord of the Turning of the Wheel."

21. Diana L. Eck, *Banaras: City of Light* (New York: Columbia University Press, 1982), 82.

22. Henry Miers Elliot, *India as Told by Its Own Historians* (London: Trübner, 1867–77), 2:222–24.

23. Jonathan Duncan, "An Account of the Discovery of Two Urns in the Vicinity of Benares," in *Asiatic Researches* 5 (1799): 131–32.

24. D. Prain, "A Sketch in the Life of Francis Hamilton (Once Buchanan) Sometime Superintendent of the Honourable Company's Botanic Garden, Calcutta," in *Annals of the Royal Botanic Garden, Calcutta* 10 (1905): xx.

25. Xuanzang, *Mémoires sur les contrées occidentales,* trans. Stanislas Julien (Paris: L'imprimerie impériale, 1857–58).

26. Xuanzang, *Si-yu-ki: Buddhist Records of the Western World,* trans. Samuel Beal (London: K. Paul, Trench, Trübner, 1906). In this book, I cite either this translation or Xuanzang, *The Great Tang Dynasty Record of the Western Regions,* trans. Roingxi Li (Berkeley, CA: Numata Center, 1996). Max Deeg is in the process of preparing a new translation and commentary, a much-needed addition to scholarship.

27. A bronze image of Avalokiteshvara is illustrated but not commented on in B. R. [Braj Ranjan] Mani, *Sarnath: Archaeology, Art & Architecture* (New Delhi: Archaeological Survey of India, 2006), 84. It appears to be from eastern India.

28. *Times of India,* "Sarnath Museum Starts Its Digitalisation," 26 September 2012, http://timesofindia.indiatimes.com /city/varanasi/Sarnath-museum-starts -its-digitalisation/articleshow/16553605. cms.

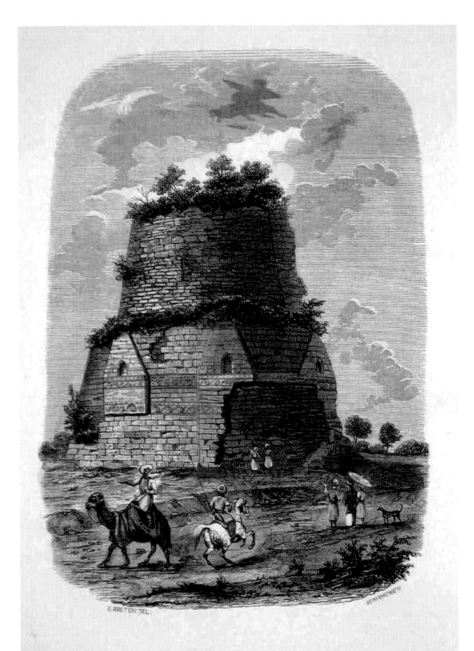

E. BRETON DEL. VERDMOREH

SARNAT. — MONUMENT DU CULTE DE BOUDDHA.

(Inde.)

Pl. VI.

CHAPTER 1

The Discovery of Sarnath / Excavating Sarnath

Sarnath did not have an uninterrupted history. Few Buddhists remained in India after the twelfth century; the common but inadequately problematized explanation is invasions, too often described as Muslim invasions. Although Buddhists from Tibet and Southeast Asia, particularly Burma, made pilgrimages to India from the thirteenth through the seventeenth centuries, their goal, it seems, was to reach Bodhgaya, the site of the Buddha's enlightenment. They left occasional inscriptional records of their visits there. But Sarnath seems to have been neglected by these pilgrims, as if the site where the Buddha delivered his first sermon and where the Buddhist order was formed mattered significantly less. Even earlier, when Sarnath functioned as a monastery, foreign Buddhists seemed to view the site of the first sermon more in passing than in depth. Faxian, the Chinese pilgrim who was there soon after 400 CE, recorded what he saw at the place he called the Deer Park of the Rishis in cursory fashion: a tower — presumably a stupa — where the five who heard the Buddha's first sermon met him; then, sixty paces north of that, another tower where,

facing east, he preached that sermon; and perhaps two other towers as well as two monasteries (*sangharamas*) that still had resident priests.[1] Faxian was much more concerned with reporting the legends of places than with their detailed geography.

Xuanzang, who was there more than two centuries later, about 635, either saw a more thriving site or simply was more detailed in his description. He observed some fifteen hundred monks there, all of them belonging to the Sammitiya sect, which we hear about more from Xuanzang than from any other source. He saw at the monastery an enormous temple with a gilt Buddha image and, inside, a life-size brass image of the Buddha in *dharmachakra mudra* — that is, turning the Wheel of the Law, not surprisingly the most common seated form of the Buddha at Sarnath. These references to metal images are intriguing in light of the total absence of metal sculptures found in the course of excavations at Sarnath, perhaps suggesting that the appearance of these figures was gilding over stucco or stone. Northeast of this temple, Xuanzang notes a stone stupa, one he attributes to Ashoka (he often

FIGURE 1.1
A view of Sarnath. From Ernest Breton, *Monuments de tous les peuples* (Paris, 1843), pl. VI.

attributes the patronage of monuments to this third-century BCE king), and, in front of that stupa, a brilliantly polished stone pillar that he claims marks the place where the Buddha preached his first sermon. Xuanzang observed several other stupas at Sarnath, each associated with a specific event—for example, the place where three past Buddhas walked back and forth and where the Buddha of the future, Maitreya, received his prediction of the attainment of Buddhahood, and another place where the bodhisattva was a six-tusked elephant.[2] The locations of these stupas become, in Xuanzang's narrative, a device to recount stories and events that shaped the nature of his faith. In the course of his description of the Deer Park, Xuanzang also notes several ponds, not so much to record their existence but to mark their association with the Buddha—for example, the pond in which the Buddha washed his robes and another in which he bathed. Today, bodies of water remain on the perimeter of Sarnath, as if defining the boundary of the site. Neither Faxian nor Xuanzang, of course, was writing a travelogue; rather, they were recording, after their return to China, what they had observed. These Chinese pilgrims' recollections were never meant to serve as a sort of written geography, as a mapping of the places they visited, nor are we the audience they sought to address.

But it was not until the late eighteenth century that people again began to give attention to Sarnath. At first, it was considered more as a place with antiquarian remains and was not specifically associated with the Buddha's presence there (FIGURE 1.1).

DISCOVERING SARNATH IN MODERN TIMES

Sarnath was not always recognized as the site of the Buddha's first sermon, though it was proposed as a Buddhist site. Jonathan Duncan, the British superintendent and resident of Benares and subsequently governor of Bombay, as Mumbai was then called, reported to the Asiatic Society on a pair of stone vessels, stored one within the other and containing some human bone, that were found in 1794 "in the vicinity of a temple called Sarnauth."[3] He states that these remains were committed to the Ganges but then speculates that they probably belonged to "one of the worshippers of Buddha, a set of Indian heretics, who, having no reverence for the Ganges, used to deposit their remains in the earth." He suggests this because "a statue or idol of Buddha" was found underground in the same place and at the same time as the stone vessels when some people were digging for stones "from some of the extensive ancient buildings" there. In other words, the ancient site was being ransacked for ready-carved materials that could be used in modern construction. Duncan supposedly provided his audience with an eye copy of the inscription on this image, but he did not supply it for readers of the journal, although it is very likely the seated Buddha image bearing an inscription of Mahipala found near the Dharmarajika stupa and discussed below (FIGURE 3.54).

CUNNINGHAM AT SARNATH

Alexander Cunningham was at Sarnath in 1835–36 to survey the site, but what we know of his work there at the time is from his report of 1861–62, after he

would have encountered Stanislas Julien's 1857–58 translation of Xuanzang's pilgrimage to India.[4] He does not explicitly say that the report is essentially old business, but it seems quite clear that Cunningham conducted no further exploration of the site after that initial work, the first comprehensive exploration of Sarnath and its environs (FIGURE 1.2).[5] His commitment to a scientific basis for archaeological work is rather contradicted, as Michael Falser notes, by his pillaging of some of the most important Buddhist sites in India, among them Sarnath.[6]

Cunningham focuses on three major monuments of Sarnath, the principal ones visible even today in the excavated area, as well as several monastic dwellings (*viharas*). First is the most prominent of Sarnath's monuments, the Dhamekh stupa, a solid stone-faced structure that rises almost thirty-five meters above the ground. Cunningham's work on this monument was conducted over a period of eighteen months, he reports, and the cost of the work, 1,200 rupees, was borne entirely by him, perhaps suggesting the unofficial work he conducted at the site. Although constructed in phases, each one enveloping the previous stupa, the Dhamekh stupa's present appearance probably dates to the seventh century, as Joanna Williams has effectively argued.[7] Cunningham notes that he employed—and supervised, he says, by way of taking credit for the work—two masons to make full-size drawings of the bands of decoration on the structure. Then, to show the scientific accuracy of his measurements, he notes the inaccurate measurements provided by all those who preceded him.[8] He states that James Fergusson, the crusty indigo planter turned architectural historian, said Cunningham's work on the stupa was conducted "under Mr. Prinsep's auspices"—that is, under James Prinsep, an assay master of the Calcutta mint and a brilliant Orientalist.[9] But Cunningham is quick to note that although the cost of opening the stupa was shared among Prinsep, Cunningham, and two others—interesting that it was a private venture, not government sponsored—the work, Cunningham tells us in italics for emphasis, was done under his own auspices, not even at the suggestion of Prinsep. He then describes the Dhamekh stupa in meticulous detail, even greater detail than this book does in the next chapter. His description of the stupa, in the precision of scientific knowledge and his careful measurements, as Tapati Guha-Thakurta notes, represents for him a contrast with the "randomness and destruction of Jagat Singh's diggings."[10] By implication, it even contrasts with the damage wrought by other colonial administrators such as the unnamed one who used forty-eight sculptures from Sarnath to serve as a breakwater for the piers of a new bridge over the Barna River and another who allegedly used fifty to sixty cartloads of stones from Sarnath buildings in the course of erecting an iron bridge over the Barna River.[11] These were engineers, like Cunningham, but ones who failed to understand the quest for scientific knowledge that Cunningham imagined he represented.

Cunningham then discusses the large circular hole—all that remains of the structure then commonly called the Jagat Singh stupa and today known as the Dharmarajika stupa, the structure that was

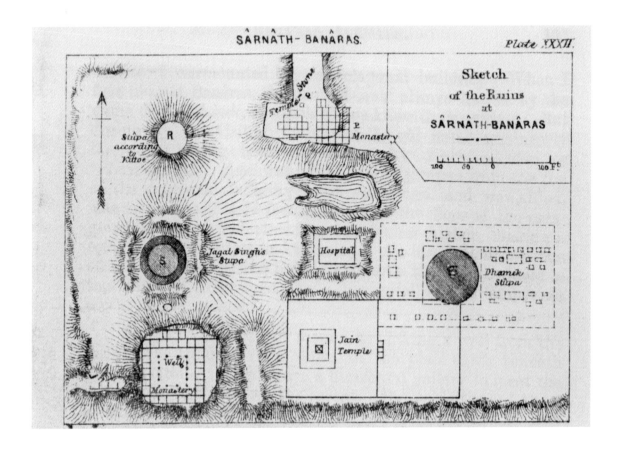

plundered for brick by Jagat Singh, the dewan of Raja Chait Singh of Benares. Cunningham's primary concern was to find the reliquary and an inscribed image that Jagat Singh had found in 1794, as reported by Duncan.[12] Cunningham describes how he sent the archaeologist and illustrator Markham Kittoe to search the remains of Jagatganj, the source of the plundered bricks, for the missing Buddha image. Kittoe found the statue (see FIGURE 3.54), a seated Buddha that Cunningham describes as preaching despite the missing hands; Kittoe also transcribed the inscription, which records it

as a gift of Mahipala of Gauda, probably the Pala dynasty king who ruled circa 988–1038. However, Cunningham noted that it is impossible to verify the accuracy of the inscription's translation because he was unable to consult Kittoe's transcription. He had only a modern Nagari script version of the inscription.

Cunningham then sought the stupa's reliquary, using a technique he often employed: asking local people, not an unreasonable method, although even in 1835–36 he was there more than forty years after the stupa had been dismantled. That time gap may

FIGURE 1.2
Plan of Sarnath. From Alexander Cunningham, *Four Reports Made during the Years 1862-63-64-65 (Archaeological Survey of India Report)*, vol. 1 (1871), pl. XXVIIa.

not be particularly important in a culture with a strong oral tradition. Even if the information one receives from informants is not precise, it gives an important sense of local tradition. But in Cunningham's case, it worked. He found an informant who said he knew about the reliquary and described it in some detail, noting that there was an inner box of marble containing gems and pieces of human arm bone, all presented to Duncan. But the box of plain stone, his informant reported, was left in its original position. So Cunningham "engaged him to dig up the box," which he successfully did at a depth of 3.6 meters.[13] Cunningham gave this reliquary and sixty statues from Sarnath to the Museum of the Bengal Asiatic Society, where it was, he notes, cataloged as a sarcophagus found at the Manikyala stupa, a site in present-day Pakistan whose reliquary is today in the British Museum.[14] By 1883, after the Asiatic Society's museum collection was transferred to the newly established Indian Museum, the provenance was correctly noted.[15] Also corrected was Cunningham's rank. In 1836, when he presented this relic casket and many other works from Sarnath to the Asiatic Society, he was Captain Cunningham. By 1883, he had been made a major-general, which was duly noted in the Indian Museum records, perhaps at Cunningham's own insistence.[16]

After presenting the Jagat Singh stupa, Cunningham reports on his excavation of the Chaukhandi, a stupa about 755 meters south of the excavated site. Its brick base is surmounted by an octagonal structure that, he notes, carries an inscription over one of the doorways recording the building's construction

during Humayun's reign and recording this Mughal emperor's ascent up the structure. Finding no relic chamber despite excavating several shafts, Cunningham abandoned his work, suggesting that it had no relics but corresponded with a structure Xuanzang described as a stupa some ninety-one meters in height that was crowned with an upside-down vase and an arrow, leading Cunningham to suggest that this was not a "relic tower"—that is, a stupa in the conventional sense.[17]

Cunningham then turns attention to the viharas, the monastic dwellings. While excavating one building, which he calls a temple, his newfound friend, the one who led him to the stone box that encased the reliquary in the Jagat Singh stupa, told him that workmen had found a large number of sculptures while collecting building materials for the nearby village, Jagatganj. Although the bricks were removed, the statues, he was informed, remained untouched. Here, Cunningham reports, he found some sixty statues and reliefs, all upright and packed closely together in a space less than three meters square, as if placed together for protection. He presented these sculptures to the Asiatic Society in Calcutta, but they are now in the Indian Museum, where the register notes them, as it does with the stupa box, the gift of Captain (now Major-General) Cunningham.

Cunningham's use of his native informant, Sangkar as he spells it, recalls that of other explorers, in fact, of a whole range of colonial administrators who exploited knowledgeable Indians for their own gain. Aurel Stein's massive collection of Buddhist manuscripts at Dunhuang represents one form of such

"collecting" by a British colonial explorer. But perhaps the best-known use of this exploitation might be Colin Mackenzie's use of the Telugu Brahmin Venkata Boria and especially his younger brother, Cavelly Venkata Luchmiah, to engage in the process of collecting and thus forming of colonial knowledge.[18]

Cunningham concludes his report by proposing that no further excavations be conducted at Sarnath: "In the absence of any general plan of the ruins, showing the extent of the explorations carried on by Major Kittoe and his successors, I do not think it would be advisable to undertake any further excavations at Sarnath, Benares; I have already suggested that the ground immediately around the great tower [the Dhamekh stupa] should be levelled for the purpose of affording easy access to visitors. In carrying out this operation, every fragment of sculpture should be carefully preserved."[19] To this end, Cunningham prepared a design for a museum at the site (FIGURE 1.3).

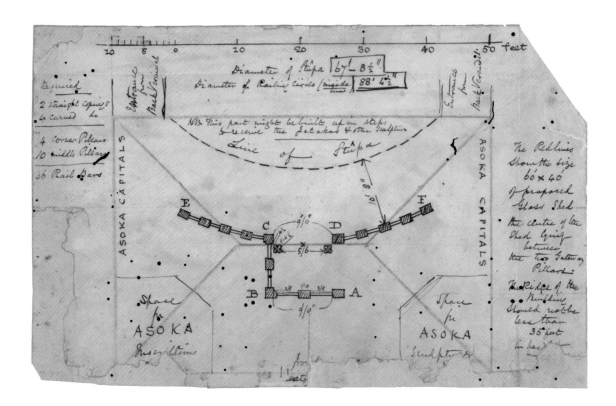

FIGURE 1.3
Hand-drawn plan for a site museum at Sarnath, contained in Alexander Cunningham's letter to J. D. Beglar, dated Simla, 23 June 1885. Kolkata, Victoria Memorial Hall.

MARKHAM KITTOE

Even though Kittoe didn't live long enough to publish the findings of his exploration of Sarnath in 1851–52,[20] he left a corpus of drawings made at the site, all of them today preserved in the British Library (FIGURE 1.4). Cunningham, however, provides some information on those excavations, drawing on a letter from Kittoe of 1852. In that letter, Kittoe notes four stupas at Sarnath, whereas Cunningham had found only three. In an uncharacteristically generous gesture, Cunningham grants Kittoe's count and adjusts his plan of the site accordingly. He also reports that Kittoe had excavated a rectangular structure about nineteen meters long by thirteen meters wide. Located thirty-eight meters west of the Dhamekh stupa, Kittoe identifies the structure as a hospital on the basis of mortars and pestles found there. Cunningham accepts this identification and adds it to his plan.[21] Finally, Kittoe describes the end of Sarnath as he saw it, the result of a great fire: "All has been sacked and burnt, priests, temples, idols, all together. In some places, bones, iron, timber, idols &c., are all fused into huge heaps."[22] This conclusion seems to resonate with Cunningham, who quotes at length a description by Edward Thomas, who continued the excavations after Kittoe's departure and modestly reports on his work and Kittoe's.[23] Thomas observed that food had been hastily abandoned and charred timbers provided evidence of destruction by fire. "Every item," Thomas reports, "bore evidence of a complete conflagration." None of them, however, not Cunningham, not Kittoe, not

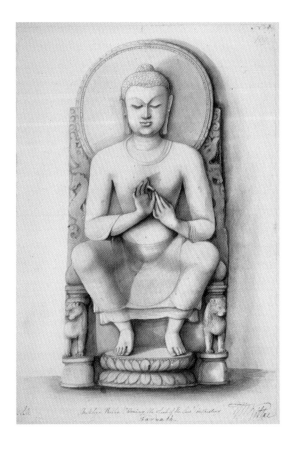

FIGURE 1.4
Drawing of seated Buddha by Markham Kittoe. From *Sarnath: Album of 50 Drawings of Sculpture at Sarnath, Bodhgaya and Benares (U.P.)* (1846–1853), n.p. London, British Library.

Thomas, attributes the fire to wanton destruction by rampaging bigoted invaders, as was and still is done so often to explain ruins or abandonment in India. Wooden structures illuminated by oil lamps were, after all, subject to destruction by fire.

SARNATH SCULPTURES GO TO LONDON

Kittoe apparently took multiple sculptures from Sarnath to England, for in his letter to Cunningham, he refers possessively to several sculptural works: "I have got fine specimens."[24] Finders keepers seems to have been an acceptable mode of operation even for those engaged in scientific enquiry. But Kittoe may not have operated on his own behalf in getting those sculptures to Britain.

A dispatch for the Court of Directors of the East India Company dated 30 March 1858 requests a selection "for our museum" from the objects discovered in the ruins of Sarnath "which may possess the greatest interest and which may throw the most light on the manners and habits of former ages."[25] This dispatch then approves the orders given for further exploration of the ruins and for the delineation of the remains, by means of photography, despite Cunningham's suggestion that further exploration cease. A letter of 13 August 1858 from R. B. Chapman, undersecretary to the government of India, addressed to Commander J. Rennie asks that he take the necessary steps to ship the objects to England, specifically to the address of the Court of Directors.[26]

There was further concern about a box of sculptures—I imagine an enormous one—that Kittoe had taken to England. The advice: "I would suggest the expediency of that Officer's widow, being called upon to state what has become of the box which it is well known was taken home by him for delivery at the India House [the headquarters of the East India Company]."[27] While there is no documentation regarding the discovery of this box, it must have been found, since several of the works Kittoe documents in his drawings now reside in the British Museum.

FOLLOWING CUNNINGHAM AND KITTOE

Records of excavations at Sarnath immediately following Kittoe's work there are sparse. Edward Thomas—described by Daya Ram Sahni as a judge and coin collector,[28] though in reality he was a serious antiquarian with significant publications on numismatics—continued Kittoe's work. He was followed by Fitzedward Hall, an American Orientalist who served as a professor of Sanskrit and English at the Government College, Benares, from 1853 to 1855. Finally, in 1865 C. Horne, generally described simply as a judge of Benares[29] but also certainly a serious antiquarian who contributed extensively to the *Journal of the Asiatic Society of Bengal*, conducted excavations at Sarnath, though without a report on his work there.

SARNATH SCULPTURES AS BREAKWATER AND BALLAST

The remains of Sarnath were more than trophies or souvenirs to bring home or scientific specimens that might help reveal a past to those with the insight to read them. On one hand, archaeological discovery and the European men—yes, always men—who

wrote about it sought to provide a history for India, one they imagined India lacked because they couldn't find a written narrative presented in chronological order, a narrative in the Western fashion. On the other hand, modernity was a vehicle for erasing history, as Sarnath's sculptures were reduced to ballast for the railway or footings for newly constructed iron bridges. M. A. Sherring reports that for one of the bridges spanning the Barna River, some "forty-eight statues and other sculptured stones were removed from Sarnath and thrown into the river, to serve as a breakwater to the piers." For the iron bridge spanning the Barna, "fifty to sixty cart-loads of stones from the Sarnath buildings were employed."[30] Further depredation to the site came about 1894, when stones and bricks from Sarnath were broken for use as ballast for the railway track that then was being constructed about a kilometer east of the excavated area.[31] Even earlier, in 1848–52, Kittoe is alleged to have used materials from Sarnath for the construction of Queen's College in Benares.[32] So it was not just "ignorant villagers," as was so often claimed, or the workmen of Jagat Singh who despoiled this and other sites but also the officials of British India. Antiquity might have been mined to stitch together a history of India written in a European-style narrative, but it also might have been mined for the imposition of "progress" on the region.

F. O. OERTEL'S EXCAVATIONS OF 1904–5

It is good that the Archaeological Survey of India (ASI) neglected Cunningham's counsel that no further excavations should be undertaken at Sarnath.[33]

Serious excavations were resumed at the site in the cool season of 1904–5 by F. O. Oertel, a civil engineer who had renounced his German citizenship and served with the Public Works Department in various parts of India, among them Benares, where he worked from 1903 to 1907. As Oertel explains in a lecture for the Indian Section of the Fifteenth International Congress of Orientalists at Copenhagen in August 1908, he had been long interested in Indian art and architecture, and, over the course of his professional career in Burma and Ceylon, he had developed a special interest in Buddhist art and religion. So upon being posted to Benares, he came to "occupy [himself] with Sarnath," as he describes his interest. He first erected a building at the site to house the sculptures that had been removed to Queen's College and then, still following his engineer's instincts, persuaded the authorities to construct a paved road to Sarnath. Finally, during his last season in Benares, he convinced Sir John Marshall, the director-general of archaeology, to grant him permission to conduct excavations at the site. Preliminary work at the site led to a generous grant from the government of India, which was supplemented by a grant from the local government, presumably from the Benares administration. His work there, extending from December 1904 to early April 1905, employed some two hundred coolies working under Oertel's direction (FIGURE 1.5) before he was transferred to Agra soon after the season concluded.[34]

Despite the lengthy report on a single season of work, this was not the excavation that yielded the preponderance of Sarnath sculptures, although it

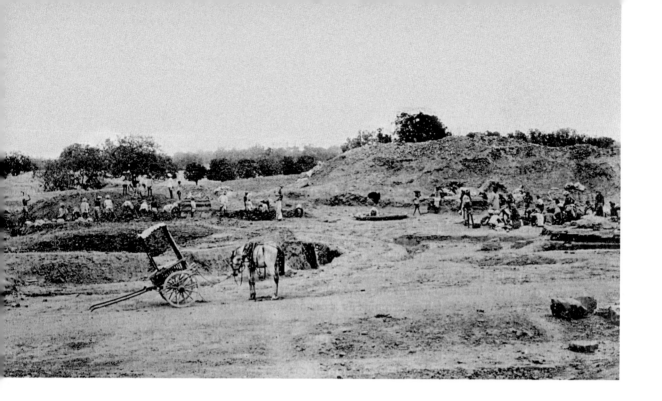

did provide the most famous—and perhaps most important—ones. His primary work was in the vicinity of the Jagat Singh stupa, known today as the Dharmarajika stupa. After excavating the shrine north of the stupa, now called the Mulagandha-kuti (or Main Shrine), Oertel found the stump and fragments of a large column just west of the shrine. This was the column of Ashoka, the one whose capital he next uncovered and a work that has become the emblem of the Republic of India. In his report, Oertel evinces none of the excitement that such a discovery might induce but rather records finding the pillar and capital in dispassionate descriptive terms. Perhaps it was no surprise to find this since, as he notes, Xuanzang had observed the pillar and described its height as a bit more than twenty-one meters, almost twice as high as Oertel estimates it stood above the original ground level.[35] If Xuanzang saw the pillar, then Oertel must have assumed it would be there, waiting for someone like him to reveal it.

Oertel conducted enough minor excavations around the Dhamekh stupa to draw a cross section of it (FIGURE 1.6). He notes that the stupa in its present form is not the form in which Xuanzang saw it, although I am not at all sure how he determined exactly which among the structures the Chinese pilgrim describes is the Dhamekh stupa. And finally, while casting blame for the present—that is, 1904–5—appearance of the stupa, he suggests that Jagat Singh's workmen managed to remove some of the structure's sculptured frieze, although it is not clear how they would have reached this elevated level or why they would have bothered when there was so much building material that could be pillaged at ground level.

About three-quarters of a kilometer south of the excavated site is the Chaukhandi stupa, a tall mound surmounted by a tall tower that was built by Akbar (1556–1605), as the inscription notes, to commemorate the visit of his father, Humayun, to the site (FIGURE 1.7). The inscription's reference to the "lofty

FIGURE 1.5
Excavations in progress, 1904–5, Sarnath. From F. O. Oertel, "Excavations at Sārnāth," in *Archaeological Survey of India, Annual Report, 1904–5* (1908), fig. 2.

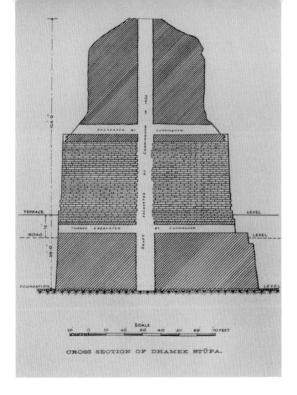

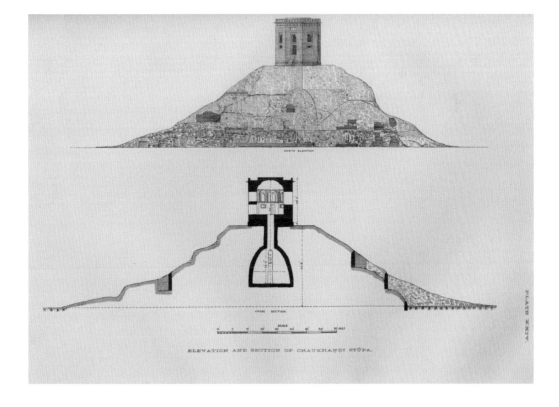

FIGURE 1.6

Cross section of Dhamekh stupa. From F. O. Oertel, "Excavations at Sārnāth," in *Archaeological Survey of India, Annual Report, 1904–5* (1908), pl. XXI.

FIGURE 1.7

Chaukhandi stupa. From F. O. Oertel, "Excavations at Sārnāth," in *Archaeological Survey of India, Annual Report, 1904–5* (1908), pl. XXIV.

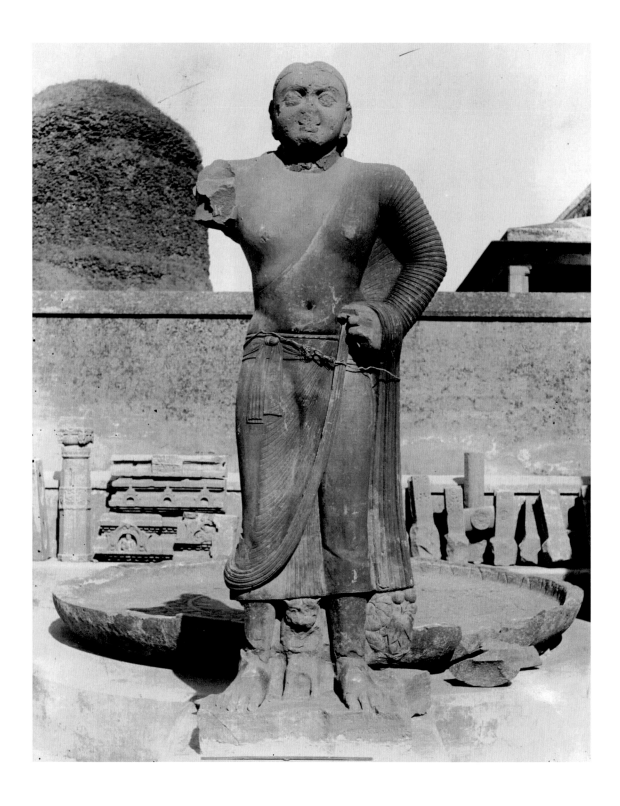

tower reaching the blue sky" echoes the metaphor used in inscriptions commemorating the dedication of temples, and perhaps it recalls a sense of the Ashokan column that almost surely had been long destroyed by the time of Akbar's visit. Oertel excavated the lower portion of the mound in order to reveal more of the Chaukhandi stupa and to understand the nature of its construction. Oertel concludes that this stupa marks the spot where the Buddha met—or, rather, remet—Kaundinya and four other ascetics who had been with the Buddha prior to his gaining enlightenment, the five who heard his first sermon, delivered at Sarnath. Quoting Stanislas Julien's translation of Xuanzang's account, he notes that two or three *li* (about a half kilometer, though the unit of measurement has not been consistent through history) southwest of the monastic area is a stupa that was built in stages, the summit in the form of a bell. Oertel's excavations show that the stupa was constructed in three stages, not entirely unusual for stupas in India.

The wish to connect this stupa and other structures with specific biographical moments, with events of the past, seems part of a larger impulse to link place and time, as if by standing in a particular locus, one can move from the present to a historical or mythical past, to be part of that past. And to the extent that ritual re-creates the past, linking a participant with it, "placeness" becomes an essential part of faith, as it does in conducting prayer while facing a particular direction or engaging in the ritual movement of pilgrimage.

From that one single season of excavation, Oertel uncovered 476 sculptures, among them two of the most important works. One is the standing figure identified in its inscription as a bodhisattva dedicated by the monk Bala in the third year of Kanishka's reign—that is, sometime late in the first century or early in the second (FIGURE 1.8). He found it "lying in the open" midway between the Main Shrine and the Jagat Singh stupa (respectively, the Mulagandhakuti and Dharmarajika, as they are called today) along with the figure's enormous stone umbrella. A similar standing figure that may be a local version of Bala's image was discovered nearby. Also unearthed in the course of these excavations was a magnificent late fifth-century seated Buddha, one of many from the site, all with hands in the preaching mudra (dharmachakra mudra) used almost as often as the Ashokan lion capital as emblematic of the site. It was found, Oertel reports, south of the Jagat Singh stupa.[36] These and other Sarnath sculptures are discussed much more extensively in chapter 3.

SIR JOHN MARSHALL AT SARNATH

Almost immediately after a three-year stint excavating on Crete, Sir John Marshall was appointed director-general of archaeology in 1902 at age twenty-six. One of his major concerns, like that of the Viceroy, Lord Curzon, who appointed him, was the professional conservation of existing structures, even more than new exploration and excavation.[37] Nonetheless, he recognized the importance of excavating Buddhist sites in India and turned his attention first to Sarnath, and subsequently to Taxila and Sanchi, before undertaking the lead in work at protohistoric sites.

FIGURE 1.8
Bodhisattva with inscribed pedestal, 1st–3rd century CE, dedicated by the monk Bala. Sarnath, Archaeological Museum Sarnath.

Marshall resumed the excavations at Sarnath in spring 1907, after a two-season lapse.[38] He essentially built on Oertel's work, further excavating areas around the Main Shrine: west, east, and north of it. He discovered a seal in a structure west of the Main Shrine bearing an inscription of a monk named Kirtti who made a gift of a lamp to the Mulagandhakuti (original ["root"] perfumed hall). Thus, today, signage at this site identifies the structure as the Mulagandhakuti and further states that it is the remnant of a huge temple where the Buddha used to sit in meditation and that, according to Xuanzang, its height was sixty-one meters, as if the seventh-century pilgrim had taken measurements with the precision of an archaeologist and recorded them in metric.

A section of Marshall's report focuses on what he calls the "Monastery Area," the part of the excavated site that includes Monasteries I through IV of the seven monastic structures revealed to date. Quite unlike most other Buddhist sites—for example, Nalanda, Paharpur, and Vikramashila, which have ordered monasteries either forming the perimeter of the site or aligned in a single axis—the monastic dwellings at Sarnath are mostly scattered around the site, perhaps suggesting residences for the monks following different schools. Inscriptions indicate followers of the Sarvastivadin and the Sammitiya were at Sarnath, though Marshall suggests that they were not living entirely in harmony with each other but rather in some degree of competition.[39] I see no reason at all to assume the presence, even the dominance, of a single sect, particularly at sites that are associated with the life of the Buddha.

Marshall's excavation of this season also explored the area that Kittoe had identified as a hospital because he found some pestles there, apparently believing these were used for grinding medicines. The site subsequently has been identified as a monastery and given the rather uninteresting name Monastery V. Finally, he reports on the remarkable monolithic railing in the "chapel," as he calls it, of the Main Shrine. He assumes it to be Mauryan in date—that is, from the third century BCE—and lavishes praise on its quality: "a tour de force...never...surpassed even by the finest workmanship on Athenian buildings,"[40] the touchstone of excellence to archaeologists working at the beginning of the twentieth century.

Two points become references, orientations of sorts, for the location of the excavations for this season: the Ashokan pillar and the Main Shrine. In the mode of Xuanzang's description of Sarnath and other sites, noting that a monument was a certain distance from the previously discussed one, Marshall here describes the places he excavated as being a specific distance east, west, or north of the Main Shrine or the Ashokan pillar.

Marshall continued his work at Sarnath in 1908, excavating there from mid-January to mid-March. He first focused on the structure he previously had called Monastery I (today at the site called the Dharmachakra Jina Vihara, though that conflates the structure with an inscription Marshall found elsewhere at the site). Earlier he had assigned the building to the eleventh century on the basis of ornament that he says was expressly made for it;[41]

here, he assigns it to the twelfth century.[42] In the course of this season, he excavated enough of the enormous structure that he could provide a conjectural elevation of it. The excavations of this season also included Monasteries II, III, and IV as well as the building that Kittoe had called a hospital; Marshall rejects that identification and suggests that it served as a monastic dwelling.[43] His excavations in the area of a group of stupas north of the Dhamekh stupa yielded an important inscription of the twelfth-century queen Kumaradevi and three sculptures so similar in style that he accurately assumes them to have been carved as a group and assigns to the ninth century.[44]

Despite the Viceroy Lord Curzon's sense of class, and to an extent Marshall's own, Marshall was the first among the directors-general to work closely with Indian scholars. He recognized their unique ability to make important contributions to understanding India's past and recognized the role they might have in writing their own history.[45]

SARNATH'S FIRST INDIAN VOICE

Although Marshall says explicitly little about his intention to give his Indian colleagues an active role in unearthing and presenting their own history, his actions clearly showed that he did. First among those whose work he promoted was Daya Ram Sahni, a Sanskritist by training who had worked on the excavations at Kushinagar in 1905, then Rajgir and Rampurva in 1906 and 1907. In an effort to keep material excavated at Sarnath close to the site, Marshall laid plans in 1904 to establish the Archaeological Museum Sarnath, the first site museum under the ASI; the building was completed in 1910. Although Sahni did not have a role in the Sarnath excavations, he was the one who supervised the work of arranging and labeling the museum's holdings, and just four years later he published the lengthy and meticulously detailed *Catalogue of the Museum of Archaeology at Sārnāth*.[46] Almost immediately after he began to work on the museum's collections, he presented the site itself in his *Guide to the Buddhist Ruins of Sarnath*, probably the most frequently reprinted volume published by the ASI.[47] Sahni became the first Indian director-general of the Survey, in 1931.

HAROLD HARGREAVES AT SARNATH

After a hiatus of several years, excavations at Sarnath were resumed for a single season, November 1914 to January 1915.[48] These excavations, conducted by Harold Hargreaves while serving as superintendent of the Northern Circle, focused on the area around the Main Shrine and the perimeter of the Jagat Singh stupa. Probably the most important find of the season, at least to art historians, are the three standing Buddha images provided by the monk Abhayamitra, one in a year equivalent to 473/74 CE, the other two in a year equivalent to 476/77 CE. They were found lying on their backs, as if intentionally buried there, east of the Main Shrine. The provision of these figures by a monk, not a lay person or merchant, follows a common pattern at Sarnath and at several other sites associated with the Buddha's life.

In the course of his report, Hargreaves raises the issue of foreign "origins," something he particularly observes in some architectural details and heads he uncovered in the course of his excavations.[49] The less rustic something appeared to the European eye — for example, contrasting with the figures from Parkham and Patna identified as yakshas — the more likely they are to have a foreign origin, whatever that might mean.

After 1915, excavation at Sarnath was sporadic at best. The effort at the site was largely invested in conservation as it was moved from a locus of scientific investigation and the further creation of an Indian past to a site to be visited, even by tourists who happened to be in Varanasi. With the exception of work at Nalanda, the focus of Indian archaeology moved from India's Buddhist past to its more distant past with the discovery of the ancient civilization that flourished at Mohenjo-daro and Harappa, one that offered links to the more familiar Mesopotamian west.

THE END OF SARNATH

Of course, Sarnath really did not have an end. It has faced periods of wanton destruction and reconstruction, of use by monks and abandonment. But as the final chapter of this book shows, it is very much alive today, populated by monks, albeit mostly from distant places and living in monasteries that are not located right on the excavated site. And it is a major tourist destination. Yet at some point, probably during the eleventh or twelfth century, the monastery was subject to major devastation.

In casting blame for damage to the site, Oertel echoes the usual lament regarding Sarnath's destruction: invaders, almost invariably described as Muslim invaders. Cunningham and his immediate successors had noted that the monastery was subjected to sudden and entirely unexpected destruction. Evidence of a great conflagration is reported as is ready-made food that seems to have been abandoned in haste, so great and sudden was the fire. Thomas, for example, reports that "the destruction of the building, by whomsoever caused, was effected by fire applied by the hand of an exterminating adversary, rather than by any ordinary accidental conflagration."[50] Building on this, J. D. Beglar wonders if the destruction could have been perpetrated by Brahmins but then quotes H. M. Elliott's translation of the *Tarikha Nialtigin*, which describes the attack on Benares in 1033 by Ahmad Niyaltigin, a governor of Punjab under Masaud of Ghazni and a part-time military commander. His raid resulted in vast plunder, the *Tarikha* reports, though without claims to religious persecution or the destruction of any structures.[51] Oertel, too, is somewhat circumspect in attributing the demise of the monastery to any specific group, although he does note that "whatever may have caused the break-up of the Buddhist community at Sarnath, the condition of the excavated ruins leaves little doubt that a violent catastrophe accompanied by wilful destruction and plunder overtook the place."[52] Earlier in his report, Oertel says of the Ashokan column, "To judge from appearances, the column must have been battered down and

violently thrown against the [neighboring] shrine," as if one could imagine an enormously strong invader picking up the multiton pillar and hurling it against a shrine. So while these invaders are not explicitly identified, the sense both at the time of the writers and certainly today is that Muslims wraught Sarnath's demise. The ASI, for example, explicitly states that the monuments of Sarnath experienced a reverse when Benares suffered under the spearhead of Mahmud Ghazni's invasion.[53] A reverse maybe, but that invasion occurred about 1020, and construction at Sarnath continued after that. If Mahmud did damage to the site — if he even reached Benares — the damage was not irreversible, because an inscription of 1026 from Sarnath credits two princesses with considerable repair and construction work at the site.[54] And an inscription of Kumaradevi records the construction of a vihara at Sarnath.[55] Perhaps they mean Muhammad of Ghor, who did conquer Benares in 1193–94 and might have plundered Sarnath, more likely for whatever wealth was imagined to be stored there and in other religious institutions than for the sake of iconoclastic destruction.

NOTES

1. James Legge, *A Record of Buddhistic Kingdoms* (Oxford: Clarendon, 1886), 96.

2. Xuanzang, *The Great Tang Dynasty Record of the Western Regions,* trans. Roingxi Li (Berkeley, CA: Numata Center, 1996), 96–206.

3. For all quotations in this paragraph, see Jonathan Duncan, "An Account of the Discovery of Two Urns Found in the Vicinity of Benares," *Asiatic Researches* 5 (1799): 131–32.

4. Xuanzang, *Mémoires sur les contrées occidentales,* trans. Stanislas Julien (Paris: L'imprimerie impériale, 1857–58).

5. Alexander Cunningham, *Four Reports Made during the Years 1862-63-64-65 (Archaeological Survey of India Report)* (Simla: The Government Central Press, 1871), 1:103–30; hereafter cited as Cunningham, *ASR.*

6. Michael Falser, "The Graeco-Buddhist *Style of Gandhara*—a 'Storia Ideologica,' or: How a Discourse Makes a Global History of Art," *Journal of Art Historiography* 13 (2015): 7.

7. Joanna G. Williams, *The Art of Gupta India: Empire and Province* (Princeton: Princeton University Press, 1982), 168–69.

8. Cunningham, *ASR,* 1:110.

9. Cunningham, *ASR,* 1:107.

10. Tapati Guha-Thakurta, *Monuments, Objects, Histories: Institutions of Art in Colonial and Postcolonial India* (New York: Columbia University Press, 2004), 88.

11. M. A. [Matthew Atmore] Sherring, *The Sacred City of the Hindus: An Account of Benares in Ancient and Modern Times* (London: Trübner, 1868), 25.

12. Cunningham, *ASR,* 1:113–16. See also Duncan, "An Account," 131–32.

13. Cunningham, *ASR,* 1:115.

14. Cunningham, *ASR,* 1:115. For trenchant discussion of Cunningham's work on the Jagat Singh stupa, see Guha-Thakurta, *Monuments, Objects, Histories*, 88–90.

15. John Anderson, *Catalogue and Hand-Book of the Archaeological Collections in the Indian Museum, Part II* (Calcutta: Printed by the Order of the Trustees, 1883), 22–23.

16. The Sarnath works deposited with the Asiatic Society were subsequently transferred to the Indian Museum. Anderson quite explicitly states that the casket was transferred to the museum: "Cunningham rediscovered the stone box,…and presented it to the Asiatic Society of Bengal along with numerous discoveries he then made at Sarnath, *and the box is now in this museum.*" Anderson, *Catalogue,* 3–4. Emphasis mine. It carries accession number S39 in Anderson, *Catalogue,* 22–23. Nonetheless, the museum staff cannot locate the reliquary casket, and in a personal communication from 8 August 2017, the museum director suggests that "its movement from the Asiatic Society to Indian Museum, to my belief, is a matter of question."

17. Cunningham, *ASR,* 1:117–18.

18. Bernard Cohn, *Colonialism and Its Forms of Knowledge: The British in India* (Princeton: Princeton University Press, 1996), 76–105.

19. Cunningham, *ASR,* 1:129.

20. Himanshu Prabha Ray, in *The Return of the Buddha: Ancient Symbols for a New Nation* (New Delhi: Routledge, 2014), 79, reports the dates of Kittoe's excavations as 1848–49. Daya Ram Sahni, in *Guide to the Buddhist Ruins of Sarnath* (Calcutta: Superintendent of Government Printing, 1911), 7, and other sources published by the Archaeological Survey of India give 1851–52 as the date of Kittoe's excavation. Cunningham, in *ASR,* 1:124, cites a long letter from Kittoe dated 18 May 1852 describing his excavations. The letter is thus dated before Kittoe's return to England in 1853 and so probably does describe his very recent work at the site.

21. Cunningham, *ASR,* 1:pl. 32. This is the structure subsequently identified as Monastery V.

22. Quoted by Cunningham, *ASR,* 1:126.

23. Edward Thomas, "Note on the Present State of the Excavations at Sarnath," *Journal of the Asiatic Society of Bengal* 23 (1854): 469–77.

24. Cunningham, *ASR,* 1:126.

25. National Archive of India, Home Department, Public, File O.C., 20 August, nos. 23–24 of 1858: Quoting Honourable Court's dispatch no. 34, dated 30 March 1858.

26. National Archive of India, Home Department, Public, File O.C., 20 August, nos. 23–24 of 1858.

27. National Archive of India, Home Department, Public, File O.C., 20 August, nos. 23–24 of 1858: Letter 309 of 1858, dated 21 June 1858.

28. Daya Ram Sahni, *Catalogue of the Museum of Archaeology at Sārnāth* (Calcutta: Superintendent of Government Printing, India, 1914), 13.

29. See, for example, M. A. Sherring, *The Sacred City of the Hindus: An Account of Benares in Ancient and Modern Times* (London: Trübner, 1868), vii.

30. Sherring, *The Sacred City of the Hindus,* 25.

31. F. O. [Friedrich Oscar] Oertel, "Excavations at Sārnāth," in *Archaeological Survey of India, Annual Report, 1904–5* (Calcutta: Superintendent of Government Printing, India, 1908), 64; hereafter, this report is cited as *ASIAR.*

32. Oertel, *ASIAR, 1904–5,* 63.

33. Cunningham, *ASR,* 1:129. To be fair to Cunningham, he adds the proviso that further excavations should not be undertaken "in the absence of any general plan of the ruins."

34. F. O. [Friedrich Oscar] Oertel, "Some Remarks on the Excavations at Sarnath Carried Out in the Year 1904–5," *Indian Antiquary* 37 (1908): 277–80.

35. Oertel, *ASIAR, 1904–5,* 69.

36. Oertel's list notes the findspot as "south of the Jagat Singh pillar." Oertel, "Some Remarks," 92, no. 23. That is corrected to "south of the Jagat Singh stupa" in Sahni, *Catalogue,* 71.

37. This is clearly stated in J. H. Marshall's eloquent introduction to the inaugural issue of the *ASIAR, 1902–3* (Calcutta: Superintendent of Government Printing, India, 1904), esp. 10.

38. J. H. [John Hubert] Marshall and Sten Konow, "Sārnāth," in *ASIAR, 1906–7* (Calcutta: Superintendent of Government Printing, India, 1909), 68–101.

39. Marshall and Konow, *ASIAR, 1906–7,* 96–97.

40. Marshall and Konow, *ASIAR, 1906–7,* 89.

41. Marshall and Konow, *ASIAR, 1906–7,* 83–84.

42. J. H. [John Hubert] Marshall and Sten Konow, "Excavations at Sārnāth, 1908," in *ASIAR, 1907–8* (Calcutta: Superintendent of Government Printing, India, 1911), 43.

43. Marshall and Konow, *ASIAR, 1907–8,* 62–63.

44. Marshall and Konow, *ASIAR, 1907–8,* 60.

45. Good biographies of Marshall include Sudeshna Guha, introduction to *The Marshall Albums: Photography and Archaeology* (New Delhi: Mapin and Alkazi Collection of Photography, 2010), 10–67; Nayanjot Lahiri, "Coming to Grips with the Indian Past: John Marshall's Early Years as Lord Curzon's Director-General of Archaeology in India—Part I," *South Asian Studies* 14, no. 1 (1998): 1–23; and Lahiri, "John Marshall's Appointment as Director-General of the Archaeological Survey of India: A Survey of the Papers Pertaining to His Selection," *South Asian Studies* 13, no. 1 (1997): 127–39.

46. Sahni, *Catalogue.* Although there is no formal report of an excavation by Sahni, he refers to his discovery of earthen pots containing remnants of cooked rice in Monastery VI. Sahni, *Guide,* 16.

47. Sahni, *Guide.*

48. H. [Harold] Hargreaves, "Excavations at Sārnāth," *ASIAR, 1914–15* (Calcutta: Superintendent of Government Printing, India, 1920), 97–131.

49. Hargreaves, *ASIAR, 1914–15,* 129–30.

50. Thomas, "Note on the Present State of the Excavations," 472.

51. J. D. [Joseph Daviditch] Beglar [Melik-Beglaroff], "A Tour through the Bengal Provinces in 1872–73," *Archaeological Survey of India Report* (Calcutta: Superintendent of Government Printing, 1878), 8:16–17.

52. Oertel, "Some Remarks," 61.

53. See "Birthplace of New Orders," *Times of India,* 26 March 2011, https://timesofindia.indiatimes.com/city/varanasi/Birthplace-of-new-orders/articleshow/7795798.cms?.

54. Cunningham, *ASR,* 1:113–14.

55. Sahni, *Catalogue,* 276.

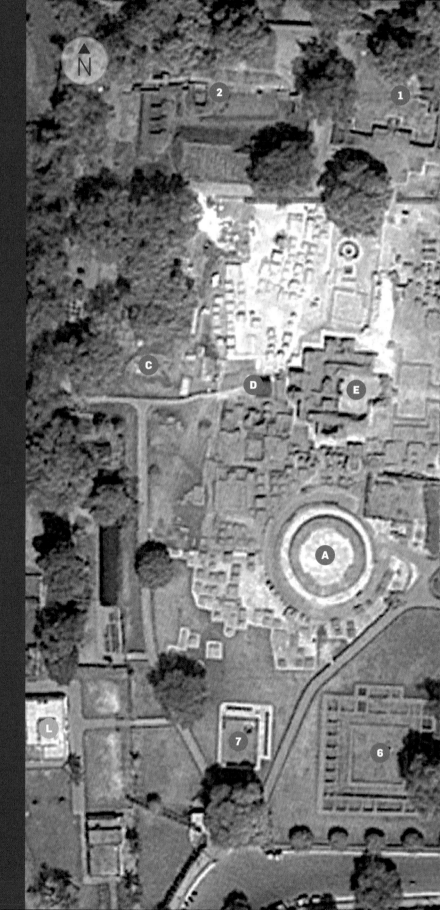

STRUCTURES INSIDE THE EXCAVATED AREA:

1 Dharmachakra Jina Vihara (so-called Monastery I)

2 Monastery II

3 Monastery III

4 Monastery IV

5 Location of Monastery V

6 Monastery VI

7 Monastery VII

A Dharmarajika stupa base

B Dhamekh stupa

C Apsidal shrine

D Ashokan pillar

E Mulagandhakuti (Main Shrine)

F Panchayatana temple

G Row of stupa bases

H First gateway to Monastery I

I Second gateway to Monastery I

STRUCTURES OUTSIDE THE EXCAVATED AREA:

J Digambara Jain temple

K Maha Bodhi Society

L Archaeological Survey of India Office

FIGURE 2.1
Satellite view of the excavated area at Sarnath, 21 April 2009. Plan by M. B. Rajani and Sonia Das, National Institute of Advanced Studies, Bangalore.

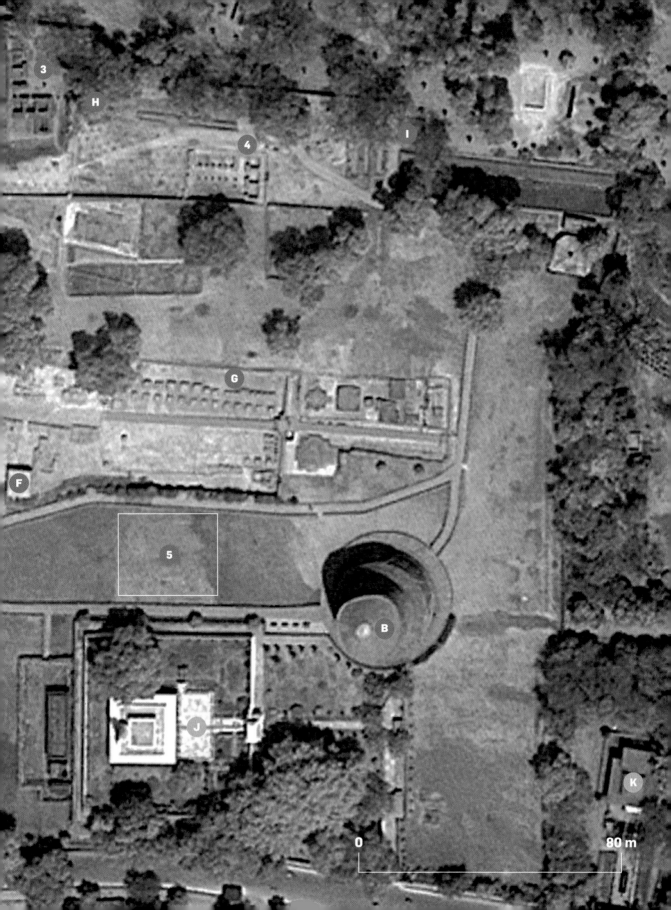

0 80 m

Sketch
of the Ruins at
SÂRNÂTH - BANÂRAS

Chandrkar
or
Chandra Tâl

Narokar
or
Sarang Tâl

Khajwi

Naya Tal

Barahipur

Dhamek

Indigo
Factory

Sârnâth
Temple

Garden
of
Chaju Mall
and
Hira Mall

Ganj

Chaukandi

From Sultánpur

Asi Nala

A. Cunningham del.

Lith: Suv: Gen¹ Office Calcutta June 1871.

1000 500 0 1000 2000 Feet

The Excavated Site

For many visitors, the excavated site (FIGURE 2.1) is simply a prelude to the rich imagery housed in the Archaeological Museum Sarnath. That may be because it lacks the coherence of many Buddhist sites such as Nalanda, Paharpur, and Vikramashila, though not, curiously, the sites associated with the life of the Buddha, which similarly lack obvious coherence. To many, it appears much like a hodgepodge of foundations that give little sense of Sarnath as an inhabited place where monks lived and studied, forming a connection to the establishment of the Buddhist order. The excavated site, moreover, represents only a portion of the ancient monastic complex, one that extended even beyond the Chaukhandi stupa on one side and to the bodies of water, now largely dry, on the other.

In this chapter and elsewhere in the book, I refer to Sarnath as a *monastery* or *monastic establishment* and to the seven monastic dwellings also as *dwellings* or *viharas*, to use a Sanskrit term that is widely misapplied. I do so, however, mindful of Gregory Schopen's parse of these words and his well-argued sense of what a monastery is.[1] Despite the image that the word *monastery* might evoke, especially to a Western reader, they were not, he says, isolated, chaste, serene, ascetic, and austere spaces. The very word *vihara*, commonly understood as "monastery" because it is used in inscriptions (even those from Sarnath), means "a place of recreation, a pleasure ground." The term *arama* (or *sangharama*), also usually interpreted as "monastery," means—and meant to the Buddhist monks resident there—"a place of pleasure, a garden." That resonates well with the ancient name of the place, Mrigadava, or Deer Park, perhaps more literally Deer Forest. And the pleasures there were not just spiritual or intellectual, as Schopen further notes. It was a garden where the deer probably frolicked, but a garden is also a place where the gods liked to sport, and, we might imagine, so did the monks and nuns. Monasteries can be aesthetic, material, even sexual. Nevertheless, because I cannot think of an English word or phrase that better describes what Sarnath, as we call it today, once was, I use the word *monastery* to refer to the entire excavated site and the unexcavated area that composed the ancient establishment as well as

FIGURE 2.2
Plan of Sarnath. From Alexander Cunningham, *Four Reports Made during the Years 1862-63-64-65 (Archaeological Survey of India Report)*, vol. 1 (1871), pl. XXXI.

to the individual residential establishments housing monks or nuns.

When Faxian got to Sarnath at the beginning of the fifth century, he saw four stupas there: one where the Buddha met Kaundinya and his four companions, who, initially, had followed Siddhartha during his period of asceticism and rejoined him at Sarnath to become his first disciples; one where the Buddha, facing east, preached his first sermon; one where the Buddha predicted a future Buddha, Maitreya; and one where the serpent (*naga*) Elepatra asked the Buddha when he would be transformed from his serpent state.[2] Two stupas remain standing at Sarnath, both discussed below, and a third has been demolished, but the base of that stupa is clearly evident. There is no evidence of the fourth stupa that Faxian mentions unless its remains lie beneath the Maha Bodhi Society's Mulagandhakuti Vihara; Alexander Cunningham observed a mound there, and as M. B. Rajani pointed out to me, it is the same distance from the Dhamekh stupa as the distance from the Dhamekh stupa to the Dharmarajika stupa. Faxian also mentions, almost in passing, two monasteries (sangharamas) that still had priests in them when he was there.[3]

Xuanzang, the Chinese pilgrim who was at Sarnath in the early seventh century, presents a fuller description.[4] He starts with a very tall stupa located northeast of Varanasi, on the western side of the Varuna River. Next to it is a pillar, he notes, erected by Ashoka that is "glistening and smooth as ice."[5] This may be his recollection of the pillar found within the excavated area, the one surmounted by the four addorsed lions. But he then traveled about five kilometers—"ten li," as he describes the distance—to the monastery he calls Mrigadava, Deer Park—that is, Sarnath—and there he recalls another pillar in front of a stupa built by Ashoka that was, as recounted in the translation, about seventy feet (21.3 meters) high and shining "bright as jade."[6] Here, he says, the Buddha preached his first sermon. There was also a great monastic center, one housing some fifteen hundred priests.

Like Faxian before him, Xuanzang notes a stupa at the site where the Buddha met Kaundinya, and yet another stupa nearby where, he says, about five hundred Pratyeka Buddhas simultaneously achieved nirvana. Beside it is the stupa where Maitreya was assured of becoming a Buddha in the future, and yet another stupa marks the spot where Kashyapa Buddha prophesied that Shakyamuni would become a Buddha. The stupa marking the naga Elepatra's assurance of transformation, noted by Faxian, goes unrecorded by Xuanzang. Lakes, as Beal's translation describes the small bodies of water that demarcate the site, are to the north and west of the monastery; Xuanzang doesn't mention a lake to the east, though one remains today. Cunningham's plan shows these bodies of water (FIGURE 2.2). What concerns Xuanzang more than mapping the site is recording the miraculous events that are marked by the monuments, thus making the monuments more important than the monks actually living at the site, the ones with whom the Chinese pilgrim must have interacted during his time at Sarnath. Because he went to India specifically

to secure accurate copies of Buddhist texts, we might understand his recording of the miracles as texts themselves, the monuments then serving to anchor those miracles.

Despite the descriptions of these two Chinese pilgrims, taken by so many scholars even today as accurate mapping of Sarnath, they were not written on site but rather upon the pilgrims' return to China and so at best represent memories, recollections, verbal souvenirs. It thus seems to me an exercise of little value to try to associate remaining stupas or monastic dwellings with those described by the Chinese pilgrims.[7]

THE SITE

It is not entirely clear who owned the land that now constitutes the excavated site at the time Sarnath was first explored. But then the strict and formal demarcation of property ownership was far less precise at the end of the eighteenth century than it subsequently became. It must have been claimed, however, by Raja Chait Singh, initially a vassal of the Nawab of Lucknow but after 1775 forcibly placed under the administration of the East India Company. Raja Chait Singh's dewan, Jagat Singh, freely used the site, particularly the stupa that bore his name until it came to be called the Dharmarajika stupa, as a source of building materials. The site was privately owned by the time Cunningham worked there in 1835, so it is not clear by what authority he gained permission to undertake his work there. In 1856, it was acquired from an indigo planter named Fergusson by the government,[8] presumably the East India Company,

which still had two years of authority remaining before ceding power to the Crown. By default, then, it became the property of the Archaeological Survey of India when the latter was established in 1861.

The fenced-in excavated area measures approximately 60,000 square meters (FIGURE 2.3). The structures, mostly building foundations, give no clear indication of an orientation to the site. One might, however, imagine one east-west axis formed by the line between the Dharmarajika stupa and the Dhamekh stupa and a similar orientation implied by the east-facing structure generally called the Main Shrine though renamed in recent signage the Mulagandhakuti. The Ashokan pillar was found just west of the Main Shrine, its lowermost portion still in situ. Most of the structures that confidently can be called monasteries are located along the northern part of the excavated area, although Monasteries V, VI, and VII[9] are located on the site's southern periphery. At a distance less than a kilometer south of the excavated site is the Chaukhandi stupa (more precisely, it is 755 meters from the Dhamekh stupa to the Chaukhandi stupa), indicating that the place as used in antiquity was by no means confined to the excavated area. Between the excavated area and the Chaukhandi stupa are temporary souvenir stands and constructed buildings, but to my knowledge there has never been excavation in this area to see the extent to which the Chaukhandi stupa stood as an independent structure not integrated with the living monastery that came to be at the place recognized as the site of the Buddha's first sermon. But satellite imagery suggests that Sarnath probably

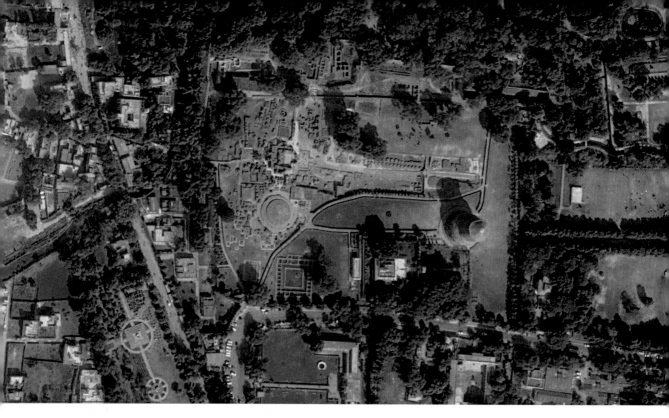

extended beyond the excavated area by about 1.5 kilometers on the north-south axis and a kilometer on the east-west axis. That imagery shows that the Chaukandi stupa was very much included within the ancient monastic area.[10]

Although I examine the individual components of Sarnath's excavated site below, I do so with some hesitation, recognizing that they need to be seen not in isolation but rather as interrelated parts of a complex. As the components were revealed by archaeologists, they were explored, measured, and seen as layers of building activity. Today they are considered archaeological relics. However, the concern has been largely with their construction, not their use as part of a dynamic monastery peopled with monks and nuns and temporary lay residents.

The earliest date that can be assigned to any of the monuments at Sarnath is the third century BCE—during the reign of the emperor Ashoka. That

is consistently the case for sites associated with the Buddha's life, as if the monarch, who apparently visited all four of the principal sites, not only declared these to be the sites of the Buddha's birth, his enlightenment, his first sermon, and his attainment of nirvana but also provided funds for the establishment of structures at the sites in order to concretize their identification.[11] While Ashoka's pilgrimage, at least the details of it, is part of legend, the date of material remains at Sarnath and elsewhere is determined by archaeological evidence.

Like several other sites associated with the life of the Buddha, the place of his first sermon started as a park, Mrigadava. It recalls Lumbini, the park in which the Buddha was born; Veluvana, the grove outside of Rajgir that was given to the Buddha by King Bimbisara; and Jetavana, his beloved park outside Shravasti, where he spent many rainy seasons. As at almost all other Buddhist sites, nothing remains

FIGURE 2.3
Google Earth image of the excavated area at Sarnath, 2016.

from the time of the Buddha himself (the sixth to fifth centuries BCE)—the earliest monuments dating to the time of Ashoka (circa 269–32 BCE). An extraordinarily astute statesman, Ashoka benefited every bit as much from his association with Buddhist orders as Buddhists did from his patronage. Buddhist monasteries such as the one at Sarnath received the monarch's financial support, but he in turn gained favor from the legitimacy that Buddhist support conferred on him. He moreover benefited from the network of Buddhist monasteries and the monks who traveled as mendicants, creating a religious network that could be used strategically to consolidate his authority over an enormous empire.

It may very well be the case that Ashoka's patronage transformed Sarnath and several other places from sites of pilgrimage to residential monasteries. That should not be taken to suggest that Sarnath and other sites associated with the life of the Buddha ceased to receive those on pilgrimage; rather, at all of these sites, perhaps with the exception of the site of the Buddha's birth, the earliest material evidence—the structures—date to the time of Ashoka.[12] It may be that during the time of Ashoka, stupas that the monarch provided became the focus of pilgrimage, and Buddhist monks developed a settled monastic life rather than a peripatetic one.[13]

Although evidence suggests that the so-called Main Shrine was commenced some time during the fourth or fifth century, it is hard to believe that the pillar bearing Ashoka's edict, immediately west of the shrine, stood in isolation before that shrine was built. Both the Dharmarajika and Dhamekh stupas probably date to Ashoka's time, at least in their earliest form—that is, at their core—but none of the other structures evident at the site seems to date so early. However, because the pillar inscription is addressed to monks and nuns of Sarnath, we must assume there were some sort of residential structures to accommodate them. What I imagine, then, is that the core of Sarnath in its earliest phase focused on the area between the two stupas of the excavated site with the additional structures built subsequently but in no planned order or arrangement, a site that then expanded outward from that core. While the bodies of water shown in the site plan may define the ultimate boundaries of Sarnath and once have served the needs of the monks resident there, it is not likely that the core area used by the early residents for their daily activities would have extended as far as these bodies of water. Nonetheless, a core population of monks and nuns large enough to warrant a warning from Ashoka must have required considerable support. It would not be reasonable to speculate that they grew and harvested their food, made their own garments, built their residential and religious structures, and carved their sculptures—all specialized work that suggests mutually dependent communities rather than a closed religious institution.

PILLAR WITH INSCRIPTION OF ASHOKA

Serving as the emblem of the Republic of India, the capital of the pillar with the inscription of Ashoka, excavated in 1904–5, was found immediately west of the Main Shrine with parts of the pillar shaft

remaining in situ. The base of the shaft, some 4.5 meters below the present ground level, stands on a large stone slab that serves to distribute the pillar's weight and lend stability to the structure. Because the pillar was not standing intact, many believe it was destroyed in a wanton act of vandalism. Xuanzang reports that the pillar, "bright as jade . . . glistening and [sparkling] like light," was erected at the very spot the Buddha began to turn the Wheel of the Law—that is, the place where he preached his first sermon.[14] He adds that people pray before the pillar, as if by the seventh century it had become an object of devotion, not a vehicle for conveying Ashoka's edicts as originally intended. The Chinese pilgrim's report was probably accurate, for on the Bodhgaya railing, we see figures with hands folded reverentially before a pillar and possibly circumambulating it. Even today, worshippers pray before the pillar at Lauriya-Nandangarh, one of only two Ashokan pillars that remain standing intact, and visitors to Sarnath, some of them Euro-devotees, sit as if in meditation before the pillar shaft, probably without any idea of the inscription's content.

Like other pillars erected by Ashoka, this one is monolithic, its capital carved from a separate piece of sandstone, possibly from the quarries of Chunar, just forty-four kilometers south of Sarnath though on the opposite bank of the Ganges, as Vidula Jayaswal argues, or possibly from the quarries on Pabhosa Hill, about two hundred kilometers west of Sarnath on the Jamuna River, as Harry Falk suggests.[15] The pillar does not contain the usual six edicts of Ashoka but rather, similar to the inscription on the pillar at Sanchi, an eleven-line admonition to the monks and nuns as well as the laity residing at Sarnath to avoid a schism, relegating those who do seek to "break up the *Sangha*" to wear white robes and live in a "nonresidence."[16] This admonition must have seemed a great deal more important to Ashoka than a declaration that the pillar marked the spot of the Buddha's first sermon and the establishment of the Buddhist order, in contrast to the Lumbini pillar inscription, in which he notes in a sort of addendum that this was the site of the Buddha's birth. What constituted breaking up the order is not at all clear. Was this in response to the beginning of the

FIGURE 2.4
Remains of the Ashokan pillar at Sarnath, 3rd century BCE.

separate schools of Buddhism? The opening lines of the inscription on the Sarnath pillar state that the admonition came from Ashoka himself, here identified as "Devanampriya Priyadasi" (Beloved of the Gods, Who in Turn Loves Everyone), an epithet of Ashoka, as we learn from his inscription at Maski that begins with "Devanampriya Ashoka" (Ashoka, Beloved of the Gods).[17] Portions of the pillar, one of them the pillar's stump still in situ, remain beneath a modern glass-enclosed structure probably intended to shield them from depredation by visitors to the site (FIGURE 2.4).

THE DHAMEKH STUPA

By far the largest and most prominent standing monument at Sarnath is the Dhamekh stupa (FIGURE 2.5), located at the easternmost portion of the excavated area and aligned more or less with the Dharmarajika stupa. It probably was once rivaled in size by the Dharmarajika stupa, which measured 33.5 meters in diameter as compared to the Dhamekh stupa's 28.3-meter diameter. Sarnath is unique among sites associated with the life of the Buddha for having more than one large stupa.[18] Modern signage suggests that the Dhamekh stupa marks the spot where the Buddha preached his first sermon, a suggestion based on an inscription dated 1020 that refers to it as the Dharmachakra stupa—that is, the stupa of the Wheel of the Law, which the Buddha set in motion when he preached his first sermon. The problem with that identification is that the sculpture bearing this inscription, an image of the Buddha, was found at the Dharmarajika stupa, not the Dhamekh stupa.

The structure, rising 43.5 meters above the original base and 31.6 meters above the present terrace, stands on a foundation of what Cunningham calls very large bricks sunk 8.5 meters below the ground level of the excavated area. The lower part of the Dhamekh stupa is constructed of stone, each block of masonry clamped to the adjacent one; the upper part is built of brick that once may have been faced

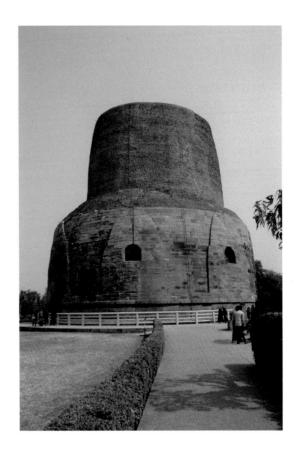

FIGURE 2.5
Dhamekh stupa, ca. 800, in its final form.

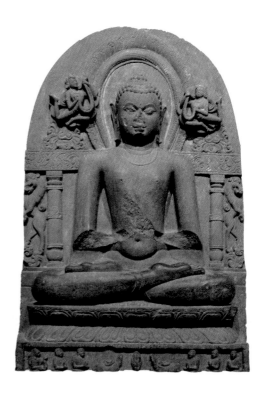

with stone. Adorning the bottom portion are eight arched projections with niches generally formed in the same shape. In each niche, Cunningham observed a pedestal with a depression that must have been intended to hold the tenon projecting from the base of a sculpture;[19] the sculptures likely were eight Buddha images. This is similar to several miniature stupas at Sarnath and other Buddhist sites that bear four niches, each with an image of the Buddha performing a different mudra (for example, FIGURE 2.6).[20] At just over a meter and a half in height, these niches are large enough to house many of the seated Buddha images excavated at the site but not the taller standing figures. Daya Ram Sahni suggests that three seated images discovered close to the Dhamekh stupa—two representing the Buddha (one in dharmachakra mudra, the other in bhumisparsha mudra) and the third representing Avalokiteshvara

FIGURE 2.6
Miniature stupa, ca. 10th century, a composite stupa as it presently appears.

FIGURE 2.7
Seated Buddha discovered in 1907–8 excavations, ca. 9th century. Sarnath, Archaeological Museum Sarnath.

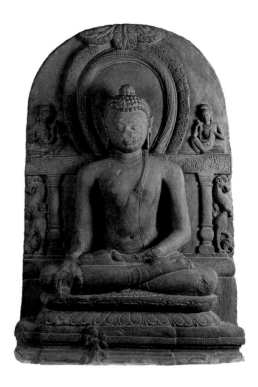

(FIGURES 2.7, 2.8, 2.9) — were once among the figures placed in the niches.[21] Sir John Marshall, who excavated the images in the course of the 1907–8 excavations, proposed that the three were carved by the same artist,[22] which is very possible given their style. They are about 112 centimeters in height and so would fit nicely in the niches. Their date, about the eleventh century, is probably close to the date of the floriated band carved in a relief band that runs fully around the stupa at the level of these niches; in fact, the floral pattern on the lintel at the shoulder level of these images appears very close to the form of the floriated relief band on the stupa, suggesting that this band, and thus the stupa in its present form, dates closer to 800 or maybe even as early as the seventh century. That is considerably later than most writers have dated the Dhamekh stupa, but there is little justification for an earlier date.[23]

THE DHARMARAJIKA STUPA

All that remains today of the Dharmarajika stupa, also known as the Jagat Singh stupa, is a circular platform that formed the base (FIGURE 2.10). Signage at the site asserts unequivocally that Ashoka erected the stupa, one of 84,000 that was constructed to enshrine relics of the Buddha from the original eight stupas. That, of course, adds special sanctity to Sarnath overall and specifically to what is left of the Dharmarajika stupa, essentially a relic itself—an archaeological relic. But the evidence for that conclusion is flimsy at best. The stupa's attribution to Ashoka comes from an inscription on the base of a Buddha image said to have been found within the stupa.[24] The inscription, dated equivalent to 1026, during the reign of the Pala dynasty king Mahipala, records gifts by two generous brothers named Sthirapala and Vasantapala (see FIGURE

FIGURE 2.8
Seated Bodhisattva Avalokiteshvara discovered in 1907–8 excavations, ca. 9th century. Sarnath, Archaeological Museum Sarnath.

FIGURE 2.9
Seated Buddha discovered in 1907–8 excavations, ca. 9th century. New Delhi, National Museum of India.

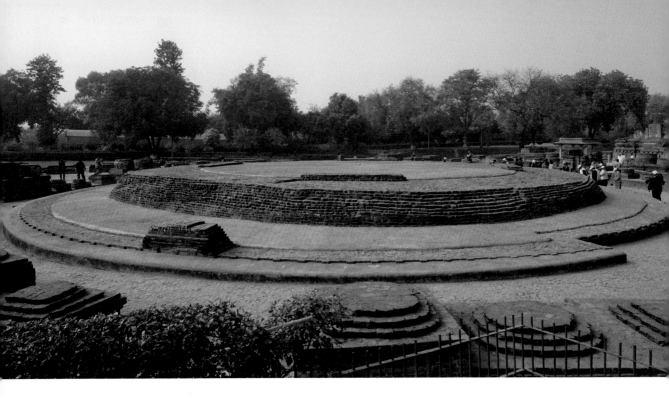

3.54). According to most readings of the inscription, they restored a stupa of Ashoka and also "built a new temple of stone from the eight holy places," presumably the eight major pilgrimage places associated with the Buddha's life.[25] That, however, is not quite what the inscription says. Rather, it says that they repaired the Dharmarajika, the source of this name for this structure, which most writers take to be an epithet for Ashoka. But it could be an epithet for the Buddha, king of dharma—that is, king of the law—for it was at Sarnath that he set in motion the Wheel of Dharma. And the term widely translated as "temple" is *gandhakuti* (perfumed hall), probably a temple of the Buddha but by no means certainly.

From that, some imaginative creators of Sarnath's history turn to Xuanzang, who refers to a stone stupa built by Ashoka with a pillar in front of it. Here, Xuanzang reports, the Buddha preached his first sermon.[26] Thus, at least in the seventh century, if Xuanzang recalled correctly when he wrote many years later, it was believed that the Buddha preached his first sermon at the site of the pillar and the stupa that came to be known as the Dharmarajika. So it may be—but only maybe—that this stupa, whose base remains, is the one that Xuanzang cites, and it may be—but again only maybe—that the stupa marks the site of the Buddha's first sermon, at least the site imagined at some point in the past to mark that site.

THE CHAUKHANDI STUPA

Less than a kilometer south of the excavated site is the structure known as the Chaukhandi stupa, a monument constructed entirely of brick (FIGURE 2.11). The base appears to have been composed of three square terraces, each somewhat smaller than the one below though each is approximately the same height, 3.7 meters.[27] That square base—which gives the stupa its name, Chaukhandi, meaning four-sided or square—might suggest the stupas erected by the Pala king Dharmapala (circa 783–820) at Paharpur and Vikramashila, both in

FIGURE 2.10
Base of the Dharmarajika stupa, Sarnath.

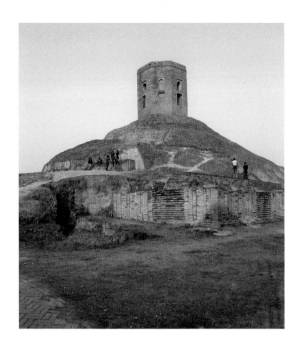

eastern India and both more or less square in plan. Above the third tier, though not really evident today, the structure becomes octagonal, with "starlike points," as the excavator Oertel notes.[28] At the summit is an octagonal structure erected by the Mughal emperor Akbar in AH 996/1588 CE to commemorate the visit of his father, Humayun, to this place, one of a great many indications of Delhi's Muslim rulers' admiration for the ancient past.[29] The ornamentation at the stupa's base (FIGURE 2.12) clearly shows

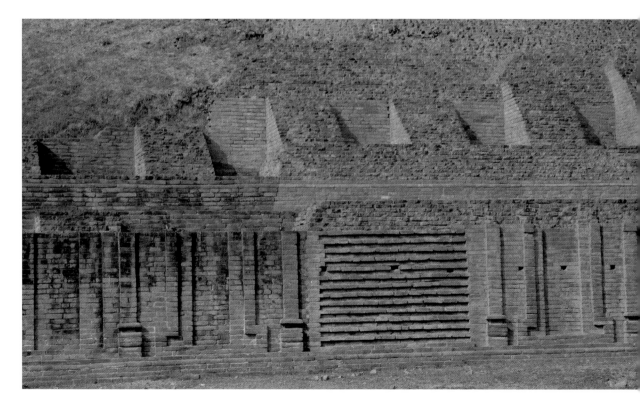

FIGURE 2.11
Chaukhandi stupa, Sarnath, ca. 4th–5th century, according to signage at the site, but brickwork at the base suggests a date of ca. 8th–9th century. The octagonal structure at the top is dated 1588.

FIGURE 2.12
Detail of Chaukhandi stupa base, probably originally with additional detail rendered in stucco, Sarnath.

regularly spaced pilasters creating niches, a form commonly seen on brick structures—for example, on the temple of Site 12 at Nalanda. The original base, then, was considerably more elaborate when the stucco that must have covered the brick was fully intact and probably formed sculptural decor within the niches.

Signage at the site assigns the construction to the fourth or fifth century, although neither Cunningham nor Oertel proposes a date for the monument; Oertel suggests that the stupa marks the probable spot where the Buddha again met his five companions after enlightenment.[30] That is based on a reading and very loose interpretation of Xuanzang's account of a stupa located two or three li[31] southwest of the monastery, where he says the five ascetics who earlier had abandoned the Buddha again met him. Everything about it, say both Cunningham and Oertel, corresponds to the Chinese pilgrim's description. It was, according to Beal's translation of Xuanzang, 300 feet (91.5 meters) high, with its base broad, high, and adorned with rare and brilliant valuables. There are no niches arranged in rows, the Chinese pilgrim continues, but a dome in the shape of an inverted alms bowl crowns the structure.[32] The location is certainly south of the excavated area—more precisely, south-southwest of it and so two or three li would, in fact, just about double the distance of the Chaukhandi from the excavated site, while the height Xuanzang gives is about triple the present height of the structure, some 22.5 meters to the base of the octagonal structure bearing Akbar's inscription. In the end,

of course, the vague correspondence between the Chaukhandi and Xuanzang's account makes little difference. He wrote it long after he was at Sarnath, not from detailed notes he made along the way. Both the early excavators and the ASI, which currently manages the site, have associated monuments with events not only to give them meaning to the faithful—faithful Buddhists, devoted historians, and tourists—but also to give the present-day ruins a meaning that links them to specific moments in the past. To the faithful, the scientific accuracy of identification is of little importance.

THE MAIN SHRINE

There is only one very large structure in the excavated area that has the characteristic appearance of a temple, and its central location, oriented toward the east, likely makes its customary identification as the Main Shrine reasonable (FIGURE 2.13). For Sarnath's excavators, it served as a point of reference for the works uncovered, which were often described as found in a specific direction from the Main Shrine and at a particular distance from it. Today, signage at Sarnath describes this shrine as the Mulagandhakuti, the place where the Buddha sat in meditation. This name, like those for several other parts of the excavated site, draws on Xuanzang's description of Sarnath. The Chinese pilgrim described a temple more than 200 feet (61 meters) high standing on a stone foundation. Its brick walls contain, he said, niches each enshrining a gilt Buddha image, while inside is a life-size gilt image of the Buddha with hands in dharmachakra mudra, presumably

FIGURE 2.13
Aerial image centered on the Main Shrine, also called the Mulagandhakuti, Sarnath, 6 October 2006.

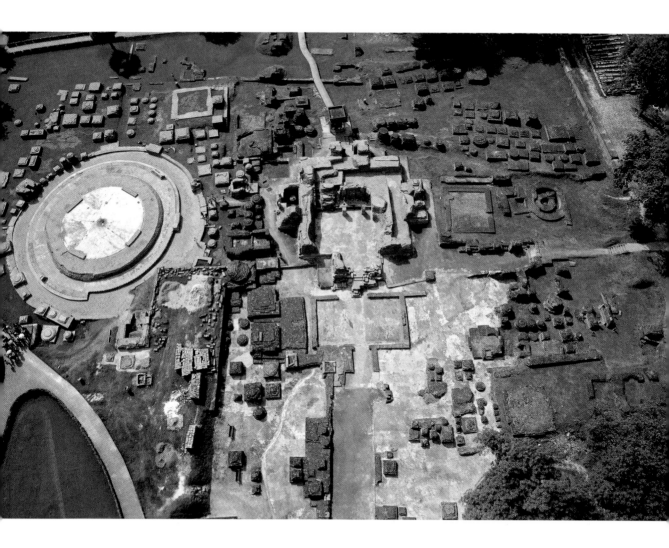

a seated figure.[33] The idea that this is where the Buddha sat appears to be an invention of the ASI; Daya Ram Sahni goes even further, suggesting that this shrine marks the spot where the Buddha delivered his first sermon.[34] The name given to the temple, Mulagandhakuti, comes from two sources, neither referring specifically to this monument. Seals found west of the Main Shrine—the report does not specify how far from the shrine—refer to the *mulagandhakuti* of the exalted one in the Saddharmachakra, a name commonly used in ancient references to the Sarnath monastery.[35] The second

source for the name comes from the inscription, dated equivalent to 1026, recording gifts of Sthirapala and his brother, Vasantapala. It notes that, along with repairing the Dharmarajika stupa, they constructed a new gandhakuti made of stones from the eight holy places,[36] presumably the eight associated with the life of the Buddha. It is a leap of faith to assume that the structure referred to in the seals and the 1026 inscription is the one otherwise identified as the Main Shrine. That 1026 inscription is also probably the source of frequent attributions of the structure to the eleventh century, although the

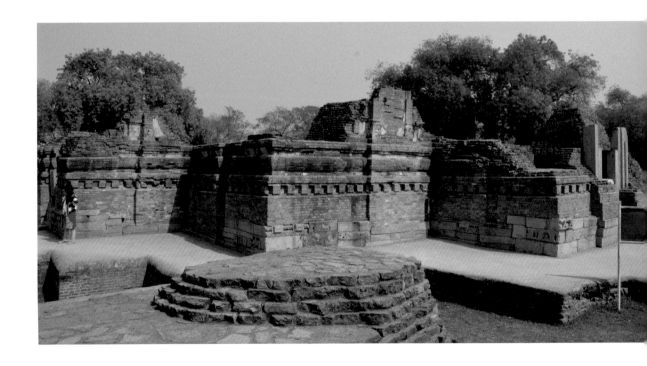

FIGURE 2.14
Detail of Main Shrine, also called the Mulagandhakuti, Sarnath.

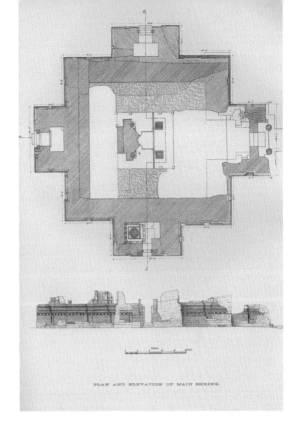

PLAN AND ELEVATION OF MAIN SHRINE.

sign at the site is probably more correct in its dating of it to the Gupta period.[37] Both the architectural members and sculptural fragments that remain part of the Main Shrine (FIGURE 2.14) have modest stylistic analogies with Gupta-period temples such the ones at Nachna and Bhumara. All this gives archaeological Sarnath a grounded history, one associated with a written past and even with the Buddha himself.

The temple has walls that are about three meters thick and approximately 20.5 meters long on each side (FIGURE 2.15). It has projecting shrines on the north, west, and south sides that are accessible in the course of circumambulation of the exterior but not from the interior. The walls would have been sufficient to support the weight of a massive superstructure that, for many, recalls the towering temple cited by Xuanzang. Two of the projecting shrines, the ones on the north and west, were empty when Oertel worked at the site in 1904–5, but a standing Buddha was found in the southern shrine, though it is not clear that this was the figure's original location; Oertel describes it as standing on a pedestal that is later in date and concludes that it was probably moved from somewhere else.[38]

But more important than the Buddha image is the partially preserved monolithic railing found in this shrine (FIGURE 2.16). The square railing, which measures 2.5 meters long and 1.4 meters high for each side, is carved of polished, buff-colored sandstone. Today the railing surrounds the remains of a brick stupa, although it probably was originally placed on top of the Dharmarajika stupa, where it surrounded the crowning umbrella.[39] Two inscrip-

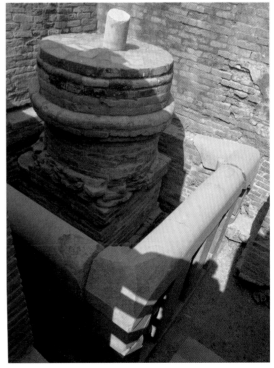

FIGURE 2.15
Plan of Main Shrine. From F. O. Oertel, "Excavations at Sārnāth," in *Archaeological Survey of India, Annual Report, 1904–5* (1908), pl. XVIII.

FIGURE 2.16
Monolithic railing, today in the Main Shrine, Sarnath, probably originally serving as the *harmika* of the Dharmarajika stupa.

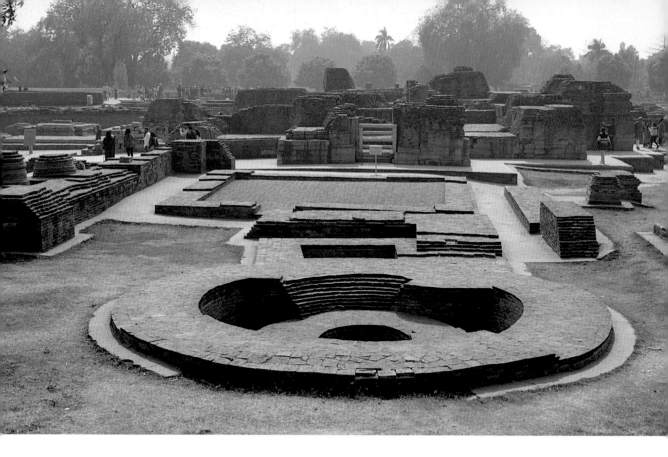

tions on the railing carved in letters paleographically ascribed to the third or fourth century record homage to the masters of the Sarvastivadin sect.[40]

In front of the Main Shrine is a large rectangular courtyard; it is approximately 61 meters wide by 38 meters long and extends east to west from the Main Shrine (see FIGURE 2.13). Sahni proposes that it was intended for monks to listen to lectures because on the back wall there is a solid brick platform that he suggests would have been used by the teacher or "chairman of the congregation." That seems unlikely. If we take as a model the present-day appearance of the Maha Bodhi temple at Bodhgaya, then this simply would have been an open courtyard without any designated function, one providing an unrestricted view of the Main Shrine.

CIRCULAR SHRINE

Immediately north of the Main Shrine is a courtyard that leads to a circular foundation—or, more precisely, a pair of concentric circular foundations that are approximately 3.8 meters in diameter (FIGURE 2.17).[41] Harold Hargreaves, whose excavation revealed the structure, wondered if the inner structure might be a stupa base and the outer one the walls of a circumambulatory passage (*pradakshinapatha*), but he rejected the idea, noting that there is no obvious entrance point and the rectangular structure that abuts it would have prevented a full circumambulation. He also wondered if the concentric structures might represent successive encasements of a stupa.[42] Krishna Kumar, however, starts with the assumption that the shrine was a circular *chaitya-griha*—that is, a shrine to enclose a

FIGURE 2.17
Base of circular shrine north of the Main Shrine, Sarnath.

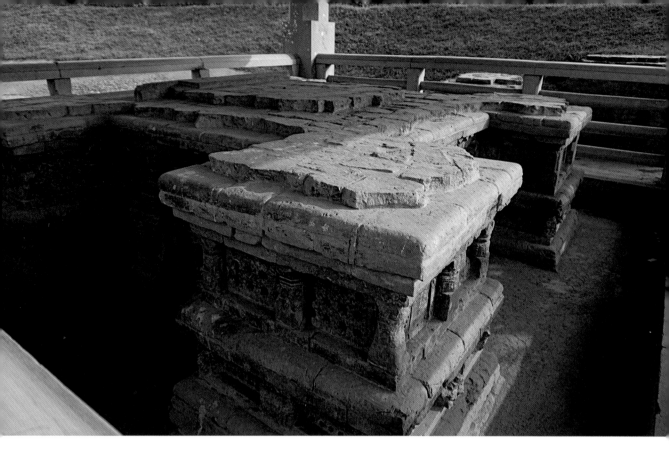

stupa such as one at Guntupalli in Andhra Pradesh and other places in southern India—despite the fact that there is no evidence to suggest what the elevation of the structure might have been.[43] Most likely, this is the base of a stupa, not unlike the many brick stupa bases that remain nearby. Kumar goes on to surmise that this structure marked the spot where the Buddha prophesied the Buddhahood of Maitreya, an event described by both Faxian and Xuanzang but a place entirely fabricated by Kumar.

THE PANCHAYATANA TEMPLE

Much is made of the structure described as the Panchayatana temple (FIGURE 2.18), actually the brick plinth of a very small temple comprising a central structure with four corner shrines (hence *panchayatana*, or "five-fold shrine"). It is located between the Dharmarajika stupa and the Dhamekh stupa, immediately north of the grassy area that covers Monastery V and within an enclosure that is intended to shield it from rain that might destroy the remaining stucco adornment. It is by no means the only panchayatana structure at Sarnath—several others may be seen among the remaining plinths at the site. But among all the architectural remains in the excavated area, this most clearly reveals details of form rendered in terracotta with traces of stucco, giving it a sense of vitality that most of the other remains lack. The structure's adornment includes pilasters and rich floral decoration that suggests a fifth- or sixth-century date. The architectural form, too, recalls structures of this date, most notably the Gupta temple at Deogarh. While almost all visitors to the site take time to see the structure, it

FIGURE 2.18
Brick temple plinth called the Panchayatana temple, Sarnath.

desperately needs an interpretive plaque. Today, there is only a sign reading "Panchayatana Temple," with an arrow pointing toward it on one side and, curiously, with an arrow pointing away from it on the opposite side.

THE APSIDAL SHRINE

Hargreaves's 1914–15 excavations revealed the foundation of an apsidal shrine located west of the Ashokan pillar and the Main Shrine and, like the Main Shrine, oriented toward the east (FIGURE 2.19). Because the bricks used for the construction of the shrine are large and thick, Hargreaves suggests that the building should be assigned to the Maurya period.[44] That may be accurate. A newer structure that Hargreaves

dates to the Kushana or early Gupta period was built over the northern side of this apsidal building, indicating that by then it had fallen into ruin. Apsidal shrines, though not common, are certainly found elsewhere—for example, the temple enshrining the Maniyar Math at Rajgir, a brick structure adorned with stucco images, including both a Vishnu and dancing Shiva and also two naga images, offering the possibility, however remote, that this shrine had some association with nagas, perhaps the naga Elepatra. As noted in the next chapter, the links between Sarnath and eastern Indian sites—particularly Nalanda, just eleven kilometers from Rajgir, and Bodhgaya—are especially strong, and we might look toward this structure as a model for the Maniyar Math.

THE MONASTIC DWELLINGS

In the excavated site, the monastic dwellings are not placed in a systematic fashion—such as forming all four sides of the site's perimeter, each of them facing a large central stupa, as they do at Paharpur and Vikramashila, for example—or lining a single row, as most of them are at Nalanda. They are, however, on the periphery of the excavated site, not centrally located, allowing a focus on the Main Shrine. Three monastic dwellings, numbers V, VI, and VII, are more or less located on the south side of the excavated site, while the remaining five are located along the northern boundary of the excavated site. Unlike the seemingly more ordered sites of Paharpur and Vikramashila, created for the most part in a single building campaign, Sarnath's overall plan might

FIGURE 2.19
Foundation of an apsidal shrine, Sarnath.

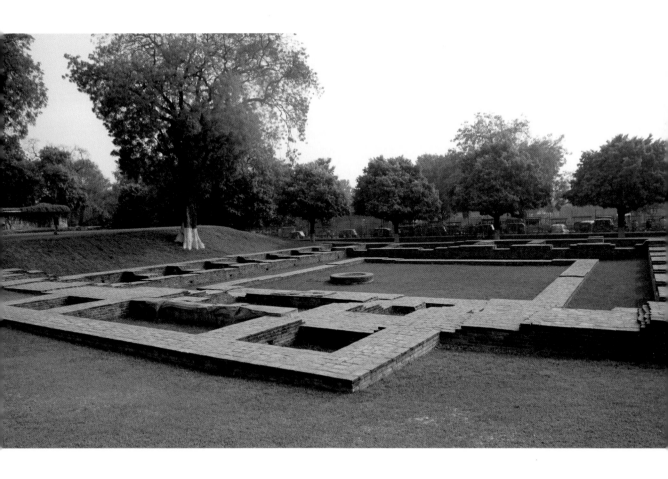

appear to be less cohesive, but that is likely because the site is the product of more than a millennium of growth, of new construction and reconstruction of older structures.

The first two monastic dwellings located at the site's present entrance are numbered VI and VII. Monastery VI (FIGURE 2.20), first excavated by Markham Kittoe in 1851–52, is located to the right of the pathway leading from the entrance; signage now identifies this as Monastery V, probably because the one numbered V in all the excavation literature has been covered with grass and is no longer visible. This monastery follows a plan common to that of many other monastic dwellings at ancient sites in India, such as Nalanda. Cells large

enough to accommodate a single monk are located around the perimeter of a central courtyard containing a well. The dwelling is entered from the north. Opposite the entrance, on the southern side, was apparently a larger cell intended to accommodate an image much as we see at other Buddhist sites—for example, Cave 1 at Ajanta. The structure was built in at least three phases, the earliest probably dating to the first century or earlier as indicated by the large bricks used for its construction.[45] The other stages of construction are suggested by cells on the monastery's southwest corner, where there is clear evidence of two stories—the lower one with sealings that designate it as the Gandhakuti of the Holy One[46] (*s´ri saddharmmachakkre mula-*

FIGURE 2.20
Monastery VI, Sarnath.

gandhakutyam Bhagavatah). This was written in a script generally assignable to the sixth or seventh century, while the upper one yielded a terracotta sealing whose paleography may be assigned to about the ninth century.[47] Of course, it is perfectly possible for seals and seal impressions—that is, sealings—to have been deposited in a structure of a much earlier date; they serve only as a terminus ante quem.

Monastery VI appears to have been destroyed by fire, for here Kittoe found "the remains of ready-made wheaten cakes,"[48] while Sahni in 1917 found earthen pots containing the remnants of cooked rice.[49] All this suggests that the monastery was abandoned in haste, leaving no time for the residents to eat the prepared food. Although some have speculated that the conflagration burned all of Sarnath as part of an attack, it appears that the fire was confined to this monastery. Fire was always a threat to structures built with a great deal of wood, even if brick was used for the walls. Cooking fire and illumination by oil lamps were both necessary and dangerous.

Monastery VII (FIGURE 2.21), immediately to the west of Monastery VI, is considerably smaller, though it follows the usual plan—that is, with cells, only one of which remains, around a central courtyard, the structure measuring about nine meters on a side. Bases that were intended to support pillars, possibly stone pillars, possibly wooden ones, remain within the courtyard and probably formed an interior verandah much like the one at other monastic sites such as Cave 1 at Ajanta. Sahni proposes that this is one of the latest structures at Sarnath, a view he says is supported by "late medieval" inscriptions found while clearing the well.[50]

The monastery numbered V, called by Kittoe a hospital because he found there numerous mortars and pestles that he assumed were intended for grinding medicinal compounds, is located to the east of Monastery VI and somewhat north of VI and VII, in a direct line between the Dharmarajika stupa and the Dhamekh stupa. Sahni suggests without evidence that it dates to about the eighth or ninth century but that it stands on the remains of an older structure dating to the Gupta period, presumably the fifth century.[51] Cunningham agrees that the structure served as a hospital, apparently unaware of the characteristic cells forming the perimeter.[52] He says, however, nothing about the date of this structure. Although this structure has been covered with grass to create a park between the Dharmarajika stupa and the Dhamekh stupa, the outline of the structure is visible in a Google Earth image made on 20 April 2009 (FIGURE 2.22).[53]

FIGURE 2.21
Monastery VII, Sarnath.

FIGURE 2.22
Google Earth image showing light green area (within the white rectangle) covering Monastery V, Sarnath, 20 April 2009.

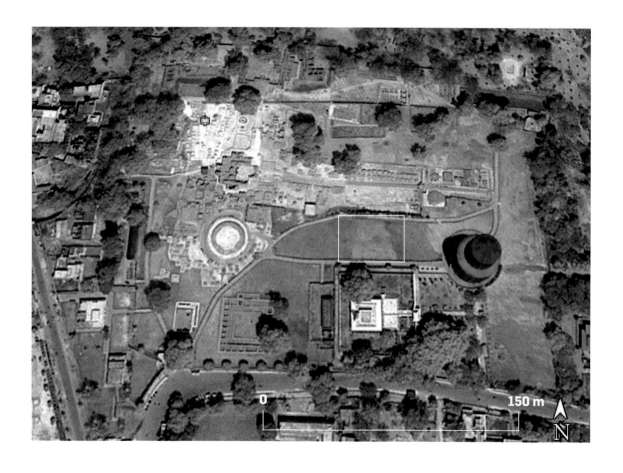

The remaining monastic dwellings are located along the northern border of the excavated site. Because of constant rebuilding and expansion, the clear distinction of one from another is blurred in several cases. As elsewhere at the site, the numbering is somewhat disordered. Moving from left to right along the northern boundary, first comes Monastery II, then Monastery I (whose identity as a monastery has been challenged), followed by Monasteries III and IV. That numbering has more to do with the order in which they were excavated than with either a chronological sequence or the way in which a visitor to the site, in antiquity or the present, might see them.

The structure that was until 1922 identified as Monastery I is enormous, especially if the two gateways understood to be part of it are included and properly identified (FIGURE 2.23). From its western edge to the second gateway on the east, the structure measures just over 231 meters, vastly larger

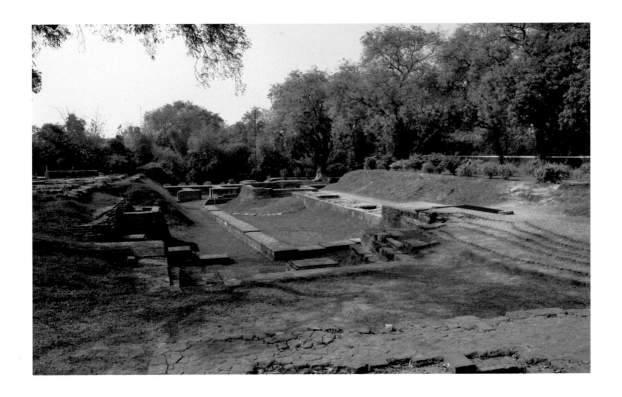

FIGURE 2.23
Monastery I, Sarnath.

than any other monastic dwelling, one of a few reasons Sahni believes that the structure was a temple, not a monastery.[54] He adds that the elongated plan of the structure is unlike that of a monastery and that the extensive decoration distinguishes it from other monastic dwellings. But then he leaps to the conclusion that it must have been the Dharmachakra Jina Vihara identified in Queen Kumaradevi's inscription of the twelfth century because she claims, in a not-very-unique trope, that the structure was an ornament to the earth and even the Creator was taken with wonder when he saw it.[55] This inscription was, moreover, found north of the Dhamekh stupa, though precisely where is not indicated, but in any event not at the site of this structure. The structure abuts Monastery III (FIGURE 2.24), and the opening identified as the first gateway to this monastery, if that's what it is, is located at the southeast corner of Monastery III. The second gateway (FIGURE 2.25) is located considerably farther away, east

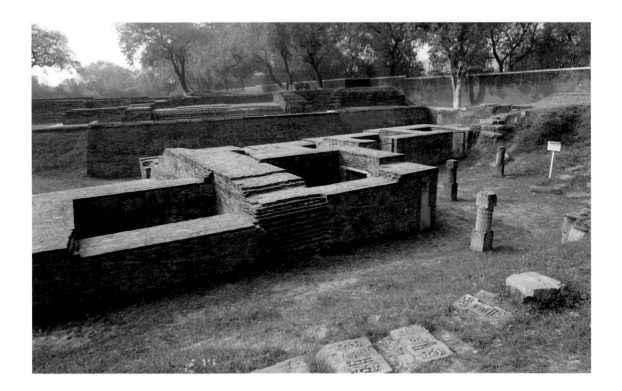

FIGURE 2.24
Monastery III, Sarnath.

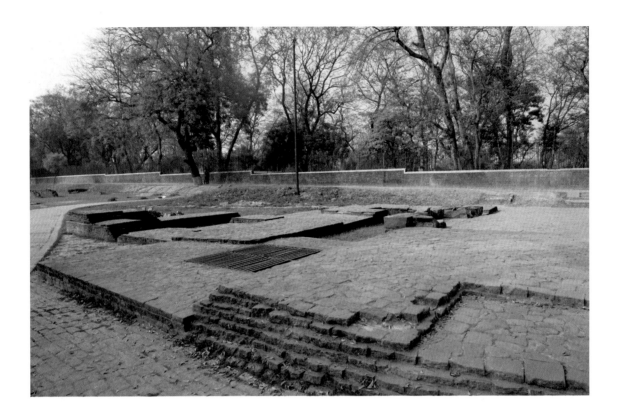

of Monastery I. I would doubt that a temple might be located on the northern perimeter of the site. The term *vihara*, as in Dharmachakra Jina Vihara, is commonly used to identify a monastery or often an entire monastic complex, as designated by many seal impressions at Nalanda Mahavihara and by seals at Sarnath that refer to the entire complex as Saddharma-chakrapravartana Vihara—that is, the Vihara Where [the Buddha] turned the Wheel of the Law. As Gregory Schopen notes, the term *vihara* carries the notion of a place of beauty and pleasure.[56] Signage at this structure covers both possibilities. A long placard identifies it as the "Dharma Chakra-Jina Vihar" and asserts without the possibility of ambiguity or doubt that it is the structure Kumaradevi provided. A simple blue sign, however, simply states "Monastery Nr. 1."[57]

Monasteries III and IV (FIGURE 2.26; see FIGURE 2.24) are located east of the remains of Monastery I but within the area demarcated by the second gateway imagined to be that of the Dharmachakra Jina Vihara. The final monastic dwelling in this northern line, the westernmost one, is numbered Monastery II (FIGURE 2.27), a long rectangular structure with few cells visible. A canal runs along the northern border of this group of monastic dwellings, one that likely served to carry off water from these structures. Clearly visible along the southern side of Monastery I is a second but smaller water channel that probably brought water to these dwellings. This would explain why there are wells in the two visible monastic dwellings on Sarnath's southern side but none here serving the dwellings along the northern border.

FIGURE 2.25
So-called second gateway to Monastery I, Sarnath.

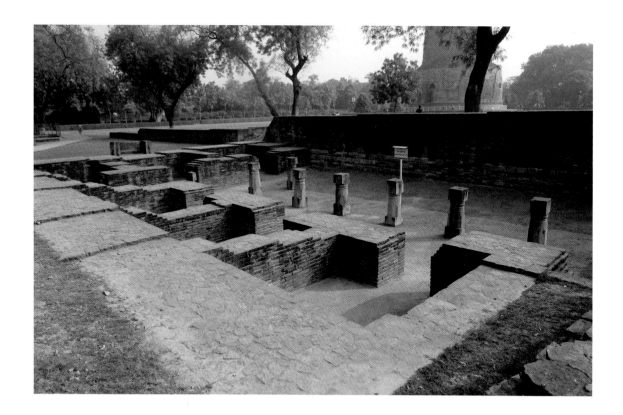

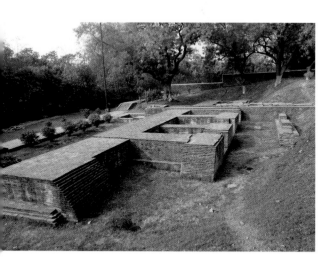

Beside the water channels, there are ample signs of the everyday lives of the monks and nuns who lived here. Walking along the northern sides of the monasteries, it is easy to find large shards of pottery that must have been used for food and water. Generally, in India too little attention has been paid to the vestiges of everyday life at historical sites such as Sarnath, making them seem even more remote from the populated places they once were.

We need to acknowledge that a great deal of expansion and reconstruction blurs distinctions between the monastic structures. And since today virtually nothing but the foundations of them remains, it is hard to visualize the appearance of these dwellings at any point in antiquity. In any event, their appearance doubtless changed regularly over the many centuries that Sarnath was an active home to Buddhist monks and nuns.

FIGURE 2.26 (ABOVE)
Monastery IV, Sarnath.

FIGURE 2.27 (BELOW)
Monastery II, Sarnath.

NOTES

1. Gregory Schopen, "The Buddhist 'Monastery' and Indian Garden: Aesthetics, Assimilations, and the Siting of Monastic Establishments," *Journal of the American Oriental Society* 126, no. 4 (2006): 487–505.

2. Xuanzang, *Si-yu-ki: Buddhist Records of the Western World,* trans. Samuel Beal (London: K. Paul, Trench, Trübner, 1906), 1:lxviii.

3. Xuanzang, *Si-yu-ki,* 1:lxviii.

4. Xuanzang, *Si-yu-ki,* 2:45–61.

5. Xuanzang, *Si-yu-ki,* 2:45.

6. Xuanzang, *Si-yu-ki,* 2:46. The pillar that is worshipped as Lat Bhairav might be that first one Xuanzang observed. It is on the west side of the Varuna River, though the river's curved course also situates the pillar south of the Varuna. And it is about seven kilometers from Sarnath, not five. Little, however, is accomplished by correlating an existing pillar with one that may have been seen by Xuanzang.

7. Even long after Cunningham's time, writers have continued the quest to correlate excavated structures with ones cited by the Chinese pilgrims. See, for example, Krishna Kumar, "On the Identification of Buddhist Monuments Noticed by Fa-Hsien at Sarnath," *Journal of Indian History* 59, nos. 1–3 (1981): 87–96.

8. F. O. [Friedrich Oscar] Oertel, "Excavations at Sārnāth," *Archaeological Survey of India, Annual Report, 1904–5* (Calcutta: Superintendent of Government Printing, India, 1908), 63; hereafter, this report is cited as *ASIAR.*

9. Throughout this book I follow the excavators' numbering and naming of sites. The most complete plan is that of Daya Ram Sahni, *Guide to the Buddhist Ruins at Sarnath* (Calcutta: Superintendent of Government Printing, 1911). Where modern signage at the site is at variance with the excavators' identifications, I note that. For

example, signage at the site identifies Monastery VI as Monastery V. The monastery called in the most excavation reports Monastery V, originally believed to have been a hospital, has been entirely covered with grass that forms the park leading from the Dharmarajika stupa to the Dhamekh stupa. A Google Earth image dated 20 April 2009 shows the lighter green grass covering that monastery. My thanks to M. B. Rajani of the National Institute of Advanced Studies for finding that image and explaining its significance.

10. I am grateful to M. B. Rajani for her assistance reading and interpreting the satellite data.

11. The *Ashokavadana* reports his visit to the four sites (as well as Kapilavastu and Shravasti), led by the monk Upagupta. See John S. Strong, *The Legend of King Aśoka: A Study and Translation of the Aśokāvadāna* (Princeton: Princeton University Press, 1983), 244–56. Ashoka's inscription on the pillar at Lumbini declares the site to be the locus of the Buddha's birth.

12. R. A. E. Coningham et al., "The Earliest Buddhist Shrine: Excavating the Birthplace of the Buddha, Lumbini (Nepal)," *Antiquity* 87, no. 338 (December 2013): 1104–23.

13. For a good discussion of this and other changes to the *sangha*—that is, the Buddhist monastic community—see Lars Fogelin, *An Archaeological History of Indian Buddhism* (Oxford: Oxford University Press, 2015).

14. Xuanzang, *Si-yu-ki,* 2:46.

15. Vidula Jayaswal, *From Stone Quarry to Sculpturing Workshop: A Report on Archaeological Investigations around Chunar, Varanasi & Sarnath* (Delhi: Agam Kala Prakashan, 1998), 220–23, explains that the black spots—more properly, inclusions—seen on the pillar and other Sarnath sculptures but not in the even-colored Chunar sandstone are not part of the stone itself but rather from a one-centimeter-thick

coat of crushed pink sandstone mixed with hematite pellets to cover drums of stone placed one on top of the other to form the pillar shafts. Harry Falk, *Aśokan Sites and Artefacts: A Source-Book with Bibliography* (Mainz: Von Zabern, 2006), 154–57, says that the pillars, including the one at Sarnath, were unquestionably monolithic and that the sandstone of Pabhosa Hill, with its black inclusions, was the source of the stone. Under any circumstance, we need to be cautious about saying uncritically that the stone used for Maurya pillars and other sculptures is Chunar sandstone, especially without the counsel of mineralogists.

16. E. Hultzsch, *Inscriptions of Asoka,* Corpus Inscriptionum Indicarum, vol. I (Oxford: Clarendon, 1925), 162.

17. Hultzsch, *Inscriptions of Asoka,* essentially punts when it comes to translating the terms used to describe Ashoka in almost every one of his inscriptions. Despite a lengthy discussion of the terms *devanampriya* and *priyadasi* (pp. xxix–xxx), his English translation of the inscriptions keeps the Sanskrit or Prakrit epithets.

18. Many small stupas are found at these sites, however, and Sanchi, a monastic site not associated with the Buddha's life, has three large stupas.

19. Alexander Cunningham, *Four Reports Made during the Years 1862-63-64-65 (Archaeological Survey of India Report)* (Simla: The Government Central Press, 1871), 1:108; hereafter cited as Cunningham, *ASR.*

20. Cunningham, however, suggests that each of the niches housed an image of the preaching Buddha, shown with his hands in *dharmachakra mudra.* Cunningham, *ASR,* 1:108.

21. Sahni, *Guide,* 36.

22. J. H. [John Hubert] Marshall and Sten Konow, "Sārnāth," in *ASIAR, 1906–7* (Calcutta: Superintendent of Government Printing, India, 1909), 60.

23. Joanna Williams makes a convincing case for dating the stupa in its present form to the first half of the seventh century and argues that the slab inscribed with the so-called Buddhist creed that Cunningham found embedded about a meter from the stupa's summit, one that on epigraphical style can be dated to the sixth or seventh century and usually assumed to be a later insertion, may be contemporary with this final phase of the stupa's construction. Joanna G. Williams, *The Art of Gupta India: Empire and Province* (Princeton: Princeton University Press, 1982), 168–69.

24. Cunningham, *ASR,* 1:113. But elsewhere he states that it was found at the Chaukhandi stupa: Cunningham, *Mahabodhi; or, the Great Buddhist Temple under the Bodhi Tree at Buddha-Gaya* (London: W. H. Allen, 1892), 65.

25. E. Hultzsch, "The Sarnath Inscription of Mahipala," *Indian Antiquary* 14 (1885): 139–40. See also Jean Ph. Vogel, "Buddhist Sculptures from Benares," *ASIAR, 1903–4* (Calcutta: Superintendent of Government Printing, India, 1906), 221–23; and Arthur Venis, "Some Notes on the So-Called Mahipala Inscription of Sarnath," *Journal and Proceedings of the Asiatic Society of Bengal* 2 (1906): 445–47. The eight sites to which the inscription refers are probably Lumbini (site of the Buddha's birth), Bodhgaya (site of his enlightenment), Sarnath (where he preached his first sermon), Shravasti (where he performed a miracle and spent several rainy seasons with his followers), Sankasya (where the Buddha descended from the Trayastrimsa Heaven, accompanied by Indra and Brahma, after preaching to his mother), Vaishali (where the Buddha received an offering of honey from a monkey), Rajgir (where he quelled the wild elephant Nalagiri), and Kushinagar (where he attained nirvana). As noted in "Introduction," this volume, note 5, there is no canonical list of eight sites.

26. Xuanzang, *Si-yu-ki,* 2:46.

27. Oertel, *ASIAR, 1904–5,* 75.

28. Oertel, *ASIAR, 1904–5,* 75.

29. Firuz Shah Tughlaq's transport of two Ashokan pillars to his capital might be another, as might Jahangir's inscription on the Allahabad pillar initially inscribed by Ashoka.

30. Oertel, *ASIAR, 1904–5,* 76.

31. The li is a unit of measurement for distance that varied in time but was always less than a half kilometer.

32. Xuanzang, *The Great Tang Dynasty Record of the Western Regions,* trans. Roingxi Li (Berkeley, CA: Numata Center, 1996), 200.

33. Xuanzang, *Si-yu-ki,* 2:45–46.

34. Sahni, *Guide,* 21. Xuanzang, who, however, says that a pillar, presumably the one bearing the four addorsed lions, marks the location of the first sermon.

35. Marshall and Konow, *ASIAR, 1906–7,* 97–98.

36. Hultzsch, "The Sarnath Inscription," 140.

37. Sahni, *Guide,* 19.

38. Oertel, *ASIAR, 1904–5,* 68.

39. Sahni, *Guide,* 20.

40. Marshall and Konow, *ASIAR, 1906–7,* 96.

41. H. [Harold] Hargreaves, "Excavations at Sārnāth," in *ASIAR, 1914–15* (Calcutta: Superintendent of Government Printing, India, 1920), 106–7.

42. Hargreaves, *ASIAR, 1914–15,* 106.

43. Krishna Kumar, "A Circular Caitya-Gṛha at Sarnath," *Journal of the Indian Society of Oriental Art,* n.s., 11 (1980): 63–70.

44. Hargreaves, *ASIAR, 1914–15,* 109–10.

45. Sahni, *Guide,* 16.

46. *Gandhakuti:* literally a perfumed chamber, the central cell in a monastery reserved for the Buddha himself. See Gregory Schopen, "The Buddha as an Owner of Property and Permanent Resident in Medieval Indian Monasteries," *Journal of Indian Philosophy* 18, no. 3 (1990): 183.

47. Sahni, *Guide,* 16.

48. Cunningham, *ASR,* 1:128.

49. Sahni, *Guide,* 16.

50. Sahni, *Guide,* 16. Late medieval is not a very precise chronological designation.

51. Sahni, *Guide,* 16, 37.

52. Cunningham, *ASR,* 1:125.

53. I'm grateful to M. B. Rajani for explaining that during the dry season satellite images would likely reveal subterranean structures because the grass would appear somewhat different in color, a result of the roots blocked by the foundation below the soil.

54. Daya Ram Sahni, "Exploration and Excavation: Sarnath," in *ASIAR, 1921–22* (Simla: Government of India Press, 1924), 45.

55. For a translation of the inscription, see Sten Konow, "Sarnath Inscription of Kumaradevi," *Epigraphia Indica* 9 (1907–8), 326–28.

56. Schopen, "The Buddhist 'Monastery,'" 487, 489.

57. Hiram W. Woodward Jr. observed the north-south alignment of the Dharmarajika stupa, the Main Shrine, and Monastery I and suggested that they could represent the dharma, the Buddha, and the sangha, respectively. See Hiram W. Woodward Jr., "Queen Kumārādevī and Twelfth-Century Sārnāth," *Journal of the Indian Society of Oriental Art,* n.s. XII and XIII (1981–83): 8.

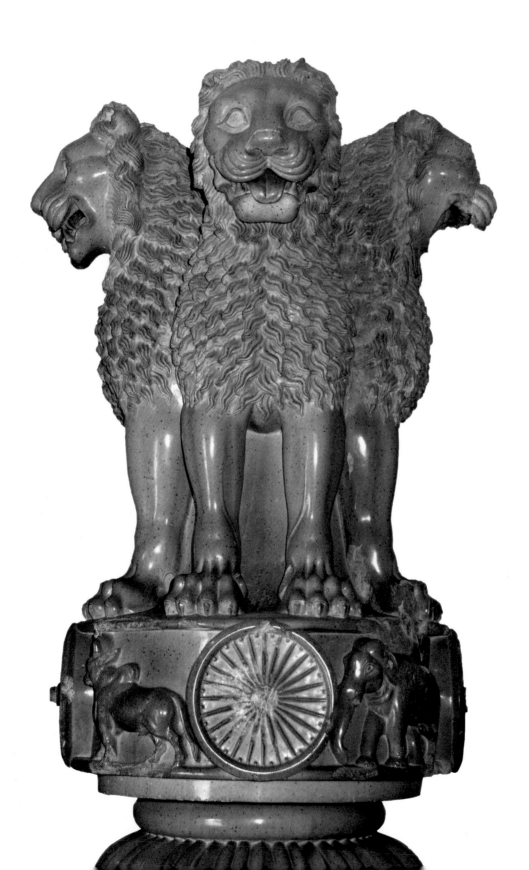

CHAPTER 3

Sarnath's Sculptures

The term *sculpture* carries the notion of art, imposing a transformed sense on a work. As magnificent, even moving, as the sculptures at Sarnath are, they were not intended to perform a purely aesthetic function. The earliest images, those dating to the first and second centuries CE, are just called bodhisattvas in their inscriptions, as if the images and the beings they represent are not distinguished; by the fifth century, inscriptions refer to the figures as *pratima*, generally translated as "sculpture" or "image" but derived from a verb meaning "to copy or imitate." To the excavators of Sarnath, the works were archaeological relics, "antiquarian objects and curios," as F. O. Oertel, who excavated Sarnath in 1904–5, described them.[1] Nonetheless, it is hard to imagine that even the ancient monks would have beheld the works simply as icons or iconographic objects, failing to be moved by the beauty they often exude.

In many ways during the nineteenth century, Sarnath's sculptures were treated as commodities, not works of art or historical documents. That was certainly the case when they were hauled away to use in the construction of foundations and bridges.

And they were commodities of diplomacy when, for example, one was gifted to the Thai prince Damrong during a visit to India in 1892. More commonly, however, corporeal relics of the Buddha, rather than sculptures, were presented as diplomatic gifts.[2]

In this chapter, my terminology will seem a bit sloppy. I often refer to images as Buddhas or bodhisattvas, as if they were more than a representation, perhaps presenting them as the faithful, both ancient and contemporary, saw or see them. Some of these figures, such as the dated images of about 475 CE, I describe as Buddhas even when the inscriptions do not clearly identify them as such. Since I believe the meaning is obvious from the context, I do this to make the text more readable.

THE SARNATH SCHOOL OF SCULPTURE

Writers—for example, John Rosenfield and Joanna Williams[3]—often refer to a Sarnath school of sculpture. At the least, we should not assume a school in the sense of a European school, in which a master and his apprentices worked in a similar manner. Or should we? We just don't know how workshops of

FIGURE 3.1
Sarnath pillar capital. Sarnath, Archaeological Museum Sarnath.

sculptors were organized, although it is probably reasonable to guess that families of artists worked in such a way that elder members trained younger ones. And while monks apparently served as scribes in some monasteries, there is no evidence that they functioned as sculptors.

When discussing a Sarnath school, these writers focus primarily on the images that may be dated by inscription or style to the fifth century CE and further use the term *classical* to describe these sculptures.[4] Doing so is not especially helpful since there is no relation at all with the sculptures of fifth-century-BCE Greece. Or, if by *classical* they mean "ideal" or "aesthetically pleasing," no one seems to bother to explain what constitutes "ideal" or to recognize the extent to which "aesthetically pleasing" is a culturally shaped response.

At the same time, I do think there was a distinctive fifth-century style at Sarnath, one that might be contrasted with the contemporary sculptures of Mathura but one that, at the same time, bears considerable similarity to Buddhist sculpture of about the fifth century elsewhere in India—for example, as far away as Ajanta. But to suggest that sculptors at Sarnath originated this style and provided the impetus for artists elsewhere—that is, those working in distinctive regional idioms—goes way beyond anything that can be clearly demonstrated.

If existing sculptural works tell the full story, there was not a consistent production at Sarnath. In other words, we do not see generation after generation of artists working at the site as was common in European cities, where the demand for works of art from the fifteenth century onward resulted in regular commissions from guilds or individual patrons. At Sarnath, as elsewhere in India, the demand existed largely when a major project such as the construction of a temple or the expansion and restoration of a stupa was undertaken. It is thus hard to imagine a resident workshop at Sarnath that continued from its establishment as a Buddhist locus with permanent architecture in the Maurya period right through the twelfth century—the date of the latest sculptural works there, at least until the twentieth century, when structures once again were added to the environs of Sarnath. Artists did, however, work on site,[5] and as they did so, they could easily look around them at the standing sculptures, incorporating something of their form into the works they were producing. That gives the sense, to modern observers, of a continuous stylistic tradition, as if a single workshop were present consistently through time.

THE PILLAR OF ASHOKA AND LION CAPITAL

The brilliantly polished pillar that carries Ashoka's admonition against schism in the order,[6] as well as the similarly polished capital with four addorsed lions (FIGURE 3.1), one of the best-known works in India, was discovered during the excavations of 1904–5 just west of the Main Shrine. Although the pillar was found in several fragments, the stump still in situ, the capital was found more or less intact (FIGURE 3.2). Only parts of the large stone wheel carried on the backs of the four addorsed lions composing the capital were found close to the column. Oertel declares it "undoubtedly the finest piece of sculpture

of its kind so far discovered in India." He goes on to say that "when comparing it with later productions of animal sculpture in India, one fully realizes Fergusson's verdict that Indian art is written in decay,"[7] a view expressed by the crusty Scotsman James Fergusson, and an oft-repeated colonialist trope. It assumed a Greek inspiration for the beginning of Indian art during the time of Ashoka, setting the stage for decline as Indian art, in this view, became ever more indigenous. The implication is that without a European base on which to build, Indians were incapable of working independently, a sort of justification for the maintenance of colonial rule.

Most of the inscribed pillars carry six nearly identical inscriptions, all edicts of Ashoka. A few pillars are uninscribed—for example, the one at Vaishali, which may postdate Ashoka's time, and one at Bodhgaya that, like the Vaishali pillar, is unpolished and bears no inscription, again possibly indicating a date after Ashoka's time. The only other pillar surmounted by four addorsed lions is the one at Sanchi, which similarly carries an admonition against schism between the monks and nuns, suggesting the possibility that we ought to consider the capital in relation to the inscription's content. What constitutes schism at the time of Ashoka is not entirely clear, although the punishment for those who foment it is specified: banishment and wearing distinctive white garments. But if the evolution of disparate schools of Buddhism constitutes a sort of schism in a once-unified order of monks, then certainly there were divisions. A later inscription on the Ashokan pillar at Sarnath, one dating to about

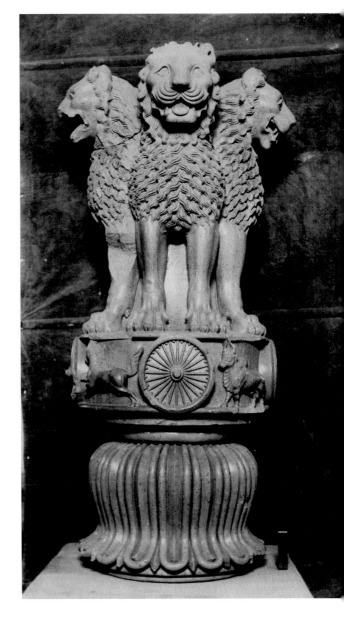

FIGURE 3.2
Photograph of the lion capital (4th–2nd century BCE), at the time of its excavation, ca. 1911. Photographer unknown.

the fourth century, pays homage to masters of the Sammitiya and Vatsiputra schools,[8] and by the time Xuanzang arrives on the scene in the seventh century, he records only Sammitiya monks at Sarnath, some fifteen hundred of them who lived in their lofty halls and (multi)storied pavilions.[9] Earlier and maybe even in the seventh century, despite Xuanzang's account, there were also Sarvastivadin monks at Sarnath, as we might infer from the inscription on a bodhisattva image dedicated by the monk Bala and discussed below. In his inscription on a similar image at Shravasti, he identifies himself as belonging to the Sarvastivadin school,[10] and a brief inscription found in the south chamber of the Main Shrine pays homage to the masters of the Sarvastivadin sect.[11] It seems possible, then, that the individual monastic dwellings discussed in the previous chapter housed monks of a single sect; perhaps those on one side of the excavated site were occupied by Sarvastivadin monks, while those on the opposite side were occupied by Sammitiya monks.

Both the pillar and its capital are carved from brilliantly polished buff-colored sandstone generally assumed to come from the quarries at Chunar, some forty kilometers away. The stone would have been carefully rolled down the hill from the quarry site to the Ganges River, where it would have been transported upstream on boats to the confluence with the Varuna River, then upstream along the Varuna to the closest point to Sarnath, where the stone would have required overland transport for some six kilometers. This would have been no easy feat, for at about 11.5 meters in length, the column would have weighed several tons.[12]

Because the pillar was found in several fragments, writers generally assume that it was damaged willfully. Daya Ram Sahni wrote, "It follows...that the column was overthrown about the 10th, 11th or 12th century A.D. That this ruthless act was perpetrated by a determined iconoclast is shown by the fact that the column was destroyed right down to the floor which surrounded it at that time."[13] The implication is that Muslim invaders were the culprits and that iconoclasm was the motive, even though the pillar and its capital have no clear religious imagery.

Much is made of the "mystery" of this pillar's brilliant polish as well as that of other works ascribed to the Maurya period. The polish has become a hallmark for the identification of Maurya works, so much so that it is often called Maurya polish, as if the technique is exclusive to this very brief time, essentially the third century BCE. It is not. Works that are demonstrably later in style show identical polish—for example, a *shalabhanjika* (a double-sided sculpture of a woman holding a shala tree), now in the Patna Museum, that may be assigned to about the first century BCE. In other words, the polish should be understood as an eastern Indian technique or, even more specifically, a technique of Ashoka's capital, Pataliputra. It was neither confined to a particular period of time nor, as widely imagined, applied by a royal workshop. As for the polished finish, one doesn't have to invoke the intervention of extraterrestrials or extraordinary scientific advancement. It is true that for most sandstones, attempts to polish the surface simply result in dislodging the grains. But for very

fine-grained sandstone such as that from the Chunar quarries, it is possible to polish the surface with a very fine abrasive or even by patiently rubbing it with wood.

The majestic capital shows four addorsed lions mounted on a round abacus (as the pedestal is usually described) that is taller than those supporting the other Maurya capitals. On the abacus are four animals—a bull, a lion, an elephant, and a galloping horse—separated from one another by a wheel, almost surely a reference to the Buddha's turning of the Wheel of the Law. Even more pointedly referring to the Buddha's sermon, is the large stone wheel whose rim was supported on the backs of the four addorsed lions. The wheels are, however, also a symbol of the ideal universal monarch in the Indian tradition, the chakravartin, doubtless a reference to Ashoka, who surely sought to project himself as a chakravartin. Three of the four animals on the abacus may be associated with events in the life of the Buddha—the elephant with Queen Maya's dream anticipating Siddhartha's birth, the horse with his departure from the palace, the bull with the Buddha's first meditation under a rose apple tree. The lion, like the lions mounted atop the abacus, may be a reference to the Buddha, who was recognized as the Lion of the Shakya Clan (Shakyasimha, one of his most common epithets). But Jean Przyluski further underscores the complex meaning of this pillar and its capital by relating the four animals on the abacus to Lake Anavatapta, imagined to be situated at the center of the world.[14] According to a myth that third-century BCE viewers would have recognized, a water spout arose from the center of

this lake and discharged four streams, each one channeled through the mouth of an animal at the edge of the lake—the very four animals depicted on the abacus. From there, the streams flowed to the corners of the earth, much as the Buddha's words—and Ashoka's too—were intended to have universal currency. The pillar, then, would have simultaneously represented the water spout and the world axis (axis mundi), an elevated place that symbolically, rather than geographically, marks the center of the world, a charged locus that is enormously sacred.[15]

As we probe the meaning of the pillar as it might have been understood by knowledgeable viewers at the time of its conception, we might distinguish between the art historian's task of uncovering past understandings and the present-day popular recognition of the capital as the emblem of the Republic of India. That is certainly the understanding of the many who flock each day to the Archaeological Museum Sarnath to behold the symbol of nationhood, as if proximity to the capital brings the beholder closer to the spirit of India—though perhaps not the one Jawaharlal Nehru conceived when advocating this Buddhist sculpture as the emblem of a nonsectarian, strongly secular republic.[16]

The general naturalism of the lions, particularly the sensitivity to such anatomical details as the tendons of the taut legs and the flesh around the jaws, has led many to wonder about the source for these and other works ascribed to the Maurya period. Works from the time of Ashoka represent the beginnings of Indian art—at least the earliest

art that has survived but for that of the Harappan civilization, some two thousand years earlier—yet it hardly looks like the work of artists who never before had put chisel to stone. Thus, some have speculated an earlier sculptural art that no longer survives, one perhaps fashioned from wood, while others have proposed these as the works of foreign artists, a particularly colonialist view. After all, how could Indians, imagined as incompetent, produce such works, the reasoning went. But those concerns imagine an evolution from abstraction to naturalism, as if the goal of Indian artists, like their counterparts in Europe, was to replicate nature. That was not the case in India, however, where art was not intended to mirror nature, where man was not created in the image of gods, even if gods might assume humanlike form. While there may have been an earlier art fashioned from perishable material, we do not need to invoke a struggle on the part of artists to create ever more naturalistic forms.

Despite European emphasis on the Dhamekh stupa, this pillar and its capital served as the image for Sarnath, the place where the Buddhist order was founded. Thus, copies of the pillar were produced far from India—for example, at Wat Umong in Chiang Mai, Thailand, where the pillar is said to date to the time of King Mangrai in the thirteenth century (FIGURE 3.3), and at Mandalay Hill in Myanmar, where there is a much more recent copy. A reasonably accurate copy stands at the Todaiji, in Nara, Japan, and another at the Lingshan Buddhist Scenic Spot, near Wuxi, China.

FIGURE 3.3
Copy of Sarnath pillar, Wat Umong, Chiang Mai, Thailand.

Fragments of a second pillar were discovered in the course of the 1914–15 excavations conducted by Harold Hargreaves and are today preserved in the Indian Museum and the Archaeological Museum Sarnath (FIGURES 3.4a, 3.4b).[17] Although only small pieces of the capital were discovered, enough is evident to show that it featured a row of pecking geese, much like those on the Sanchi and Rampurva lion capitals. The size of these fragments suggests that this capital may have been larger than the more famous one with four addorsed lions. In addition to these fragments, a monolithic stone railing (see FIGURE 2.16) remains at the site on the south side of the Main Shrine. Although possibly of Maurya date, it was not associated with the pillars; it more likely served as the *harmika* surrounding the umbrella shaft at the top of the Dharmarajika stupa.

OTHER EARLY SCULPTURES

With the exception of two heads commonly attributed to the Maurya period but likely somewhat later in date, most of the Sarnath sculptural work from prior to the first century is relief on architectural members, most notably twelve uprights of a railing that was discovered fixed into a mud-and-brick floor just northeast of the Main Shrine, almost surely not their intended location (FIGURE 3.5). Very much like the uprights of the railing around Stupa 2 at Sanchi and dating to about the same time, the second or first century BCE, these uprights are replete with floral imagery. Two of the pillars are adorned with a stupa at the top and two with a faceted pillar supporting a *triratna* (the

FIGURES 3.4a, 3.4b
Pillar capital fragments. Sarnath, Archaeological Museum Sarnath.

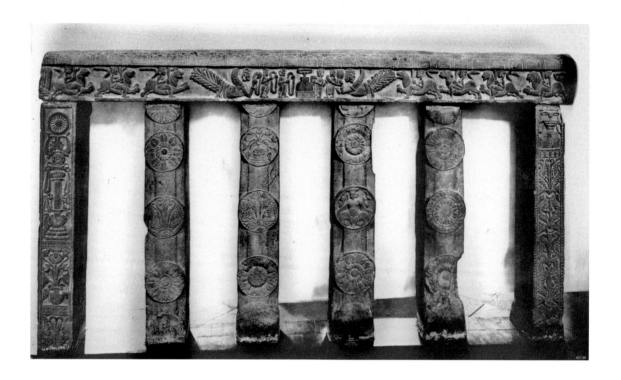

tri-pronged motif symbolizing the Buddha, dharma, and the sangha) that in turn supports a wheel (FIG-URE 3.6). Several of the pillars, like some of those at Sanchi Stupa 2, have the decoration confined to medallions: three full medallions on the upright and half medallions at the top and bottom. Despite the excavators' assertion that the railing uprights date to the Maurya period,[18] their second or first century BCE date is suggested by the relatively planar form of the decor, recalling that of Stupa 2 at Sanchi and the railing at Bharhut.

John Marshall and Sten Konow believed that originally there were fourteen railing uprights forming a rectangle measuring approximately 2.3 by 2.6 meters, as probably suggested by the

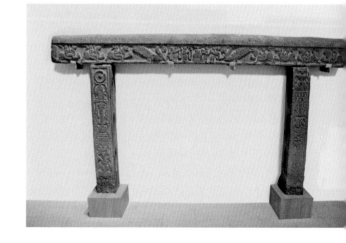

FIGURE 3.5
Part of railing. Found northeast of the Main Shrine. Sarnath, Archaeological Museum Sarnath.

FIGURE 3.6
Part of railing. Found northeast of the Main Shrine. Sarnath, Archaeological Museum Sarnath.

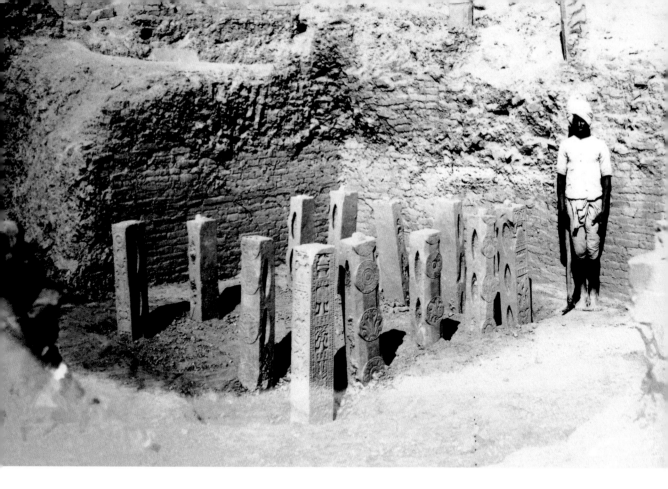

arrangement when they were excavated (FIGURE 3.7). They propose that there were five uprights on the north and south sides and four on the east and west sides of this rectangle—that is, counting the corner uprights each as part of the longer and the shorter ends.[19] The cross bars and coping of this railing were not discovered in the course of their excavation or in any subsequent one; however, two of the pillars are displayed today in the Archaeological Museum Sarnath with a coping that is datable to the same time as the uprights and probably was subsequently excavated.

The other early relief from Sarnath is a portion of a door lintel (FIGURE 3.8) that Oertel reported, rather imprecisely, to have been found east of the Main Shrine.[20] The floral motifs that appear to have framed the doorway anticipate those on the earliest surviving temples, those dating to the fifth century. This relief, however, is considerably earlier, probably dating to the first century BCE; the Archaeological Museum Sarnath catalog assigns it to the late Kushana period,[21] essentially the first through third centuries CE, but the wall label in the museum corrects this date, assigning it to the first century BCE. The style of the floral relief is remarkably similar to that on the uprights of the gateways to Sanchi Stupa 1 (the Great Stupa). The sole figural sculpture, a garland-bearing flying figure on the far left of the relief, is distinctly similar to the human figures of that stupa's gateways. Generally,

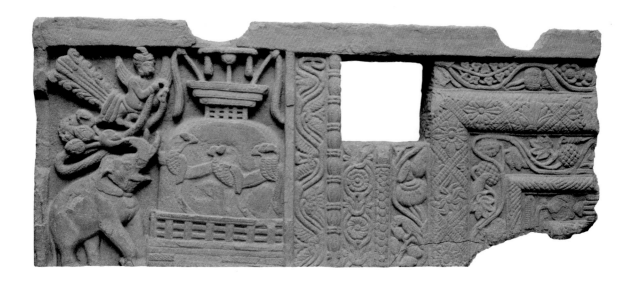

the stupa depicted on the left of the lintel is assumed to be the one at Ramagrama, in Nepal, probably a correct assumption. Wild elephants, says Xuan-zang, provided flowers for the Ramagrama stupa, and when Ashoka sought to open this stupa—one of the eight original stupas containing the Buddha's remains, which he intended to divide among 84,000 stupas—he was persuaded not to do so even though he opened the other seven original stupas. The stupa at Ramagrama was guarded by a naga, a serpent divinity, who assumed the form of a Brahmin and persuaded Ashoka not to open it.[22] The elephant to the left of the stupa bearing flowers and the serpent encircling it are probably an allusion to the Ramagrama stupa.

THE KUSHANA BODHISATTVAS

Of all works made during the Kushana period, essentially the first through third centuries, one of the most important is the bodhisattva dedicated at Sarnath by the monk Bala in the third regnal year of the Kushana monarch Kanishka (FIGURE 3.9). Although there is much controversy about the starting date of Kanishka's reign,[23] it likely began about 110 CE, giving this image a date of 113 CE. (It is remarkable that regnal years of Kushana kings were the basis of a calendrical system so soon after the advent of Kushana rule in northern India.) There is no evidence whatsoever for Kanishka's patronage of Buddhism, despite the date of this figure in the reign of Kanishka and the frequent claims of his

FIGURE 3.8
Relief probably depicting the Ramagrama stupa. Found east of the Main Shrine. Sarnath, Archaeological Museum Sarnath.

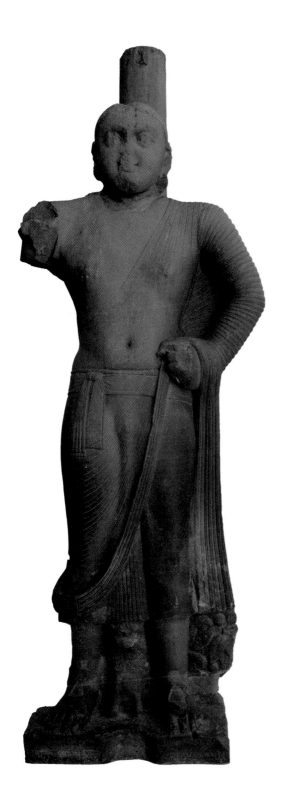

support for the faith. It is important to distinguish between calendrical systems that use a king's reign as an anchor point and the direct engagement of the king himself in whatever transaction is recorded.[24] However, Kanishka is said to have called the Fourth Buddhist Council, probably in Kashmir, to provide commentaries on the texts of the Sarvastivadin Buddhist order. There would be little reason for Kanishka to engage in the faith at this level unless he were trying to emulate Ashoka's ordering of the Third Council. Emulation of Ashoka, revival of his name, and reconstruction of his monuments are leitmotivs of Indian history to the present day.

Found lying in the open midway between the Main Shrine and the Dharmarajika stupa base, this figure stands 2.9 meters, including the inscribed pedestal. "Not far from it," as Oertel describes the location,[25] were found the pieces composing a beautifully carved stone umbrella (FIGURE 3.10). The umbrella originally was supported by a shaft bearing a longer inscription that, like two inscriptions on the pedestal, declare the image and umbrella to be the gift of the monk Bala in the third year of Kanishka's reign. It further specifies that the image is a bodhisattva and that it was given in Baranasi (Varanasi), where the Buddha walked, as if the site of the first sermon was then simply recognized as Varanasi, not a particular location on its outskirts, as it is today. Unlike most of the other sculptures of Sarnath, this one is carved from the distinctive mottled red sandstone generally used for sculptures from Mathura and probably quarried at Bansi Paharpur, about ninety kilometers south of Mathura, where quarries are still worked today.[26]

FIGURE 3.9
Bodhisattva dedicated by the monk Bala in Kanishka's third regnal year. Found between the Dharmarajika stupa and the Main Shrine. Sarnath, Archaeological Museum Sarnath.

Bala's generosity, if that is how it is most accurately described, is not limited to this image. An almost identical work from the site of Shravasti, now in the Indian Museum, Kolkata, was also dedicated by him. Although the year of that dedication cannot be read, it also specifies that Bala provided the image, the umbrella, and its shaft and that it was set up at the place where the Buddha walked at Shravasti. It also notes, like the Sarnath inscription, that Bala made the gift to the Sarvastivadin teachers (*acharyyanam Sarvastivadinam*).[27] This image, too, was carved from the red sandstone commonly used at Mathura, not a stone used for other works from Shravasti. A year earlier than the Sarnath sculpture—that is, during the second year of Kanishka's reign—the nun Buddhamitra dedicated a bodhisattva image at Kaushambi. Like Bala, she was well versed in the *Tripitaka* (often described as the Pali Canon) and specified that she set up this life-size image where the Buddha walked. In fact, her relation to Bala is clinched by an inscription dating a couple of decades later, one at Mathura that records the gift of a bodhisattva by a nun who is both a relative of Buddhamitra and a student of Bala.[28] So we have to assume Bala and his Sarvastivadin adherents were pretty serious proselytizers, sending images carved at Mathura to Buddhist monasteries at sites associated with the Buddha himself, not a small task since these are life-size stone sculptures that had to be transported over a considerable distance. Sarnath, for example, lies about 675 kilometers from Mathura, heading downstream on the Jamuna River to its confluence with the Ganges at modern Allahabad, and from there on to Varanasi. Shravasti is somewhat closer to Mathura, a distance of 525 kilometers, but lacks the convenience of a river route for transport. So, was Mathura the center of production for all of the earliest Buddha images as often claimed? The answer may be yes, but we should focus more on the source of patronage than the place of manufacture, crediting instead the Sarvastivadin school with the production and dissemination of these images.

Instead of engaging in a discussion of where the Buddha image was "invented,"[29] we might ask how we should read the evident disparity between the appearance of this image, which iconographically would seem to represent the Buddha, and the inscription, which calls the image a bodhisattva. Some have argued that the simple monastic garb suggests a Buddha image and that the donor sought to play down this radical departure from previous tradition, which seems to have eschewed anthropomorphic images of the Buddha in favor of symbols that likely indicate his presence. Others have suggested that the term *bodhisattva*, literally "bodhi-ness" or "enlightenment-ness"—that is, one who has achieved the potential for enlightenment or one who has fully achieved it (namely, a Buddha)—might have referred to Siddhartha either before or after his attainment of Buddhahood. My sense, however, is that Bala knew precisely what he was providing and was not the least shy about proclaiming it. If he says that the figure is a bodhisattva, then we should take him at his word. Note that he says it *is* a bodhisattva, not a bodhisattva image (pratima), as

FIGURE 3.10
Umbrella originally placed over the head of the bodhisattva
dedicated by Bala. Sarnath, Archaeological Museum Sarnath.

later inscriptions, even at Sarnath, specify. It thus almost surely refers to Siddhartha after his Great Departure from the palace but prior to his attainment of Buddhahood at Bodhgaya. This is the very persuasive argument of Ju-Hyung Rhi.[30]

The bodhisattva image stands erect, a small lion between his feet that probably refers to his epithet Shakyasimha, Lion of the Shakyas. He wears no jewelry, only a monastic garment (*sanghati*) that covers the figure's left shoulder, exposing the right shoulder and upper-right torso. The lower garment is held in place with a sash. So diaphanous is the garment that the subtly rendered form of the body beneath is clearly evident. A halo was positioned behind the figure's head as indicated by the lower

portion with scalloped edge that remains intact (FIGURE 3.11). The figure's outer garment is draped over the proper left arm; the right arm is missing, but the right hand probably was raised in the reassuring gesture, *abhaya mudra*, the gesture of almost all Kushana bodhisattva images from Mathura. The upper portion of the halo must have broken when the figure fell, for the head was severed though now has been reattached to the body. The enormous umbrella, about three meters in diameter, was supported by the large shaft, octagonal in its lower portion and multifaceted nearer the top. Its decor is placed within concentric rings, the inner one and outermost ones resembling a full-blown lotus much like the lotiform medallions that serve as the background to busts on the Bharhut and Bodhgaya railings. The second band from the center carries winged lionlike figures, *shardulas* (often described as *leogryphs*), separated from one another by small full-blown lotuses. The next band carries auspicious symbols, many of them like those seen on the stone tablets known as *ayagapatas* of Kushana Mathura.

The image dedicated by Bala inspired at least one local copy, and probably another as well. While the image dedicated by Bala was found to the south of the Main Shrine, a figure that is very close in appearance but almost surely a local copy carved from buff-colored sandstone (FIGURE 3.12) was found northeast of the Main Shrine. This figure, standing 1.8 meters and so somewhat shorter than the Bala figure, is uninscribed but was probably conceived as a bodhisattva. Lacking some of the subtlety of modeling that renders credible flesh in the Bala image, this

FIGURE 3.11
Rear view of bodhisattva dedicated by Bala showing remains of halo, Sarnath.

figure also wears somewhat more crudely rendered garments, particularly across the upper torso, where the folds are indicated only by incised lines. Between the feet is a crouching figure whose identity is impossible to determine, as if the sculptor had seen but not understood the meaning of the lion between the feet of the Bala figure.

The second figure that appears to be a copy of the Bala image (FIGURE 3.13) was found southwest of the Main Shrine, as if standing images were placed at the intermediate corners of this structure. Although the garment is draped so the right shoulder is exposed, unlike fifth-century images at Sarnath whose garments cover both shoulders, Daya Ram Sahni suggests that this figure, 3.2 meters high including the tenon, dates somewhat later than the other two works because it lacks any indication of garment folds across the upper torso, anticipating the fifth-century figures whose garments are also unmarked by sculptured folds.[31] I take that argument somewhat less seriously since the later figures almost surely were painted, and folds, among other features, easily could have been indicated by paint. Joanna Williams, however, makes a compelling stylistic argument for considering this a work of circa 380–410—that is, during the reign of Chandragupta II.[32] The figure, though erect with the weight evenly distributed between the two legs, does not show *abhanga* (curved hips, or *déhanchement*) of fifth-century figures but is sufficiently more svelte than the other two figures such that it might be a somewhat later product, perhaps dating to the fourth

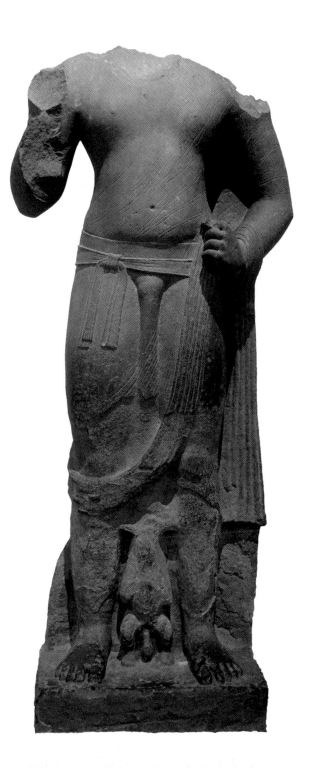

FIGURE 3.12
Bodhisattva, probably local copy of image dedicated by Bala. Found northeast of the Main Shrine. Sarnath, Archaeological Museum Sarnath.

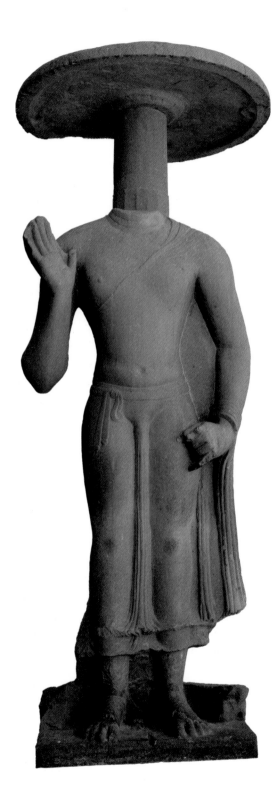

century. We should be cautious about imagining a smooth, continuous evolution of style in the art of India, perhaps in art anywhere. Change in form is not always the result of a slow, gradual evolution but rather of innovation often wrought by an inventive individual or workshop that captures the admiration of a patron.

Even though bodhisattva images almost identical to the Year 3 figure at Sarnath were found at Shravasti and Kaushambi, only at Sarnath did the Kushana figure spawn copies. That suggests to me that there was an existing workshop somewhere at or near Sarnath but not at the other two Buddhist sites. That is not entirely surprising since I can imagine sufficient demand for sculptural imagery in the greater Varanasi area to warrant a workshop, one that also may have fabricated stone architectural components. We do not, however, have to imagine that workshop resident at Sarnath itself. The location of the workshop, somewhere in the Varanasi area, would have been especially commercially viable because the products could have been transported along the Ganges, even to distant places.

GUPTA SCULPTURES

Sometime during the fifth century, Sarnath must have seen a major infusion of patronage that resulted in new building projects, ones that would have required sculptural images. This is consistent with a pattern seen across northern India in the realm ruled by the Gupta dynasty (319–550). What appears to be a surge of patronage may be the result of construction in durable materials, stone in

FIGURE 3.13
Bodhisattva, probably local copy of image dedicated by Bala. Found southwest of the Main Shrine. Sarnath, Archaeological Museum Sarnath.

particular, that was adorned with stone sculpture. Whatever the explanation, we see stone sculptures and temples to house them across northern India, contrasting with the concentration of earlier production in northern India at one place, Mathura.

One partial explanation for the seeming surge in work may result from excess capital accumulated by mercantile communities involved in Indian Ocean trade. We have to extrapolate from very limited evidence, but Sanskrit inscriptions datable to the fifth century found on coastal Southeast Asia (for example, in the Kedah region of Malaysia and the Kutei region of Indonesian Borneo) suggest the presence of Indian trade diasporas—that is, communities of expatriate Indians resident there to facilitate trade with India. Faxian, in India from about 399 to 412, followed an overland route to India, one that was frequented by traders, and returned to China via maritime routes on traders' ships. The Gupta dynasty, referenced in Sarnath inscriptions, ruled territory that included ports on both the east and west coasts of India. So it is easy to imagine an increasingly wealthy community of traders, ones who might provide support for establishments associated with the life of the Buddha. While the direct patrons of individual sculptures noted in their inscriptions continue to be monks—though obviously ones with sufficient wealth to provide these images and so likely from families engaged in mercantile activities—we can imagine merchants themselves or even guilds of merchants providing the shrines that housed these images or the stupa expansion with which they are associated.

A good starting point for understanding the fifth-century production of imagery at Sarnath is the three dated standing Buddha images, all discovered in the courtyard area east of the Main Shrine in the course of excavations conducted by Harold Hargreaves from November 1914 to January 1915 (FIGURES 3.14, 3.15, 3.16).[33] Their position, revealed in the course of the excavation, suggests that they had not fallen randomly, as if abandoned at some point in the past. Rather, they were all found together with two uninscribed images of the Buddha lying horizontally, likely placed carefully, and not on the lowest level but about sixty centimeters above the pavement.

These figures are fundamentally different from those of the Kushana period, not only in their style but also in the content of their inscriptions. The figures are invariably elegant and svelte, with the weight unevenly distributed so they stand with a clear déhanchement, an abhanga pose, as it's called in Sanskrit. The garments, which now cover both shoulders, are fully diaphanous. The right hand of the one dated 473–74 (see FIGURE 3.14) is clearly raised in abhaya mudra, and those of the later two, now broken, almost surely were in the same gesture (see FIGURES 3.15, 3.16). Notably, this gesture is consistently used for depictions of Kushana-period bodhisattvas carved at Mathura.[34] The eyes of these Gupta figures are downcast, not wide open in the manner of Kushana bodhisattvas from Mathura, though as Robert DeCaroli has observed, they would be gazing at a seated viewer, who in turn would be beholding these figures.[35] The bodhisattva was born with thirty-two attributes (lakshanas).

FIGURE 3.14
Buddha image dated equivalent to 473–74. Found in the courtyard
area east of the Main Shrine. Sarnath, Archaeological Museum
Sarnath.

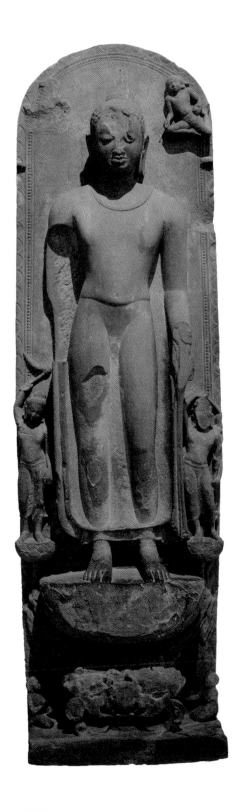

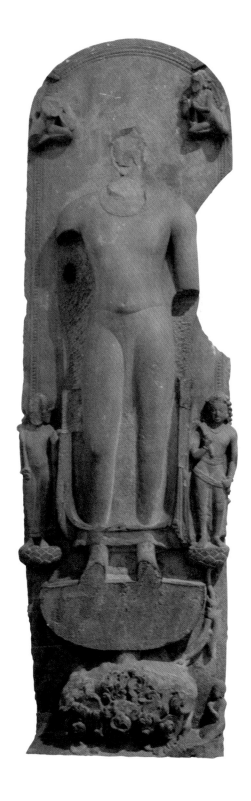

FIGURE 3.15
Buddha image dated equivalent to 476–77. Found in the courtyard area east of the Main Shrine. Sarnath, Archaeological Museum Sarnath.

FIGURE 3.16
Buddha image dated equivalent to 476–77. Found in the courtyard area east of the Main Shrine. Sarnath, Archaeological Museum Sarnath.

These figures show two of them: a prominent cranial protuberance, the *ushnisha*, also generally seen on Kushana images at Mathura, and remarkably fine webbing between the fingers, a feature new to images at this time. Some of the other thirty-two attributes may have been represented with paint—for example, the dot on the forehead (*urna*) representing the Buddha's concentrated light, and the wheel on the palms. The scalp no longer appears shaven but rather shows tight ringlets of hair, even covering the ushnisha. Robert Brown has discussed these attributes and described Sarnath sculptures of the Gupta period as feminized or less masculine than their Kushana predecessors.[36]

Inscriptions on the three dated examples clearly refer to each of the figures as a *pratimā*. But none of the inscriptions specifically uses the word *Buddha* or one of his more common epithets. Rather, one of the three, the one dated in the 154th year of the Gupta era (473/474 CE), refers to the image as a *śāstu*, generally translated as "teacher"—in other words, the Buddha in the very role he assumed at Sarnath. (I will, however, continue to refer to these and iconographically similar images as Buddha figures.) The other two inscriptions, both identical and dated in the 157th year of the Gupta era (476/477 CE), refer to the image more ambiguously as a *devaputravat*—that is, "one who possesses *devaputras* [sons of gods]."[37] Like the inscription on the bodhisattva dedicated by the monk Bala, these three images are also provided by a monk, Abhayamitra, who says in the inscription that he sought merit from his considerable investment in the provision of these works.[38]

These three dated works may be used as touchstones for the assignment of other works to about this same time. For example, a fourth Buddha image (FIGURE 3.17) discovered with the three dated ones is so similar in style that it may be the product of the same master responsible for the dated works. And two standing Buddha images in the Indian Museum, Kolkata (FIGURES 3.18, 3.19), bear such close resemblance to the dated three that they, too, may be recognized as products of the same intense activity. These five images are among the scores of similar figures recovered in the course of Sarnath excavations.

John Rosenfield notes that there are only four images that he can identify as precedents for the enormous number of works produced in the years around 475.[39] The earliest of them is probably a figure of the bodhisattva Avalokiteshvara holding a bowl (FIGURE 3.20). Oertel discovered it southeast of the Ashokan column; Rosenfield sees parts of the figure as "crude and ineloquent" and suggests that it was made at "a time or ambiance in which Mahayana symbolism was far from resolved." A second figure he describes as ante-dating those of about 475 is likely a standing figure of Maitreya (FIGURE 3.21) discovered by Oertel southwest of the Main Shrine. Rosenfield considers the sculpture to be "at about the same stage of development as the important seated Buddha figure exported to Bodhgaya and dedicated in the year 64" of an unspecified era but probably dating to the fourth century. The third is a smaller-than-life-size standing Buddha image discovered in the course of John Marshall and Sten Konow's 1907 excavation just

FIGURE 3.17
Buddha image. Found in the courtyard area east of the Main Shrine together with the three dated Buddha images. Sarnath, Archaeological Museum Sarnath.

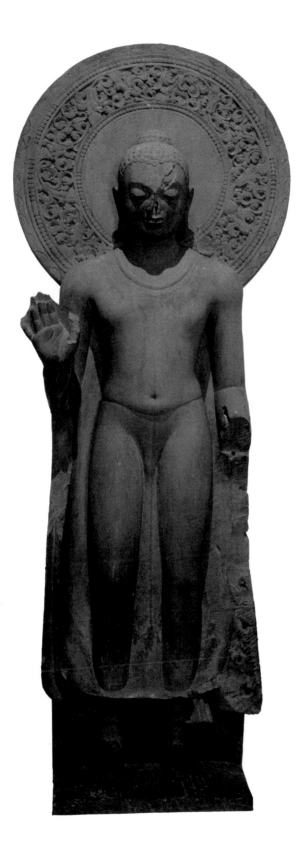

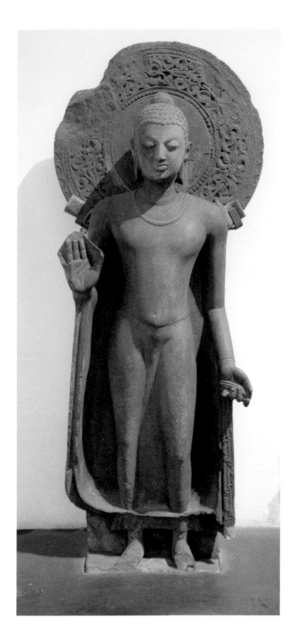

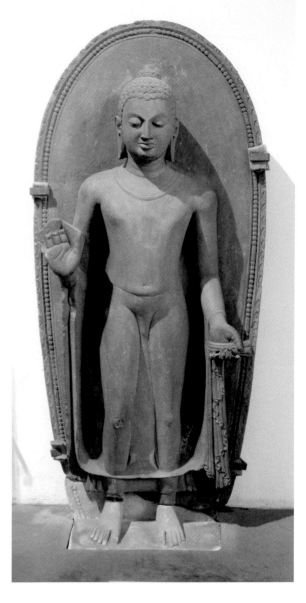

FIGURE 3.18
Buddha image from Sarnath. Findspot unrecorded. Kolkata, Indian
Museum.

FIGURE 3.19
Buddha image from Sarnath. Findspot unrecorded. Kolkata, Indian
Museum.

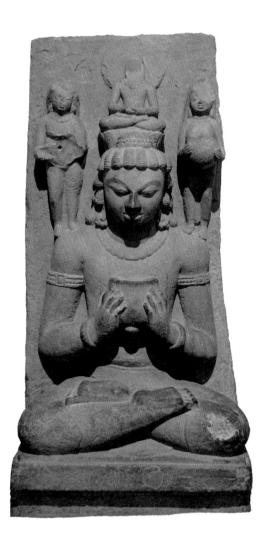

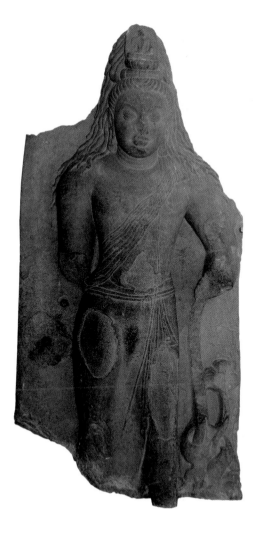

FIGURE 3.20
Bodhisattva image, probably Avalokiteshvara, holding a bowl.
Found southeast of the Ashokan pillar. Sarnath, Archaeological
Museum Sarnath.

FIGURE 3.21
Bodhisattva image, probably Maitreya. Found southwest of the
Main Shrine. Sarnath, Archaeological Museum Sarnath.

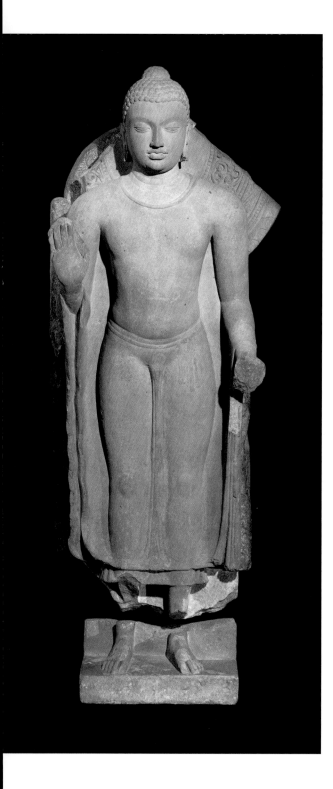

west of the Dharmarajika stupa. This figure, Rosenfield says, shows the influence of "the Mathura school." Finally, he cites a standing Buddha now in the British Museum (a product of Markham Kittoe's 1851–52 excavations), a figure whose "body is considerably less well-resolved [than the works of circa 475]," adding that "a harmonious relationship of parts has not been achieved" (FIGURE 3.22). Although I agree that two of the four figures were made a half century or so before the plethora of works dating circa 475, I have difficulty with a reasoning that sees inelegant form as an indicator of date. In other words, I would argue that although style may be—but is not always—an indicator of date, quality is unrelated to style and date. I would suggest that it might be better to look at figures that still show clear vestiges of the Kushana style prevalent at Mathura with the caution that conservative artists or perhaps those coming to Sarnath (or wherever the Sarnath sculptures were produced) from Mathura might reveal strong vestiges of the Kushana Mathura style even in the last quarter of the fifth century. Using those criteria, I would agree that the standing Buddha in the British Museum, as well as another, seated figure in the British Museum (FIGURE 3.23), demonstrates the rigidly erect posture and fuller form of Kushana sculptures. I also think there is a strong likelihood that the standing Buddha image excavated in 1907 by Marshall and Konow dates earlier than 475.[40] To those figures I would add several, among them a standing Buddha image that, like the British Museum standing Buddha, secures the lower garment with a sash (FIGURE

FIGURE 3.22
Standing Buddha image. Excavated by Markham Kittoe. Findspot unrecorded. London, British Museum.

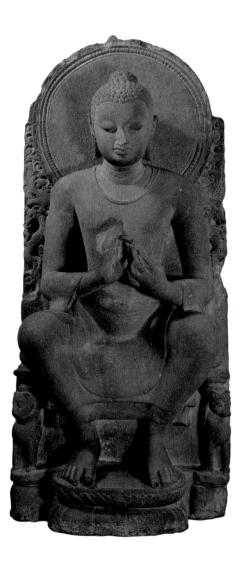

3.24), a fashion of the Sarvastivadin sect, which appears to have eclipsed the earlier, dominant Sammitiya sect at Sarnath.[41] And a standing Buddha in the Los Angeles County Museum of Art that long had been assumed to be a work of Mathura origin has recently been reattributed correctly to Sarnath (FIGURE 3.25).[42]

The excavated material shows a remarkable surge of activity at Sarnath around 475, perhaps as a

FIGURE 3.23
Seated Buddha image. Findspot unrecorded and described by the museum as possibly from Sarnath. London, British Museum.

FIGURE 3.24
Standing Buddha image. Findspot unrecorded. New Delhi, National Museum of India.

result of a new influx of patronage. But this seeming surge was part of a much broader development that produced stone temples across part of the Gupta realm and, at other Buddhist sites, generated sculptures (such as those at Kushinagar) and patronage (as documented by seals and material remains at the Buddhist monastery of Nalanda). Finally, the style that we so often imagine as the Sarnath style, a product of a so-called Sarnath school, shares much in common with imagery found widely across northern India, even as distant as Ajanta, where figures, though somewhat less slender, share the déhanchement and other stylistic features of Sarnath sculptures dating about 475.

In addition to the standing Buddha images of about 475, there are a great many seated figures, all with hands in the preaching gesture, dharmachakra mudra, recalling the Buddha's first sermon. Some eighteen are recorded in Daya Ram Sahni's 1914 catalog of the Archaeological Museum Sarnath,[43] and still more are known from other collections—for example, the Indian Museum, Kolkata. Of these seated Buddhas, certainly the best known and most often reproduced is a figure unearthed by Oertel south of the Dharmarajika stupa (FIGURE 3.26).[44] This seated Buddha is enthroned. The halo behind his head is adorned with concentric bands, the outer one a richly carved lotus creeper. Flying celestial figures are depicted on either side of the halo, and a pair of leogryphs flank the throne's backrest. On the pedestal is a centrally placed wheel, a symbol of the Buddha's sermon at Sarnath. Of the kneeling figures on either side of the wheel, the five

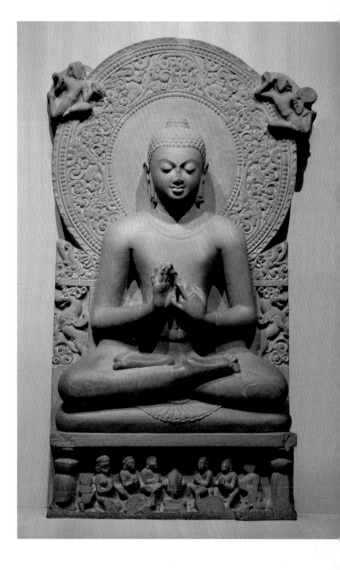

FIGURE 3.25
Standing Buddha, probably from Sarnath. Los Angeles, Los Angeles County Museum of Art.

FIGURE 3.26
Seated Buddha image. Found south of the Dharmarajika stupa. Sarnath, Archaeological Museum Sarnath.

in monks' garb represent the Buddha's companions, who had deserted him at Bodhgaya but were the first to hear the Buddha's sermon at Sarnath; while the other two, a woman and child, are probably depictions of the donors, among the very earliest donor figures in Indian imagery.[45]

Although many of the seated Buddha images are iconographically similar to the one illustrated in figure 3.26, there is considerable variation, even among those dating to the fifth century. Most are seated in the lotus position (*padmasana*), but at least one is represented with the legs pendent, the so-called European pose (*pralambapadasana*) (see FIGURE 3.23), a seated position that first appears among the sculptures at Sarnath though never among the Gupta-period images at Mathura. Related to the Sarnath model, a figure in this position adorns the stupa within Cave 26 at Ajanta, and subsequently such a figure is seen among the stucco images adorning the Great Monument at Nalanda—the works of both sites share other features with the Sarnath images of the fifth century.

Another innovation of Sarnath sculptors appears to be images of the Buddha calling the earth to witness his steadfast determination to gain enlightenment (bhumisparsha mudra). One might imagine that such figures would dominate the sculpture of Bodhgaya, where the enlightenment took place, but as Janice Leoshko has noted, the Bodhgaya sculptures likely follow Sarnath models and continue to share both features and meaning with Sarnath sculptures through the twelfth century.[46] The Archaeological Museum Sarnath, according to the

old catalog, houses seven figures of Buddha images in this gesture that Sahni dates to the Gupta period.[47] Leoshko, however, argues that no bhumisparsha Buddha is found at Bodhgaya or anywhere else in India prior to the sixth century. That does not necessarily contradict the Archaeological Museum Sarnath catalog because the first half of the sixth century falls within the Gupta period. But at least one image of the Buddha seated with the hand extended downward in this mudra may, in fact, date to the fifth century (FIGURE 3.27). If this is the image described in the catalog as B (b) 177, it is there dated to the late Gupta period. But I think it is more likely a fifth-century work. The smooth planes of the face, the only part of this figure that has not been seriously abraded, closely resemble the faces of dated fifth-century Buddha images. The somewhat better preserved bhumisparsha figure (FIGURE 3.28)—missing face notwithstanding—provided by a monk whose name is illegible does probably date to the sixth century, as J. Ph. Vogel proposes.[48] Even if one of the bhumisparsha Buddha images from Sarnath does date as early as the late fifth century, that does not contradict Leoshko's central point—namely, that Buddha images in this mudra, suggesting the Buddha overcoming the demon Mara at Bodhgaya and calling the earth to witness his steadfast determination to gain enlightenment, were made earlier at Sarnath than at Bodhgaya, the very site where the event took place. It is not just the event that is suggested by these images. Leoshko relates the image in this mudra to the rising importance of the concept of *pratitya samutpada*, the so-called Buddhist creed,

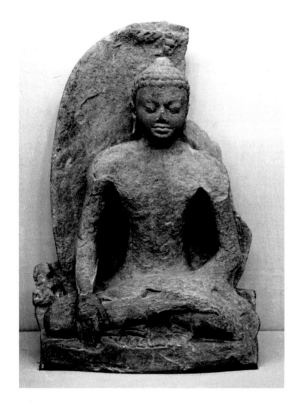

and notes importantly that these and other Buddha images must be understood as something more than iconic presentations of narrative forms.[49]

This would be yet another indication of the powerful impact that the art of Sarnath had on eastern Indian sculpture. Elsewhere I have argued that the stucco images of Nalanda's Great Monument draw substantial inspiration from Sarnath models, so much so that it seems possible to propose that Sarnath sculptors moved eastward to take advantage of new opportunities at Nalanda.[50] I had not, however, recognized the impact of Sarnath sculptors on the art of Bodhgaya. Leoshko argues persuasively against the prevailing view that Sarnath artists influenced those of Bodhgaya via the intermediary of Nalanda, proposing instead that the influence was direct and lasted long after the Gupta period.[51]

We see evidence of Sarnath's impact not only at Bodhgaya but also elsewhere in India, resulting in what I might call a greater northern Indian style. For example, at Ajanta—whose major expansion took place almost precisely at the time artists were producing large numbers of images at Sarnath (the last quarter of the fifth century)—the parallels with Sarnath styles are quite obvious. I want to be careful not to suggest a direct influence by Sarnath on Ajanta, carried by sculptors who traveled from Sarnath outward, because the flurry of activity at both sites is contemporary. Moreover, despite the pronounced déhanchement, diaphanous garment, and even the roll of flesh just below the navel of standing Buddha images at both sites, the lithe Ajanta figures are conspicuously more corpulent,

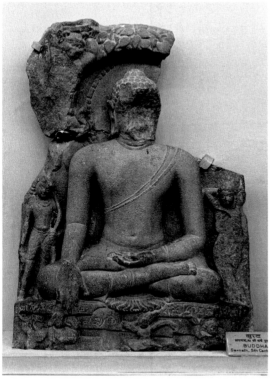

FIGURE 3.27
Seated Buddha with hand in bhumisparsha mudra. Findspot not recorded. Sarnath, Archaeological Museum Sarnath.

FIGURE 3.28
Seated Buddha with hand in bhumisparsha mudra, dedicated by a monk (name is illegible). Findspot not recorded. Sarnath, Archaeological Museum Sarnath.

a feature of figural sculpture in the Deccan region of India. Although Buddha images with the hand in bhumisparsha mudra are not seen at Ajanta, images in the gift-bestowing gesture (varada mudra) are more common by far there than they are at Sarnath or anywhere in eastern India. One type that Sarnath and Ajanta have in common is the teaching Buddha seated in the so-called European pose (pralambapadasana); invariably, the hands are positioned in the teaching gesture. That is the case with the sculpture in the British Museum (see FIGURE 3.23), identified in the museum records as "possibly from Sarnath," and a damaged one that was excavated at the site northwest of the Main Shrine (FIGURE 3.29), also a product of about 475 despite the style designation as "decadent Gupta" in the Archaeological Museum Sarnath catalog.[52] At Ajanta, comparable figures may be seen on the right projecting wall of Cave 19 and emanating from the stupa, the focal object inside Cave 26.

To what extent might reliefs depicting the Buddha's life have been a source for the transmission of Sarnath styles and iconographic detail? Stone reliefs with scenes of the major events in the Buddha's life, a sort of visual narrative, were first produced at Sarnath in the last quarter of the fifth century. Works such as the one illustrated in figure 3.30, probably a product of the late fifth century, generally show the major scenes from the Buddha's life in chronological order, in this case starting with the Buddha's birth at the bottom, moving to his overcoming Mara and enlightenment at Bodhgaya, then his first sermon at Sarnath, and, at the top, his death and attainment of

FIGURE 3.29 (RIGHT)
Seated Buddha with legs pendent, the so-called European pose (pralambapadasana). Found northwest of the Main Shrine. Sarnath, Archaeological Museum Sarnath.

FIGURE 3.30 (FAR RIGHT)
Relief depicting scenes from the Buddha's life. Findspot not recorded. Kolkata, Indian Museum.

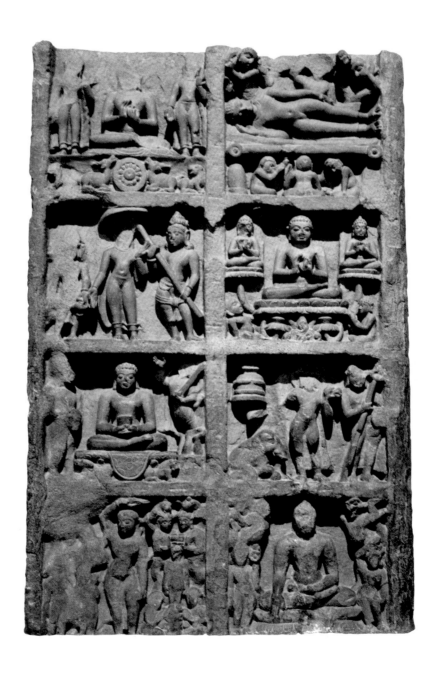

nirvana. These are the four principal events of the Buddha's life, the ones that the Buddha admonished his followers to commemorate with visits to the sites where they took place.[53] Narrative detail is minimal, the principal figure serving to indicate the event. To these four events and the sites at which they took place, four additional major events were added, as they were on a few of the surviving Sarnath life reliefs—for example, the one in the Archaeological Museum Sarnath illustrated in figure 3.31, which includes the great Miracle at Shravasti, the monkey's gift of honey at Vaishali, subduing the elephant Nalagiri at Rajgir, and the descent of the Buddha from the Trayastrimsa Heaven accompanied by Brahma and Indra at Sankasya. The reliefs that show these scenes, however, date later than those with the four principal scenes; stylistically, they may be attributed to the seventh or eighth century.

Joanna Williams's careful study of these reliefs probes possible textual sources for them.[54] Importantly, she notes, "No single text in the form preserved in Indian languages can be selected as the source of the Sarnath Gupta sculptor," although she suggests that texts associated with the Sarvastivadin sect of Buddhism appear to be closer to the details of the sculptural representations than texts associated with other sects, the Mahasanghika most notably. Particularly important is her suggestion that "one must recognize the likelihood that the Sarnath sculptors did not read at all and were familiar with such literary sources in oral form which can never be precisely reconstructed."[55] To that I might add that the Sarnath sculptors, as much as any composer or reciter

of a text, were telling the stories. They likely heard the stories in both canonical and popular forms and retold the stories in visual form to suit the needs of their patrons.

There had been earlier visual accounts of the Buddha's life, many from Gandhara and dating to the Kushana period—for example, scenes of the four principal events today preserved in the Freer Gallery at the Smithsonian, Washington, D.C. Such scenes also appear in the Kushana art of Mathura, as seen in a relief in the Mathura Museum that illustrates the four scenes from right to left and inserts the Buddha's descent from the Trayastrimsa Heaven between the scenes at Bodhgaya and Sarnath (FIGURE 3.32). These works may have served as a model for the Sarnath artists much as the Kushana bodhisattva dedicated by the monk Bala may have served as a model for subsequent images at Sarnath. But I know of no reliefs from the time of the Guptas and their contemporaries besides those at Sarnath illustrating the life of the Buddha. After the Gupta period, however, sculptors in eastern India frequently represented episodes of the Buddha's life framing a large central figure of a seated Buddha, the right hand extended downward in the earth-touching gesture (bhumisparsha mudra). These may be yet another manifestation of the impact of Sarnath on the art of eastern India.[56]

Although all but one of these reliefs, at least the ones for which the findspot was recorded, were excavated in close proximity to the Main Shrine, they were not found together, as a group.[57] Because the Buddha, on the eve of his demise, admonished

FIGURE 3.31
Relief depicting scenes from the Buddha's life. Found in three pieces: one found by Markham Kittoe in an unspecified location, two found on the eastern approach to the Main Shrine. Sarnath, Archaeological Museum Sarnath.

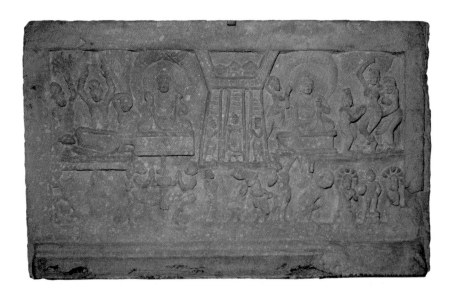

his followers to visit the very places depicted on the reliefs, it is tempting to imagine that they have something to do with pilgrimage—for example, a record of a pilgrim's journey to the four or eight sites.[58] They would be too heavy for a pilgrim to carry away as portable records or souvenirs of his visit to the sites. But they might have been gifts from the pilgrims at the conclusion of the journey, although none of them is inscribed with a record of a donor's name. Might they, then, have served as surrogates for the physical pilgrimage, as if beholding each of the scenes substituted for the lengthy and rigorous travel that would have resulted in beholding the sites themselves? In either case, the devotee would have connected to the Buddha himself by a sense of placeness, sharing a physical proximity to the life of the Buddha through the places at which critical events in his life transpired.

If that is the case, what should we make of the reliefs from Sarnath that depict the great Miracle at Shravasti, at which the Buddha engaged in a debate with six adherents of rival faiths (often described in Buddhist literature as "heretics")? Over the

FIGURE 3.32
Relief depicting scenes from the Buddha's life. Mathura, Mathura Museum.

FIGURE 3.33
Relief depicting the Miracle at Shravasti. Found northwest of the Main Shrine. Sarnath, Archaeological Museum Sarnath.

course of eight days, the Buddha performed various feats, culminating in the replication of his own form on lotuses, each one simultaneously preaching dharma (righteous law). This version of the story is recounted in the *Divyavadana*, a text associated with the Mulasarvastivadin school, one that seems to have been dominant in the early days at Sarnath. Reliefs such as the one illustrated in figure 3.33, datable to the latter part of the fifth century and discovered northwest of the Main Shrine in the course of the 1906–7 excavations,[59] show the Buddha seated in the lower-central part of the relief, his hands in dharmachakra mudra. From his body grow lotus creepers, each culminating in a full-blown lotus flower that serves as the pedestal for a seated or standing Buddha; there are eight of them in addition to the larger main figure. A similar but better-preserved relief is in the Indian Museum (FIGURE 3.34). Earlier reliefs, those of the Gandhara region made during the Kushana period, generally show another version of the Shravasti miracles, one in which he rises into the air with water from his feet propelling him upward while flames emerge from his shoulders.[60] Though versions similar to those made at Sarnath appear in the contemporary art of the Deccan—for example, at Ajanta and Kanheri—precedents are unknown at Mathura, suggesting either that this is the creation of Sarnath artists or that the monks for whom the *Divyavadana* was a central text sponsored these reliefs at several sites during the fifth century.[61]

Besides the images of the Buddha—both standing and seated, freestanding and relief—several

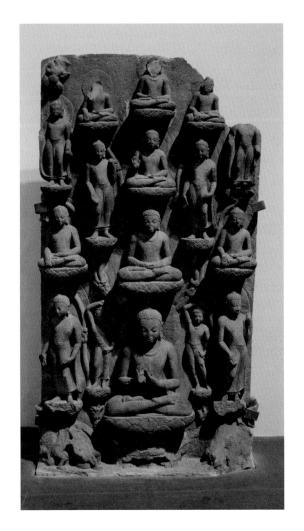

FIGURE 3.34
Relief depicting the Miracle at Shravasti. Findspot not recorded. Kolkata, Indian Museum.

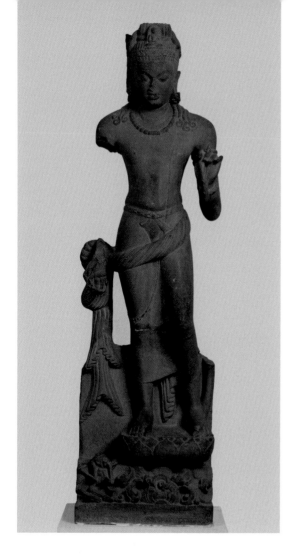

bodhisattva figures are included in the Gupta-period art of Sarnath, although they are far fewer in number than images of the Buddha,[62] probably because Sarnath was, and still is, so intimately associated with the Buddha himself. These are iconographically identifiable bodhisattvas, unlike ones of the Kushana period that can be identified as bodhisattvas only by their inscriptions. Of these, probably the best known and most elegant is a standing figure representing the Bodhisattva Avalokiteshvara found southwest of the Main Shrine in the course of the 1904–5 excavations (FIGURE 3.35). The figure, very

much like the dated Buddha images with which it is approximately contemporary, stands in a gentle déhanchement. A massive sash is tied around the hips, though more as an ornament than a belt intended to secure the lower garment. The figure is bejeweled as appropriate for a bodhisattva, his identification as Avalokiteshvara suggested by the stalk of a lotus held in the proper left hand and more or less confirmed by the seated figure in the meditative gesture (dhyana mudra) in the headdress. The figure, one of the few Gupta-period sculptures from Sarnath carved fully in the round, was provided by a lay worshipper (*upasaka*) named Suyatra, who held the administrative post of district head (*vishayapati*). A second figure of Avalokiteshvara (FIGURE 3.36), now in the Indian Museum, also dates to the same time, close to 475, and is similarly posed, although the sash ties on the figure's left side, not the right. The figure is more heavily damaged, missing the proper right lower arm, apparently extended downward in varada mudra, and the lower part of the legs. Nonetheless, the identification as Avalokiteshvara is suggested by the stalk of a lotus held in the left hand and the seated figure in the headdress with the hands folded in dhyana mudra.

Besides the figures of Avalokiteshvara, Gupta sculptures from Sarnath include several other bodhisattvas, among them a standing figure unearthed by Oertel southwest of the Main Shrine that probably represents the Bodhisattva Maitreya (see FIGURE 3.21).[63] In the headdress of this very high relief figure, which has long locks of hair flowing over the shoulders but no jewelry adornment, is

FIGURE 3.35
Bodhisattva, probably Avalokiteshvara. Found southwest of the Main Shrine. New Delhi, National Museum of India.

a seated Buddha with the hands in abhaya mudra, suggesting the Jina Buddha Amoghasiddhi, the figure in the headdress of Maitreya images.[64] The relatively heavy form of the figure might suggest a date somewhat earlier in the fifth century than the dated Buddha images, though it is certainly not a Kushana work, as Sahni suggests;[65] I am inclined to assign the figure a sixth-century date. More difficult to identify is a seated figure holding a bowl (see FIGURE 3.20) discovered by Oertel southeast of the Ashoka column.[66] It is definitely earlier than the dated Buddha images, although perhaps not a product of the fourth century, as Rosenfield suggests.[67] Standing on the shoulders of the central bodhisattva image is a pair of figures, one male and one female, each holding a bowl. I can think of no iconographic parallel to this image, although the seated figure in the headdress with the hands in dhyana mudra suggests the Jina Buddha Amitabha, from whom Avalokiteshvara is generally understood to have emanated. But we must ask how fully codified the system of identifying each bodhisattva with one of the Jina Buddhas was during the Gupta period. Dating an Indian text is notoriously difficult. Texts were generally transmitted orally, preserved in memory, and thus open to constant revision. But most scholars accept a date of about 300–500 CE for the composition of one of the very earliest Buddhist texts, the *Guhyasamajatantra*, which associates bodhisattvas with specific Buddhas.[68] This, like many other texts that art historians sometimes treat as manuals of iconography, is intended to aid a Buddhist meditator in visualizing the deity he or she might be contemplating. It is not very

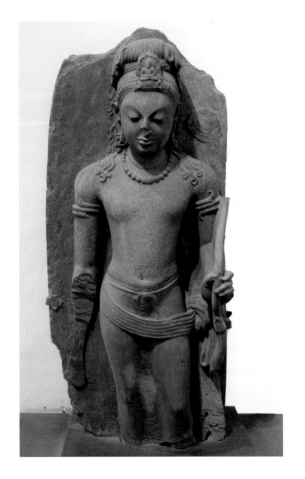

FIGURE 3.36
Bodhisattva, probably Avalokiteshvara. Findspot not recorded. Kolkata, Indian Museum.

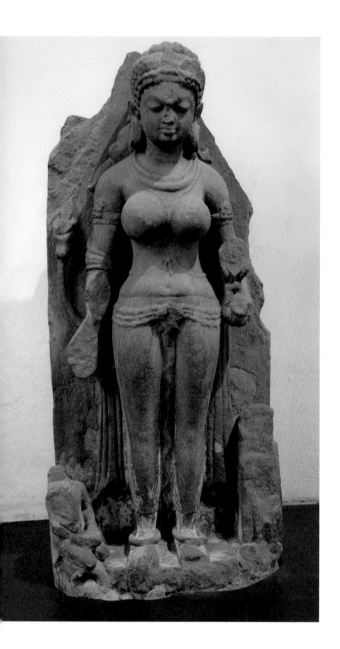

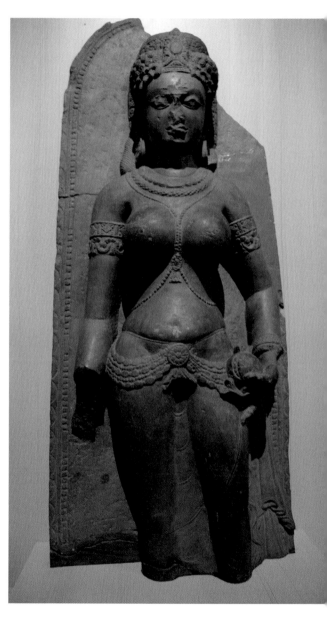

FIGURE 3.37
Tara image. Findspot not recorded. Kolkata, Indian Museum.

FIGURE 3.38
Tara image. Found south of the Main Shrine. Sarnath, Archaeological Museum Sarnath.

likely that artists had such texts committed to memory or even that they had encountered them in such detail that they would have served as a guide for the iconographic features of a sculptured image. Nonetheless, the very fact that the texts existed during the Gupta period—though we cannot be certain that the Buddhists of Sarnath practiced visualization as prescribed by these texts—suggests that it is reasonable to assume a common correlation between the particular Buddha in the headdress of a bodhisattva and the identification of that bodhisattva. The *Guhyasamajatantra* and similar texts that are more or less contemporary—for example, the *Saddhana-mala*—also identify specific images of the goddess Tara. So it is not surprising that among the Gupta sculptures of Sarnath is an image of Tara (FIGURE 3.37), conceived as the female aspect of Avalokiteshvara and a goddess associated with compassion. The figure was excavated by Alexander Cunningham and presented to the Asiatic Society of Bengal in 1836 and from there transferred to the Indian Museum.[69] Carved with the soft contours and planes characteristic of the second half of the fifth century, the figure stands erect, her eyes downcast. She stands on a lotus with two small figures at her feet, one standing and the other kneeling. Both hands are broken, so it is not possible to see what they originally carried, but a lotus stem essentially parallel to her right arm indicates a lotus flower would have been about shoulder level, similar to the lotus held by images of Avalokiteshvara. This is the earliest female goddess discovered at Sarnath, contrary to those who suggest that an image of Tara found south of the

Main Shrine is the earliest one;[70] that figure (FIGURE 3.38) should be recognized as a product of the eighth century.

BEYOND THE GUPTA PERIOD

That eighth-century image of Tara is one of a great many sculptures from Sarnath dating after the Gupta period that are too often assigned a fifth-century date. The sense seems to be that Sarnath is a fifth-century site, a place that had a brief moment in time rather than a life that spanned much more than a millennium. There is also the apparent sense that the fifth century marked an apogee in the art of India, as if everything thereafter was either derivative or rigid. In fact, it is possible to find sculptures of Sarnath that date almost continually through the twelfth century.

Thus, one of the reliefs depicting scenes of the Buddha's life (see FIGURE 3.31), though commonly identified as a fifth-century product, is surely later, probably dating to the seventh or eighth century. The scenes are neatly compartmentalized, and the carving shows little of the flowing composition and relative naturalism found in the fifth-century reliefs of the Buddha's life. In fact, it probably dates somewhat later than the fifth- to sixth-century date that museum label suggests, perhaps to the seventh or eighth century. The tendency to cluster it close in time to the fifth-century reliefs depicting life scenes, I would suggest, has more to do with the subject matter than the style of the relief and the sense that the fifth century marked the peak of Sarnath's sculptural production. If we recognize that

there must have been some major project that drew sculptors and their patrons to Sarnath around 475, then we need to grapple with the question of what happened after that. Surely the monastic establishment at Sarnath continued to flourish. In the seventh century, Xuanzang saw some fifteen hundred monks of the Sammitiya school. Even if we assume the number to be based on nothing close to a census count and that not all of them were followers of the Sammitiya school, it is clear that the site was then flourishing and that the buildings in which these monks dwelled and worshipped were not all antique structures. A doorjamb (FIGURE 3.39) that follows the format of temple doorjambs dating from the Gupta period through about the eighth century is clear evidence for this construction. Like the seventh-century Mundeshvari temple, a figure stands within a keyhole shaped niche at the bottom, while above are three adjacent bands of decor: a beautifully rendered lotus on the innermost band, the one that would have been at the door opening; then a band with a potbellied figure and above that a single standing figure; and the outermost band with pairs of amorous figures (*mithunas*) separated by diminutive frolicking figures. Despite the museum label identifying this as a fifth-century product, it is certainly later. In the fifth century—for example, at Nachna and Deogarh—the lower images project from the stone and are not confined to a niche, as the remaining figure is here. Clearly the style of the standing male in the niche, identified as Kama with a smaller figure of Rati, dates this doorjamb to the seventh century.

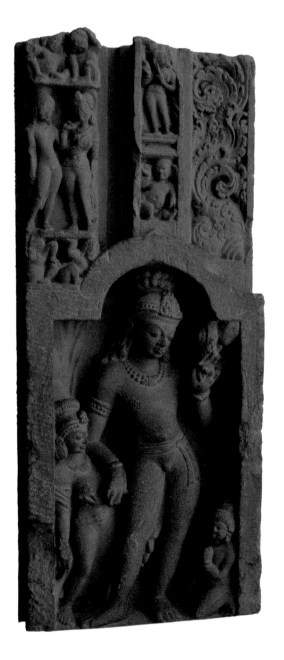

FIGURE 3.39
Doorjamb. Findspot not recorded. Sarnath, Archaeological Museum Sarnath.

Most of Sarnath's structures dating after the fifth century, maybe earlier as well, were brick constructed, except for certain structural elements such as doorways. That is frequently the case across a wide band extending from present-day Delhi eastward along the Ganges Valley all the way to the Bay of Bengal. Brick is often adorned with stucco decoration, a notoriously fragile medium. In the locations where the stucco decoration has been preserved—for example, the sculptures of Nalanda's Great Monument at Site 3—it is because they have been encased by subsequent building or by the good fortune of burial beneath earth, as was the case with the stucco sculptures of the Maniyar Math at Rajgir and the Ramayana reliefs at Aphsad, both of which were almost entirely eroded within a few years after exposure. So I would guess that we are missing a great deal of the material evidence for Sarnath's sculptures after the fifth century. While it is true that across eastern India, in the realm of the Pala dynasty, brick monuments were adorned with stone sculptures from the eighth through twelfth centuries, stone sculptures seem to have been made for installation at Sarnath's monuments less commonly during this period. Nonetheless, we can point to some without offering an explanation for their relative rarity.

For example, a tall relief with an image of the Buddha, his hands in the teaching gesture, inset much like the later relief with scenes of the Buddha's life, probably dates to the sixth or seventh century despite the museum attribution to the fifth century (FIGURE 3.40). The rather tubular torso and

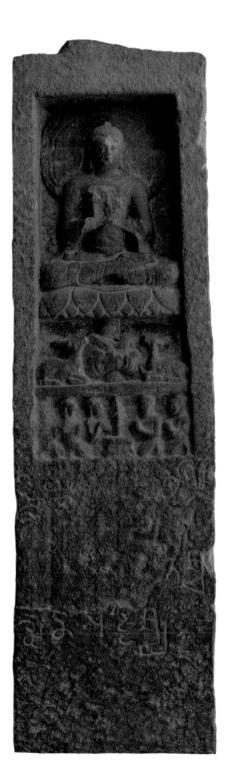

FIGURE 3.40
Relief with seated Buddha. Findspot not recorded. Sarnath, Archaeological Museum Sarnath.

more rounded face suggest that date. Other figures, too, may be ascribed to the seventh or eighth century—for example, a seated image of the Buddha, his right hand extended downward (bhumisparsha mudra) as he overcomes Mara just prior to enlightenment, probably a product of the seventh century (FIGURE 3.41).[71] Following fifth- and sixth-century images of the subject, such as those illustrated in figures 3.27 and 3.28, this is the most detailed, for it includes representations of Mara's host, figures made all the more horrific by faces on their abdomens. This is not a feature of earlier representations of this scene nor of other seventh- or eighth-century Sarnath depictions of the Buddha with the right hand in bhumisparsha mudra—for instance, the figure dedicated by the senior monk Bandhugupta (FIGURE 3.42). The torso of this figure may be stylistically related to that of a late seventh-century seated Buddha from the site of Tetrawan, about 23 kilometers south of Nalanda (at the time the greatest Buddhist monastery anywhere) and about 350 kilometers due east of Sarnath. The dedicatory inscription of this figure is, curiously, rendered in raised letters, making it far and away the earliest inscription in India so designed.[72] While the museum label dates the figure to the fifth century, Sahni is closer to the mark by assigning it to the sixth or seventh century,[73] though he does so on the basis of epigraphic style rather than the form of the body, which is significantly more tubular and less subtly modeled than the sculptures of the fifth century. Also a product of about the seventh century and showing a similarly firm torso is a preaching Buddha (FIGURE 3.43).[74] Seated on a full-blown lotus, the

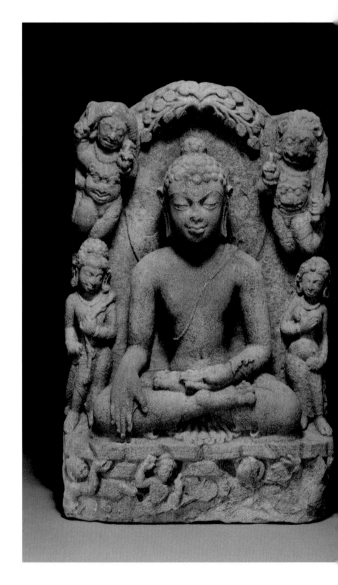

FIGURE 3.41
The Buddha overcoming Mara. Findspot not recorded. London, British Museum.

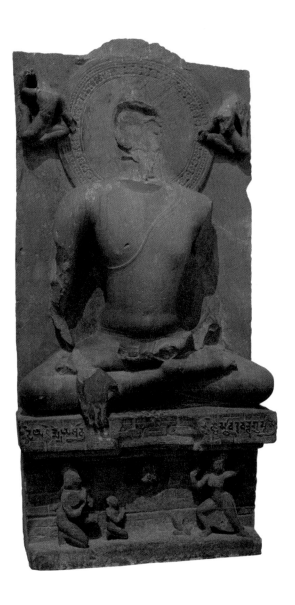

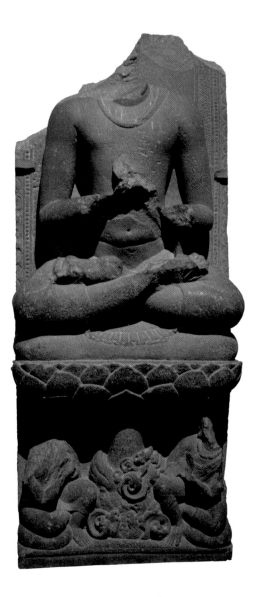

FIGURE 3.42
Seated Buddha in bhumisparsha mudra, dedicated by the monk
Bandhugupta. Found southeast of the Main Shrine. Sarnath,
Archaeological Museum Sarnath.

FIGURE 3.43
Seated Buddha image. Findspot not recorded. Sarnath,
Archaeological Museum Sarnath.

FIGURE 3.44
Bodhisattva, probably Manjushri. Found southeast of the Main
Shrine. Sarnath, Archaeological Museum Sarnath.

figure may represent the Shravasti miracle, although here the multiple Buddhas seen on relief representations of this subject, such as the ones illustrated in figures 3.33 and 3.34, are not shown.

An image of Manjushri (FIGURE 3.44) was excavated southeast of the Main Shrine.[75] The figure's identification as the bodhisattva Manjushri is suggested by the presence in the headdress of a small earth-touching (bhumisparsha mudra) figure of Akshobhya, the Jina Buddha associated with Manjushri. Thus, we can assume that the broken lotus held in the left hand was Manjushri's blue lotus (*nilotpala*) and that the right hand was held in varada mudra. A brief inscription on the back of the figure records the so-called Buddhist creed, with a few additional letters whose meaning is unclear. Sahni dates the inscription to the end of the seventh century,[76] so assigning the sculpture on the basis of style — the smooth planes and little subtle modeling — to the eighth or ninth century, as I would, is probably close to accurate.

Distinctive but closely related styles are clearly manifest in the Sarnath sculptures. Nonetheless, a few works from Sarnath were either brought to the site from distant places or made locally by artists trained elsewhere. For example, an image of the Bodhisattva Maitreya (FIGURE 3.45), identifiable by the stupa in the headdress and the large pot he carries in the left hand, shows features such as the disproportionately large head and prominent heavy-lidded eyes seen on figures datable to the seventh century from sites in other parts of northern and central India. An image of Shiva as Lord of the Dance now in the Los Angeles County Museum of Art and datable to about 800[77] and also an image of Uma-Maheshvara[78] in the same museum might be related to this Maitreya, although they are both certainly later works. Despite the Archaeological Museum Sarnath attribution of the Maitreya to the fifth century, it is much more likely a product of the seventh century.

Although much is made of Sarnath's influence on the art of eastern India — including the possibility that Sarnath sculptors moved to Nalanda

FIGURE 3.45
Bodhisattva, probably Maitreya. Findspot not recorded. Sarnath, Archaeological Museum Sarnath.

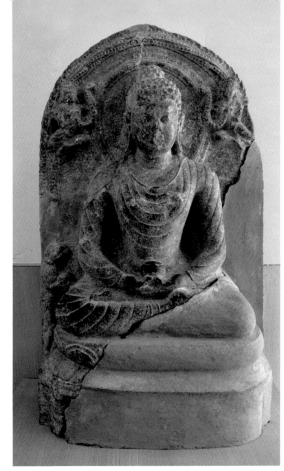

and the impact of Sarnath iconographic types on Bodhgaya—the link with eastern India is made all the stronger by at least three sculptures found at Sarnath that are carved in a distinctive eastern Indian style and from the black stone commonly used in eastern India. One is a small, headless seated Buddha dating to about the tenth century (FIGURE 3.46). Another, also a small seated Buddha but better preserved, probably dates somewhat later, maybe to the eleventh century (FIGURE 3.47). A small crowned Buddha was excavated east of the Main Shrine in the course of the excavations conducted in 1908 under the supervision of John Marshall and Sten Konow.[79] Although the excavators do not comment on the stone, Sahni notes that the stone is "blue" and that the sculpture must have been made in Magadha.[80]

FIGURE 3.46 (ABOVE LEFT)
Seated Buddha, dark gray stone, typical of sculptures from eastern India. Findspot not recorded. Sarnath, Archaeological Museum Sarnath.

FIGURE 3.47 (ABOVE RIGHT)
Seated Buddha, dark gray stone, typical of sculptures from eastern India. Findspot not recorded. Sarnath, Archaeological Museum Sarnath.

More important than their date, though, is how figures that are clearly products of sculptors working during the reign of the Pala dynasty in eastern India happened to be found at Sarnath. It is possible, though highly unlikely, that an artist from somewhere such as Bodhgaya found work at Sarnath and while there imported the black stone he was accustomed to sculpting. More likely, someone making a pilgrimage to the principal sites associated with the life of the Buddha carried these images from somewhere in eastern India, probably Bodhgaya. It might seem impractical that a pilgrim making the journey of some 250 kilometers from Bodhgaya to Sarnath would carry a heavy stone sculpture, but we have ample evidence that sculptures did travel

in antiquity, among them a Sarnath sculpture discovered at Biharail in present-day Bangladesh and discussed below.

It is notable that a significant number of Sarnath sculptures datable after the eighth century—the later medieval period as it is sometimes uselessly called—are seated images. One might speculate that they were made for relatively small niches in newly constructed temples since there is ample evidence that Sarnath was provided with new temples during the tenth through twelfth centuries. That evidence comes in the form of parts of doorways that have been excavated, stone doorways probably made for brick-constructed temples. For example, a door lintel (FIGURE 3.48) that may be datable to the

FIGURE 3.48
Temple doorway lintel. Findspot not recorded. Sarnath, Archaeological Museum Sarnath.

eleventh century is rendered in a pattern seen com-
monly among tenth- and eleventh-century temples
of northern India: there are three projecting pan-
els (in this case, with images of Brahma, Vishnu,
and Shiva) with two panels between them carved
with other figures (here, the nine planetary deities
[*navagrahas*]). The doorway of a tenth-century Jain
temple at Bilhari follows this pattern,[81] as does one
of the corner shrines of the Vishvanatha temple at
Khajuraho bearing a date equivalent to 1002.[82] This
door lintel at Sarnath, besides attesting to the con-
struction of a temple at this time, raises the need
for an explanation of images we might describe as
Hindu at a decidedly Buddhist site. The situation is
by no means unique at Sarnath, nor is this the only
Hindu work at the site. At Nalanda, for example, the
huge temple plinth of Site 2 is often identified as a
Hindu temple. At Sarnath, earlier examples include a
Vishnu that may be assigned to the early fifth century
(FIGURE 3.49), despite the museum label dating it to
the eleventh century,[83] and an image of the god Agni
that is poorly preserved and therefore difficult to
date but likely an eighth-century work (FIGURE 3.50).
Jain images, too, were found at Sarnath, among them
a small image of the Tirthankara Vimalanatha (FIG-
URE 3.51) that is probably a ninth-century product.
How do we explain these figures? Some scholars see
Hindu works at Buddhist sites as syncretic imagery;
others propose a sense of ecumenism. The answer
may be a great deal less complex. If the sculptural
workshop was located at Sarnath itself, then there
is good reason to imagine that the artists would
accept commissions from anyone seeking an image.

FIGURE 3.50 (OPPOSITE, LEFT)
Agni image. Findspot not recorded. Sarnath, Archaeological
Museum Sarnath.

FIGURE 3.51 (OPPOSITE, RIGHT)
Image of Jina Vimalanatha. Findspot not recorded. Sarnath,
Archaeological Museum Sarnath.

FIGURE 3.49
Vishnu image. Findspot not recorded. Sarnath, Archaeological
Museum Sarnath.

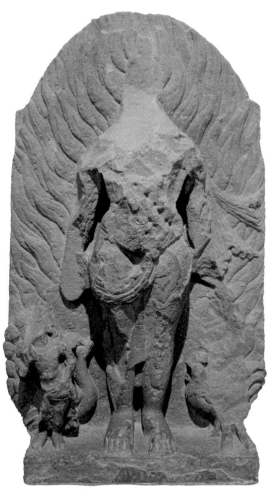

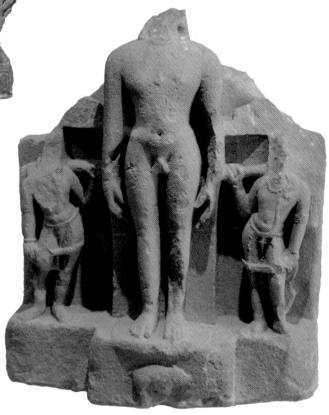

FIGURE 3.52
Unfinished image of Shiva slaying the demon Andhaka. Found in the debris of Monastery IV. Sarnath, Archaeological Museum Sarnath.

FIGURE 3.53
Unfinished image of Shiva. Findspot not recorded. Sarnath, Archaeological Museum Sarnath.

That seems particularly likely, since at least two of the Hindu figures are incomplete: an enormous image of Shiva destroying the demon Andhaka[84] (FIGURE 3.52) and a four-armed figure of Shiva (FIGURE 3.53), both datable to the tenth or eleventh century. It is particularly likely that sculptors still working at Sarnath during this time welcomed other commissions, since the excavations at the site suggest relatively few Buddhist sculptures of this date.

Nonetheless, there were certainly some new commissions, among them three seated figures excavated in 1907–8 north of the Dhamekh stupa. Almost exactly the same size and datable to about the eleventh century,[85] the three figures were almost surely made as a group, probably by the same hand, and were introduced in the previous chapter. One

represents the Buddha preaching (dharmachakra mudra); a second shows the Buddha overcoming Mara (bhumisparsha mudra); and the third depicts the bodhisattva Avalokiteshvara (see FIGURES 2.7, 2.8, and 2.9). Although the grouping is unusual—one might expect a Buddha to be accompanied by a pair of bodhisattvas—they nonetheless indicate that new images continued to be dedicated at Sarnath in the eleventh century. While these three sculptures are local products—though with clear reference to Pala features, such as the throne on which they sit—the link between Sarnath and eastern India is indicated by patronage from the Pala dynasty king Mahipala (circa 998–1038), recorded on the pedestal of a seated Buddha image (FIGURE 3.54) found in the vicinity of the Dharmarajika stupa.[86] The

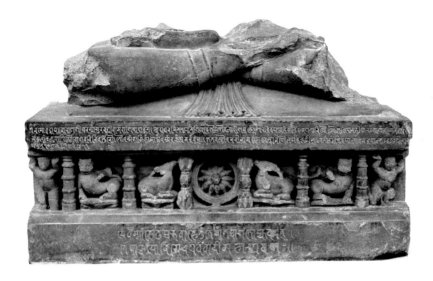

FIGURE 3.54
Pedestal of a seated Buddha bearing inscription of Mahipala dated equivalent to 1026. Findspot not recorded. Sarnath, Archaeological Museum Sarnath.

inscription notes that Mahipala, the Pala dynasty king of Gauda (essentially a large part of modern West Bengal and Bangladesh), using the agency of Sthirapala and his younger brother, had provided Hindu temples in Kashi (Varanasi) and then restored a stupa and a monastic dwelling at Sarnath. The king also built there a new stone shrine (*shaila gandhakuti*) for the Buddha that relates to what the inscription describes as the eight great places (*ashtamahasthana*), as if referring to the eight major events in the life of the Buddha and the places at which they took occurred. These events were rendered first at Sarnath on fifth-century plaques and then, especially in eastern India, they were depicted around Buddha images in bhumisparsha mudra. The inscription is dated to the year (*samvat*) 1083, presumably of the Vikrama era, which would be 1026 CE. Even though Mahipala provided the funds somewhat indirectly—that is, through the agency of these two brothers—this represents the first documented royal patronage at Sarnath since the time of Ashoka. Perhaps the fact that the Pala kings were Buddhists brought Sarnath within their spiritual orbit if not under their governance.[87]

But some royal support for Sarnath came directly from the monarch, or rather his queen, whose realm included the site of the Buddha's first sermon. Queen Kumaradevi, the wife of the Gahadavala dynasty king Govindachandra (1114–54), provided a vihara at Sarnath, called in the inscription "Dharmachakra" (the place of the dharma wheel, the first sermon). This dwelling, the inscription tells readers, was intended to last as long as the sun and moon shine, though perhaps, more realistically, it would last only while Sarnath continued to be occupied, which probably ended shortly after the vihara was built. The inscription is recorded on a large rectangular slab (see FIGURE 7) discovered in the 1908 excavations just north of the Dhamekh stupa.[88] Despite Kumaradevi's marital relation to the Gahadavala dynasty, she stresses her Pala dynasty origin in this inscription, giving her husband, the king, second billing, after proclaiming her virtues. The inscription was composed by a poet named Shri Kunda, who without modesty uses a whole verse to proclaim his own virtues, and it was carved in stone by the artist (*shilpin*) Vamana, letting us know that an artist, not a scribe or calligrapher, carved the inscription. So even in the twelfth century, Sarnath continued to thrive, as someone perceived the need for yet another monastic dwelling there.

One final figure, in this case a standing one, is especially important: a crowned Buddha, initially described in the catalog of the Indian Museum, its present home, as a figure of Vagishvari, a form of the bodhisattva Manjushri (FIGURE 3.55).[89] Although the catalog suggests no date for the figure, the wall label at the museum gives the date as circa fifth century. Without question, it dates considerably later, probably to the eleventh century, and its importance, as Janice Leoshko has noted, should not be underestimated.[90] The obvious forms and iconographic detail that this figure shares with images from eastern India, particularly from Bodhgaya, show that the Sarnath links with eastern India persisted as long as sculptures were produced at Sarnath. Sarnath's

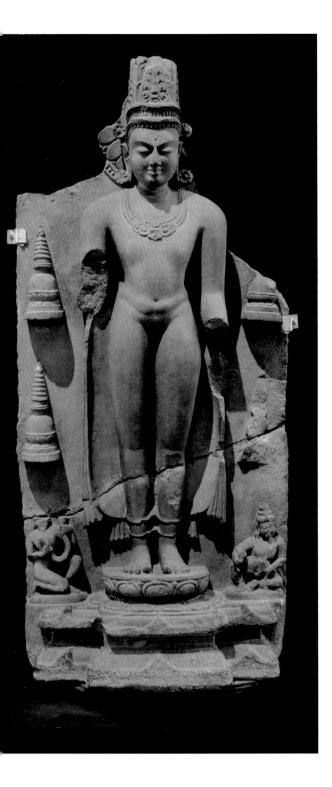

link to Bodhgaya is made evident not only by this crowned Buddha, a form common at the site of the Buddha's enlightenment, but also by the gift of the twelfth-century queen Kumaradevi, who provided the Dharmachakra Jina Vihara. In her inscription, she identifies herself as the daughter of Devarakshita, who, as Leoshko notes, apparently ruled territory around Bodhgaya. The connection between Sarnath and Bodhgaya, if not other sites in eastern India, was thus familial, providing an environment in which monks, and traders, and even possibly sculptors could move easily.

THE STUPA PLATFORM AND "MINIATURE" STUPAS

Northeast of the courtyard, in front of the Main Shrine's east-facing entrance, is a long area extending almost as far eastward as the Dhamekh stupa in which a great many small brick stupa bases stand. In the eastern part of this area is a platform with the remains of brick stupa bases arranged in pairs (FIGURE 3.56). Although the stupas that stood on these bases no longer remain—likely, they were brick-faced with stucco as we see at some other sites, Bodhgaya and Nalanda, for example—a great many small stone stupas, often described as miniature stupas, do remain. Some are placed at the excavated site, some brought to the Archaeological Museum Sarnath. Typical of these is one that, in its present form, may be a composite of several stupas (FIGURE 3.57). Mounted on a base with three facets on each side, the drum is cylindrical and adorned with a seated Buddha image on four sides, each in a different mudra. These may represent four of the

FIGURE 3.55
Crowned Buddha image. Findspot not recorded. Kolkata, Indian Museum.

Jina Buddhas, but much more likely they are references to sites associated with the life of the Buddha. A similar small stupa, this one fully intact, stands on the grounds of the Archaeological Museum Sarnath (FIGURE 3.58). Underscoring the likelihood that they represent places associated with the life of the Buddha is this view that shows the Buddha, a crowned Buddha in this case, as if sitting within the Maha Bodhi temple at Bodhgaya. Thus, it seems appropriate to suggest that these "miniature" stupas were dedicated by pilgrims who had visited the major sites associated with the life of the Buddha or, possibly, that they were used as surrogates for a more complete pilgrimage by those who could visit only one site, Sarnath in this case. It is also possible that they were dedicated on behalf of someone who was unable to undertake pilgrimage to any of the sites but wished to do so metaphorically by providing a small stupa such as this. The absence of inscriptions leaves their purpose uncertain.

FIGURE 3.56
Pairs of brick stupa bases, Sarnath. Northeast of the courtyard in front of the Main Shrine's entrance.

FIGURE 3.57
Stone votive stupa (a composite as it presently appears), Sarnath.

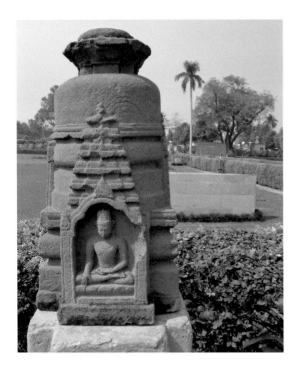

contained short incantations (*dharanis*) relating to Buddhist mortuary practice. At Kanheri, a memorial stupa gallery (as it is generally called) or cemetery (as it is sometimes called) features bases for small stupas and inscriptions indicating that they were intended for the remains of distinguished monks. These date to the late fifth or early sixth century[93] and, together with the evidence from other sites and Yijing's observation, suggest the possibility that the small stupas at Sarnath also may have served a funerary function. The location of the long row of paired stupa bases at Sarnath, just below the monastic dwellings on the excavated site's northern perimeter, offers the possibility that they incorporated the remains of distinguished monks who lived and studied and perhaps taught in those dwellings.

SARNATH SCULPTURES TRAVEL ABROAD

Although we generally think of Kushana images made at Mathura as the ones sent to other Buddhist sites, at least one Gupta-period sculpture that almost surely has a Sarnath origin traveled a considerable distance, to the monastery at Biharail in the Tanore Upazila (subdistrict) of Rajshahi Division in present-day Bangladesh (FIGURE 3.59). The sculpture is so unlike any local product that it must have been an import, and it is so similar to Sarnath sculptures dating close to 475—down to the use of buff-colored sandstone rather than the gray or black phyllite commonly used across Bengal—that we can reliably suggest its Sarnath origin. Elsewhere we find works that share much in common with Gupta sculptures of Sarnath. That might

Sarnath is not alone in having clusters of small stupas. They are found at Bodhgaya as well as at monastic sites not associated with the life of the Buddha (and thus not pilgrimage sites). In the courtyard of the temple of Nalanda's Site 12 are many small stupas, as there are at Ratnagiri in Odisha, where they are also arranged in pairs along a platform. That does not contradict the suggestion that these stupas, at least at sites associated with the Buddha's life, relate to pilgrimage, but it does suggest that the small stupas served another purpose. As Gregory Schopen has shown,[91] reports of the excavation and exploration at a great many sites—Taxila, Bodhgaya, and Ratnagiri, among others—have generated small stupas without finials but with sockets into which plugs could be placed. Many of those discovered contained ashes or bones, corresponding with the observations of the seventh-century Chinese pilgrim Yijing regarding the function of such small stupas.[92] Others

FIGURE 3.58
Votive stupa with crowned Buddha, grounds of the Archaeological Museum Sarnath.

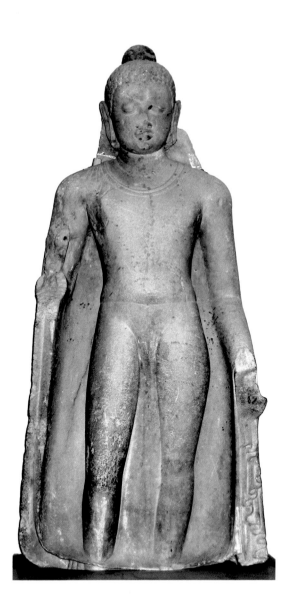

be explained by influence, though the notion of influence is somewhat too vague to explain the Sarnath characteristics shared by this sculpture—for example, the relatively slender torso, the garment unmarked by sculptured folds (though they might have been painted), and the gentle déhanchement. Influence in the Indian context suggests a known center and derivative peripheries. Centers, however, can be recognized by relatively large numbers of works found in a single location that suggest fixed, not itinerant, workshops or individual artists. The Biharail Buddha is thus far the sole example of a Sarnath sculpture that in ancient times was exported.

Colonial collecting, perhaps a too-polite way of describing the removal of sculptures from their context, is responsible for the dispersal of other Sarnath sculptures. For instance, those currently in the British Museum have a clearly recorded Sarnath origin. Four sculptures of the Buddha were transferred to the British Museum collection in 1880 when the India Museum, London (initially the museum of the East India Company), closed in 1879. Markham Kittoe apparently "collected" all four sculptures in the course of his 1851–52 excavations at the site, but he returned to England in poor health and so never wrote a report on his work there. These sculptures include the seated Buddha overcoming Mara (see FIGURE 3.41), two standing Buddha images (FIGURE 3.60; see FIGURE 3.22), and a seated Buddha (see FIGURE 3.23). Does the transport of these images from the colony to the metropole constitute traveling abroad? At the time of their removal, much of present-day India fell within the British Empire. The

FIGURE 3.59
Standing Buddha found at Biharail, Rajshahi Division, Bangladesh. Rajshahi, Varendra Research Museum. Photo by Stephen Eckerd.

FIGURE 3.60
Standing Buddha image. London, British Museum.

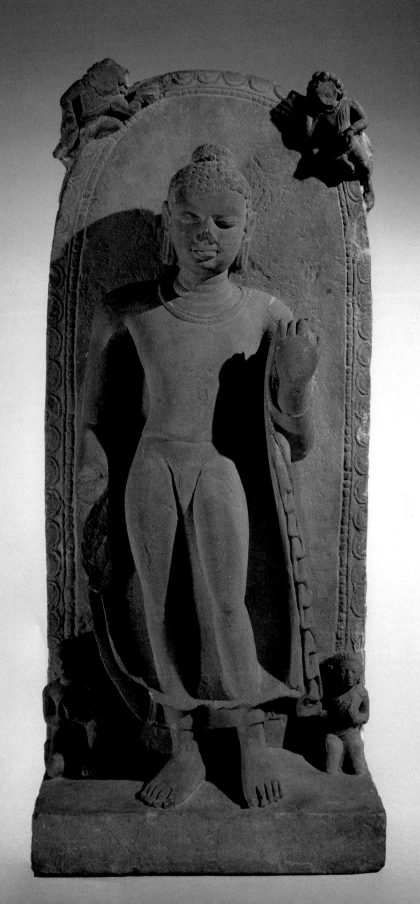

removal of objects from India was often done under the guise of scientific study rather than collecting trophies by individuals involved in their excavation; however, little scientific examination was focused on these works once they were in London.

A CURIOUS GIFT

In the Bangkok National Museum is a standing Buddha, the right hand extended downward in varada mudra. The sculpture is of unmistakable Sarnath style (FIGURE 3.61); it is possibly the image illustrated in Kittoe's drawing preserved in the British Library (FIGURE 3.62) and might be the Buddha image once in the Indian Museum Kolkata (numbered S30).[94] The label notes simply that the work is Indian art, Gupta style, from Varanasi, India, and that it was presented to H.R.H. Prince Damrong Rajanubhab. The museum registrar's catalog entry provides little more information on the travels of this figure, noting that it was given to Prince Damrong at "Deers Park." The prince was in India in 1892, even in Benares we learn, but there is not really a history of Indians—or the British on their behalf—giving away major works of art, nor even minor ones. I can find no document of this gift in Indian records, so we have to speculate about how he managed to get it. According to Prince Damrong, he was looking for a Buddhist antiquity, and generally when he wanted something, he got it. He claims that "the Archaeological Survey of India was so kind as to allow me to take away an antique that was not yet registered in the museum records."[95]

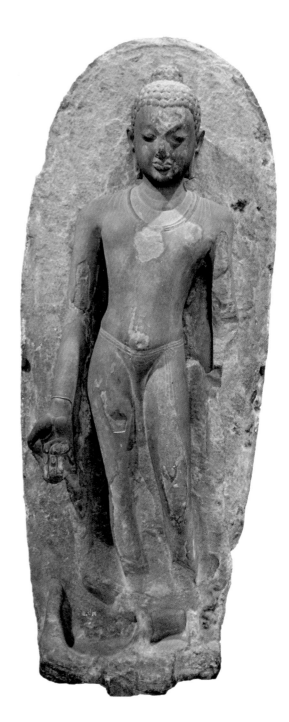

FIGURE 3.61
Standing Buddha image. Bangkok, Bangkok National Museum.

Relics (not sculptures), however, were another matter. In the late nineteenth and early twentieth centuries, the British Indian government had a history of giving Buddhist relics—that is, the contents of reliquaries—as diplomatic gifts. For example, the Siamese king Chulalongkorn was given relics, supposedly those of the Buddha himself, from the Piprawaha reliquary. The king of Siam was then recognized by the British as the only reigning Buddhist sovereign and imagined by the colonial authorities to be the "acknowledged head of the Buddhist church,"[96] as if there were a monolithic Buddhism headed by a pope-like figure. Just as at the time of the Buddha's cremation, his remains were distributed among several kingdoms, each pledging to construct a stupa over the remains, so the king of Siam distributed the remains from the Piprawaha reliquary. They were distributed, according to official documentation, to the Buddhists in Anuradhapura, Colombo, Kandy, Mandalay, and Rangoon, and, "with great pomp and ceremony," to Japan.[97] John Marshall proposed a similar distribution of the Peshawar relics. He suggested that four copies of the reliquary be made and that a portion of the relics should be placed in each: one sent to Burma, another to Japan, a third to Ceylon, and the fourth to the king of Siam.[98] We get the Siamese perspective from Prince Damrong, who wrote that in Buddhist era 2441 (1897–98) human bones discovered at Kapilavastu (Piprawaha was understood to be the site of the Buddha's home, Kapilavastu) and identified as relics of the Buddha were given to King Chulalongkorn because the Viceroy Lord Curzon knew Chulalongkorn and "considered the king to be the only defender of the Buddhist faith in the whole world, so he presented the holy Buddhist relics to His Majesty."[99] Not stated, however, was that this gift was likely viewed by the British as compensation for the British-Siamese War of 1874.

FIGURE 3.62

Drawing by Markham Kittoe of a standing Buddha from Sarnath. From *Sarnath: Album of 50 Drawings of Sculpture at Sarnath, Bodhgaya and Benares (U.P.)* (1846–1853), n.p. London, British Library.

Just as King Chulalongkorn had placed the Piprawaha relics in a bronze stupa that he had enshrined on the top of Wat Saket, popularly known in English as the Golden Mount, so Prince Damrong enshrined the Sarnath Buddha in Wat Phra Kaew—that is, the temple housing the Emerald Buddha in Bangkok. How it got from there to the Bangkok National Museum is not clear, but in the museum it joins several other sculptures from India, some with equally mysterious origins.

This may not be the first Sarnath sculpture to reach the region that is modern-day Thailand. Several standing Buddha images dating to the Dvaravati period show unmistakable similarity to the Sarnath style. Among these is a small Buddha image found at Wiang Sia, an area that may have been along a portage route from Andaman Sea ports, such as one west of Takuapa, to east-coast ports near Nakhon Si Thammarat. Although I see this as a local product, probably dating to the sixth century, its close affinity to the Sarnath style of about 475 requires explanation. It is not sufficient simply to assert Sarnath influence—or, for that matter, the influence of anything anywhere. We must at least speculate on the human agency that shaped that style. Were Indian sculptures from Sarnath imported to this region in the formative stages of Buddhism in Southeast Asia, or might artists from Sarnath have migrated to this region, perhaps initially working for an Indian merchant community resident in one of the ports? No excavation in Thailand has revealed an actual Sarnath sculpture imported in antiquity, although that does not preclude the possibility that they will be found in the future.

SARNATH SCULPTURES IN AMERICAN AND EUROPEAN COLLECTIONS

The Sarnath provenance of sculptures in India and Britain is unquestionable, but the origin of sculptures said to be from Sarnath that are housed in American and European collections is less clear. A significant majority of them are datable to the second half of the fifth century, as if that time epitomizes the Sarnath style and made them especially desirable acquisitions for these museums. None of them, however, has a clear record of provenance.

That is the case with a fine sculpture in the museum of the Asia Society, New York, a work remarkably similar to the Bangkok sculpture, though this one is more frontal (FIGURE 3.63). The figure, with the customary Gupta Sarnath déhanchement, stands against a backslab rounded at the top, common to figures such as this, with the hand extended downward in varada mudra, and not against a halo, as is common to images with the right hand in abhaya mudra. The diaphanous robe, as usual, covers both shoulders but reveals the drooping flesh beneath the navel. Although there is no record of the figure's Sarnath origin, the style leaves no question that it originates from Sarnath.[100] I would guess that the sculpture was not discovered within the present excavated area but found somewhere on the periphery in the course of "casual excavation," a gentle term for looting. As satellite imagery shows (see FIGURE 1), the site was a great deal larger than the excavated area and is replete with mounds that have not been formally and legally excavated, as a walk in the vicinity makes clear.

FIGURE 3.63
Standing Buddha image, presumably from Sarnath. New York, Asia Society Museum.

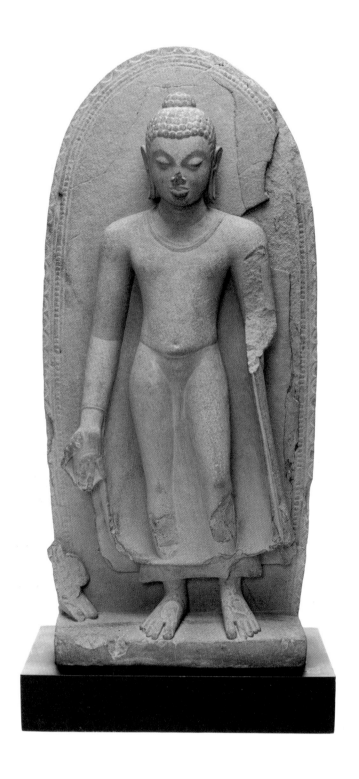

A similar piece, also a standing Buddha with the hand in varada mudra, is housed in the Cleveland Museum of Art (FIGURE 3.64), where there is also a Gupta-period Buddha head (FIGURE 3.65) that very likely originated at Sarnath. At the Nelson-Atkins Museum of Art, in Kansas City, Missouri, is a standing Buddha (FIGURE 3.66) with the right hand, though broken, originally raised in abhaya mudra. The figure appears to have been carved fully in the round—that is, without backslab—but it is likely that originally a halo encircled the head. In the Museum of Fine Arts, Boston, is the bust of an Avalokiteshvara image (FIGURE 3.67) that is identifiable as this bodhisattva by the seated Jina Buddha Amitabha with hands in dhyana mudra in the headdress. The more taut modeling and linear features of this figure suggest a date of about the seventh century. This is the approximate date of a standing Buddha figure in Berlin (FIGURE 3.68) that is said by the museum to have a Sarnath origin. Its appearance might be related to that of images in later reliefs illustrating the Buddha's life, such as that shown in figure 3.30. Finally, an elegant image of Avalokiteshvara in the Philadelphia Museum of Art (FIGURE 3.69) is also probably datable to the seventh or eighth century and certainly comes from somewhere in Uttar Pradesh if not from Sarnath itself.

Almost all of these works in American collections as well as the one in Berlin were acquired in the 1930s or early 1940s, the final decade or so of British rule in India. It was a time when attention was focused on issues a great deal more urgent than "informal excavation" or the export of sculptures in

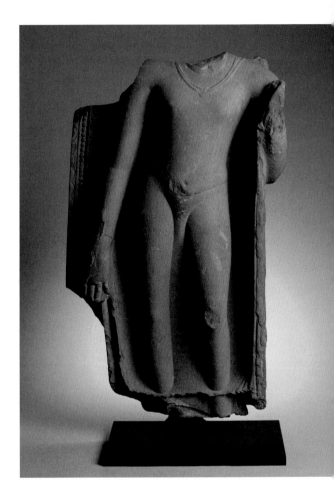

FIGURE 3.64
Standing Buddha image. Cleveland, The Cleveland Museum of Art.

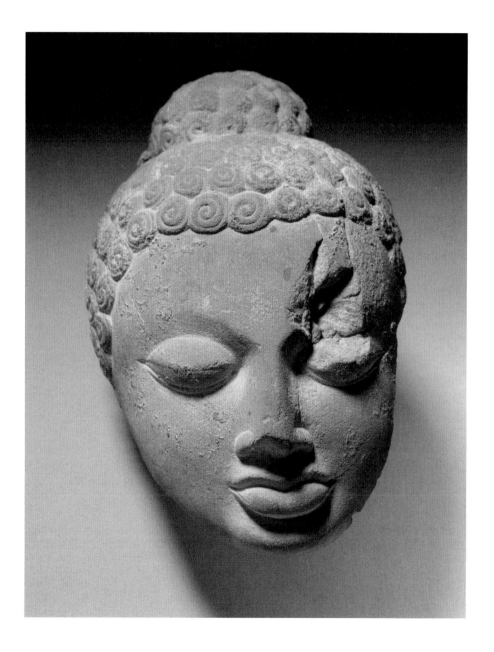

FIGURE 3.65
Buddha head. Cleveland, The Cleveland Museum of Art.

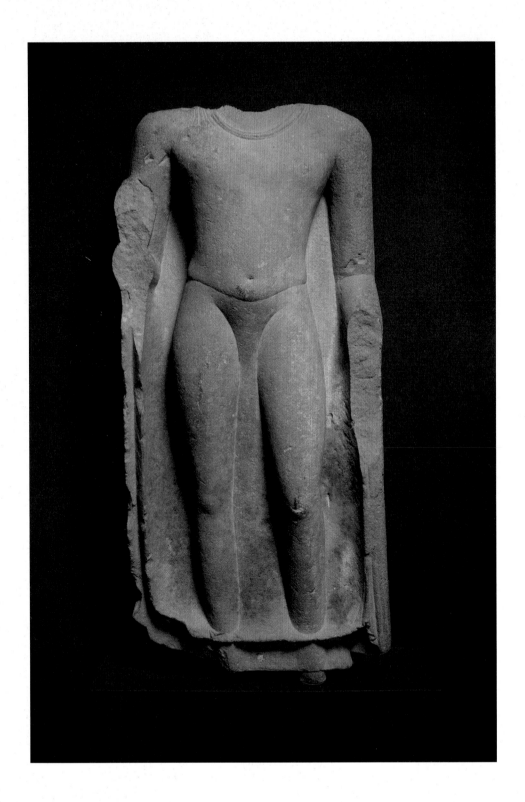

FIGURE 3.66
Torso of a Buddha image. Kansas City, Nelson-Atkins Museum
of Art.

FIGURE 3.67
Bust of Bodhisattva Avalokiteshvara. Museum of Fine Arts, Boston.

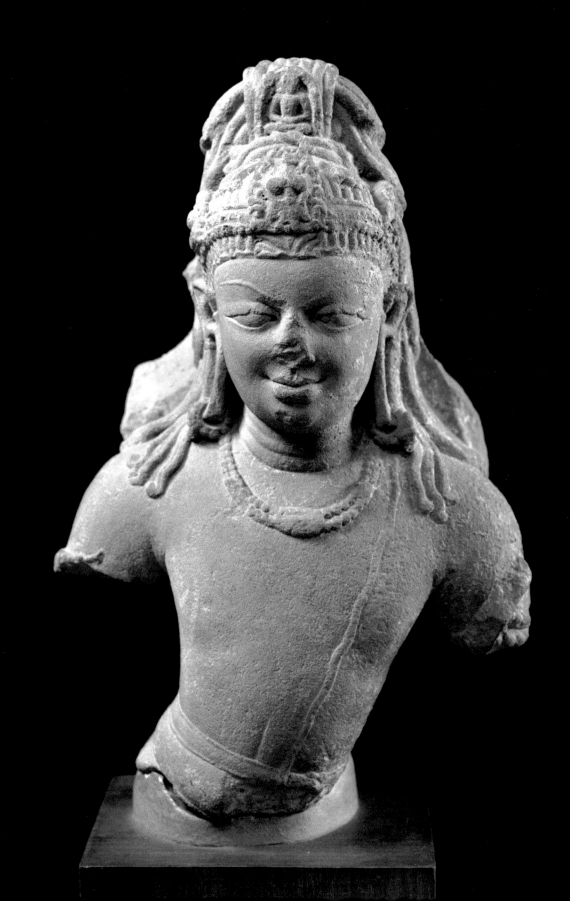

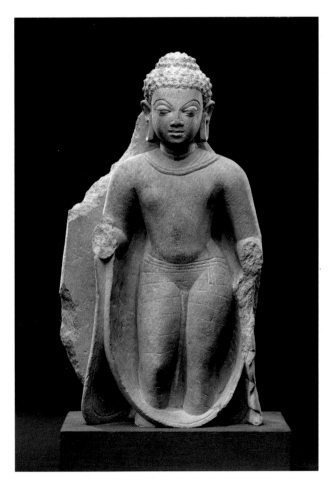

contravention of the Ancient Monuments Preservation Act of 1904[101] and prior to the enactment of the Antiquities Export Control Act of 1947, drafted and approved just before independence, which imposed much stricter measures on the export of antiquities.

A CLASSICAL STYLE

Near the beginning of this chapter, I note that many scholars use the term *classical* to refer to styles of the fifth century CE, particularly the style of Sarnath at that time. Ananda Coomaraswamy, for example, uses the term *classical Gupta style* in a 1935 article, as if to make the art that seemed so distant to many in the West more comprehensible.[102] It is not, however, a particularly useful term, and the relationship to anything Western that the term might evoke—fifth-century BCE Greece or Heinrich Wölfflin's notion of Italian Renaissance art as *klassische Kunst*—is entirely misleading. No more helpful is the idea of the Gupta period as a golden age, particularly in reference to Sarnath.[103] Somewhat more recently, for example, Karl Khandalavala edited a volume titled *The Golden Age: Gupta Art* (1991),[104] one of several books to imagine this time period and especially its visual products as something distinctive. This again draws an analogy with the Greek notion of a golden age, first attributed to the seventh-century BCE poet Hesiod but subsequently maintained by many such as Ovid, who visualized an uncorrupted golden age that many had localized in Arcadia. This is a Western notion imposed on India, not one shared by any Indian writer until the twentieth century. Just as I have argued in this book that we must exercise caution in reading the Chinese pilgrims' accounts as travelogues, so I would caution against misleading analogies with Western time periods.

FIGURE 3.68
Standing Buddha. Berlin, Museum für Asiatische Kunst.

FIGURE 3.69
Standing bodhisattva Avalokiteshvara, possibly from Sarnath. Philadelphia, Philadelphia Museum of Art, Stella Kramrisch Collection.

NOTES

1. F. O. [Friedrich Oscar] Oertel, "Excavations at Sārnāth," in *Archaeological Survey of India, Annual Report, 1904–5* (Calcutta: Superintendent of Government Printing, India, 1908): 63; hereafter, this report is cited as *ASIAR*. To be fair, Oertel also refers to sculptures on page 78 and again in his "List of Sculptures," 91–102.

2. See, for example, David Geary and Sraman Mukherjee, "Buddhism in Contemporary India," in *The Oxford Handbook of Contemporary Buddhism,* ed. Michael Jerryson (Oxford: Oxford University Press, 2017), 44–45. See also Frederick M. Asher, "Travels of a Reliquary, Its Contents Separated at Birth," *South Asian Studies* 28, no. 2 (2012): 147–56.

3. John M. Rosenfield, "On the Dated Carvings of Sarnath," *Artibus Asiae* 26, no. 1 (1963): 10–26; and Joanna G. Williams, *The Art of Gupta India: Empire and Province* (Princeton: Princeton University Press, 1982), 76.

4. See, for example, Pramod Chandra, *The Sculpture of India, 3000 B.C.–1300 A.D.* (Washington, D.C.: National Gallery of Art, 1985), 32. In deference to Chandra, I should note that he is not suggesting the term as appropriate but rather says, on page 32, that this period "is often called the classical phase of Indian art."

5. B. R. Mani, Sachin Kr. Tiwary, and S. Krishnamurthy, "Evidence of Stone Sculpturing Workshop at Sarnath in the Light of Recent Archaeological Investigations," *Puratattva,* no. 45 (2015): 197–203. Note also some unfinished sculptures from Sarnath—for example, a large image of Shiva slaying the demon Andhaka (see fig. 3.52). Vidula Jayaswal has identified sites close to Sarnath as likely centers of sculpture production, particularly Kotwa, about 6.7 kilometers south of Sarnath. Vidula Jayaswal, *From Stone Quarry to Sculpturing Workshop: A Report on Archaeological Investigations around Chunar, Varanasi & Sarnath* (Delhi: Agam Kala Prakashan, 1998), esp. 215–17.

6. The inscription was initially read and translated by Jean Ph. Vogel, "Epigraphical Discoveries at Sarnath," *Epigraphia Indica* 8 (1905–6): 166–79; a short while later, it was more carefully read and translated by Arthur Venis, "Some Notes on the Maurya Inscription at Sarnath," *Journal of the Asiatic Society of Bengal,* n.s., 3 (1907): 1–7. Most recently, the pillar and its inscription have been published in a very important work on Ashokan inscriptions: Harry Falk, *Aśokan Sites and Artefacts* (Mainz: Von Zabern, 2006), 209–14.

7. Oertel, *ASIAR, 1904–5,* 69.

8. Vogel, "Epigraphical Discoveries," 172.

9. Xuanzang, *The Great Tang Dynasty Record of the Western Regions,* trans. Roingxi Li (Berkeley, CA: Numata Center, 1996), 196.

10. Theodor Bloch, "Two Inscriptions on Buddhist Images," *Epigraphia Indica* 8 (1905–6): 180–81.

11. Oertel, *ASIAR, 1904–5,* 68.

12. See chapter 2, "The Excavated Site" (this volume), note 15, for a brief discussion of this issue.

13. Daya Ram Sahni, *Catalogue of the Museum of Archaeology at Sārnāth* (Calcutta: Superintendent of Government Printing, India, 1914), 31.

14. Jean Przyluski, "Le symbolisme du pilier de Sarnath," in *Etudes d'orientalisme à la mémoire de Raymonde Linossier* (Paris: Musée Guimet, 1932), 2:481–98.

15. Paul Mus, *Barabudur: Esquisse d'une histoire du Bouddhisme fondée sur la critique archéologique des texts* (Hanoi: Imprimerie d'Extrême-Orient, 1935; reprint, New York: Arno, 1978), 145–60. On page 153, Mus expands the notion, stating, "Le pilier de Sārnāth supporte non seulement le ciel, mais toutes les dimensions de l'espace." (The pillar of Sarnath supports not only the sky but all the dimensions of space.)

16. The elevation of this capital to the emblem of the Republic of India is discussed further in chapter 4.

17. Falk, *Aśokan Sites,* 211–12.

18. J. H. [John Hubert] Marshall and Sten Konow, "Excavations at Sarnath, 1908," in *ASIAR, 1907–8* (Calcutta: Superintendent of Government Printing, India, 1911), 69.

19. Marshall and Konow, *ASIAR, 1907–8,* 69.

20. Oertel, *ASIAR, 1904–5,* 89, 100 (no. 427).

21. Sahni, *Catalogue,* 201.

22. Paraphrase of Xuanzang's account, as translated by Li, *The Great Tang Dynasty Record,* 181–82. For a fuller description of accounts of the Ramagrama stupa, see J. F. [John Faithful] Fleet, "The Tradition about the Corporeal Relics of Buddha," *Journal of the Royal Asiatic Society of Great Britain and Ireland* (April 1907): 341–63.

23. A. L. Basham, ed., *Papers on the Date of Kanishka* (Leiden: E. J. Brill, 1968).

24. Raymond Lam, "Kuṣāṇa Emperors and Indian Buddhism: Political, Economic and Cultural Factors Responsible for the Spread of Buddhism through Eurasia, South Asia," in *Journal of South Asian Studies* 36, no. 3 (2013): 439–40 and note 39.

25. Oertel, *ASIAR, 1904–5,* 78.

26. Despite the common reference to this stone as Sikri sandstone, it certainly does not come from Fatehpur Sikri. Interestingly, Oertel is about the only scholar I know of who has correctly identified the provenance of this stone. Oertel, *ASIAR, 1904–5,* 78–79.

27. Bloch, "Two Inscriptions," 180–81.

28. Bloch, "Two Inscriptions," 180–81. For an excellent discussion of the early donors of these images, see Gregory Schopen, "On Monks, Nuns, and 'Vulgar' Practices: The Introduction of the Image Cult into Early Buddhism," *Artibus Asiae* 49, no. 1/2 (1988–89): 153–68.

29. That is part of a colonialist/nationalist debate. See Alfred Foucher, "The Greek Origin of the Image of Buddha," in Foucher, *The Beginning of Buddhist Art and Other Essays,* trans. L. A. Thomas and F. W. Thomas (London: Humphrey Milford, 1918), 111–38; and Ananda K. Coomaraswamy, "The Origin of the Buddha Image," *Art Bulletin* 9 (1926–27): 287–329.

30. Ju-Hyung Rhi, "From Bodhisattva to Buddha: The Beginning of Iconic Representation in Buddhist Art," *Artibus Asiae* 54, no. 3/4 (1994): 207–25.

31. Sahni, *Catalogue,* 37–38.

32. Williams, *The Art of Gupta India*, 34.

33. H. [Harold] Hargreaves, "Excavations at Sarnath," *ASIAR, 1914–15* (Calcutta: Superintendent of Government Printing, India, 1920), 97–131. For an analysis of these sculptures, see Rosenfield, "On the Dated Carvings of Sarnath," 10–26.

34. John C. Huntington, "Understanding the 5th Century Buddhas of Sarnath: A Newly Identified Mudra and a New Comprehension of the Dharmachakra Mudra," *Orientations* 40, no. 2 (2009): 86–87. Huntington eloquently describes these images and discusses the significance of the abhaya mudra.

35. Robert DeCaroli, *Image Problems: The Origin and Development of the Buddha's Image in Early South Asia* (Seattle: University of Washington Press, 2015), 184–88. For other explanations of the downcast eyes, see Robert L. Brown, "The Feminization of the Sārnāth Gupta-Period Buddha Images," *Bulletin of the Asia Institute,* n.s., 16 (2002): 166.

36. Brown, "The Feminization of the Sārnāth Gupta-Period Buddha Images," 165–79.

37. Rosenfield, "On the Dated Carvings of Sarnath," 12, discusses the term, noting that it is also used in an earlier inscription referring to the Kushana emperor Kanishka. My sense is that the term is intended to hint at the Buddha's divinity, though he was never imagined exactly as a *deva,* a divinity.

38. Rosenfield, "On the Dated Carvings of Sarnath," 10–11, presents the inscriptions and their translation.

39. Rosenfield, "On the Dated Carvings of Sarnath," 23: "One striking feature of this huge corpus of Sarnath carvings is the fact that those works which directly anticipate the classical style are few in number when compared with those which manifest it and those which were carved later." For all quotations in this paragraph, see Rosenfield, "On the Dated Carvings of Sarnath," 23–24.

40. J. H. [John Hubert] Marshall and Steonow, "Sārnāth," in *ASIAR*, 1906–7 (Calcutta: Superintendent of Government Printing, India, 1909), 2, pl. 28.

41. Williams, *The Art of Gupta India,* 76, pl. 85.

42. Stephen Markel, "Reattribution of an Important Early India Buddha Image in the Los Angeles County Museum of Art," in *Temple Architecture and Imagery in South and Southeast Asia,* ed. Parul Pandy Dhar and Gerd J. R. Mevissen (New Delhi: Aryan Books International, 2016), 261–72.

43. Sahni, *Catalogue,* 69–75.

44. Oertel describes the figure in some detail but does not there note its findspot. Oertel, *ASIAR, 1904–5,* 83. In his list of sculptures excavated (page 92, number 23), he records the findspot as "south of the Jagat Singh pillar." Sahni then takes that as "south of the Jagat Singh Stupa"; in other words, the stupa today called the Dharmarajika stupa. Sahni, *Catalogue,* 71.

45. Many take the busts within roundels on the railings at Bharhut and Bodhgaya, probably dating to the second and first centuries BCE, as depictions of donors, but I see compelling reason to question that identification. For a discussion of figure 3.26's iconography, see Huntington, "Understanding the 5th Century Buddhas of Sarnath, 84–93."

46. Janice Leoshko, "About Looking at Buddha Images in Eastern India," *Archives of Asian Art* 52 (2000–2001): 63–82.

47. Sahni, *Catalogue,* 68–70. I refer to it as "the old catalog" because some images then recorded as being in the Archaeological Museum Sarnath have been transferred to the National Museum of India, New Delhi.

48. Vogel's opinion, quoted by Sahni, *Catalogue,* 64–66.

49. Leoshko, "About Looking at Buddha Images," 72, 74.

50. Frederick M. Asher, *The Art of Eastern India, 300–800* (Minneapolis: University of Minnesota Press, 1980), 26, 47–48.

51. Leoshko, "About Looking at Buddha Images," 66.

52. Sahni, *Catalogue,* 72.

53. The Buddha states, "There are these four places, Ananda, that the believing clansman should visit with feelings of reverence." Then he lists them. *Mahaparinibbana* Sutta 5.8. See *Dialogues of the Buddha,* trans. T. W. [Thomas William] Rhys Davids and Caroline A. F. Rhys Davids (London: H. Frowde, 1910), 153–54. At the same time, note that Toni Huber very effectively argues that the cluster of four or eight places was not fixed and immutable. Toni Huber, *The Holy Land Reborn: Pilgrimage and the Tibetan Reinvention of Buddhist India* (Chicago: University of Chicago Press, 2008), 15–36.

54. Joanna G. Williams, "Sārnāth Gupta Steles of the Buddha's Life," *Ars Orientalis* 10 (1975): 171–92.

55. Williams, "Sārnāth Gupta Steles," 186.

56. An outstanding discussion of these scenes in the sculpture of eastern India is Janice Leoshko, "Scenes of the Buddha's Life in Pāla-Period Art," *Silk Road Art and Archaeology* 3 (1993–94): 251–76.

57. One of the reliefs, numbered C (a) 6 in the Sahni *Catalogue,* was excavated in three fragments in Monastery I.

58. Patricia Eichenbaum Karetzky, "The Act of Pilgrimage and Guptan Steles with Scenes from the Life of the Buddha," *Oriental Art,* n.s., 33, no. 3 (1987): 268–74, notes a change from pilgrimage itself as the primary means of worship of the events of the Buddha's life to the creation of reliefs illustrating those places of pilgrimage, adding that by the Gupta period these reliefs were "liberated from their ancient function of architectural décor to become independent icons and cosmic diagrams."

59. Marshall and Konow, *ASIAR, 1906–7,* 94.

60. Among many such images is one from the Paitiva Monastery at Begram, now in the Musée Guimet, Paris.

61. For an excellent and much more thorough discussion of representations of the Shravasti miracles, see Robert L. Brown, "The Śrāvastī Miracles in the Art of India and Dvāravatī," *Archives of Asian Art* 37 (1984): 79–95.

62. Williams, *The Art of Gupta India,* 79: "Although some four hundred Buddha images of this period [the Gupta period] are preserved in the Sārnāth Museum alone, only eight Bodhisattva images from Gupta Sārnāth are known throughout the world."

63. Oertel, *ASIAR, 1904–5,* 82; and Sahni, *Catalogue,* 119.

64. As discussed below, it is not entirely certain that specific Jina Buddhas were associated with specific bodhisattvas at this time, so the identification of the figure as Maitreya must be understood as tentative.

65. Sahni, *Catalogue,* 119.

66. Oertel, *ASIAR, 1904–5,* 82–83; and Sahni, *Catalogue,* 119–20.

67. Rosenfield, "On the Dated Carvings of Sarnath," 23.

68. Benoytosh Bhattacharyya, *The Indian Buddhist Iconography* (Calcutta: K. L. Mukhopadhyay, 1958), 32, provides a date of circa 300. The range of dates for this text is suggested by Francesca Freemantle, *A Critical Study of the Guhyasamāja Tantra* (PhD diss., University of London, 1971), 14.

69. John Anderson, *Catalogue and Hand-Book of the Archaeological Collections in the Indian Museum Part II* (Calcutta: Printed by the Order of the Trustees 1883), S17 on pp. 112–13.

70. Sahni, *Catalogue,* B(f)1, p. 140, a view also held by Rosenfield, "On the Dated Carvings of Sarnath," 23. The Archaeological Museum Sarnath, where the image is now housed, dates it too late, to the eleventh century.

71. Williams, *The Art of Gupta India,* 149, dates this sculpture to circa 525, probably somewhat too early.

72. Sahni, *Catalogue,* 67–68, observes that "it is the only pre-Moslem inscription known in which the letters are raised."

73. Sahni, *Catalogue,* 67.

74. This is probably the image transferred to the Archaeological Museum Sarnath from Queen's College and recorded in Sahni, *Catalogue,* 70, as sculpture B(b)180.

75. Oertel, *ASIAR, 1904–5,* 81–82.

76. Sahni, *Catalogue,* 121.

77. *Shiva as the Lord of Dance,* ca. 950–1000, Los Angeles, Los Angeles County Museum of Art, https://unframed .lacma.org/2015/03/02/collection-shiva -lord-dance.

78. *Uma-Maheshvara,* ca. 750–800, Los Angeles, Los Angeles County Museum of Art, https://collections.lacma.org /node/238483.

79. Marshall and Konow, *ASIAR, 1907–8,* 67, pl. XIXa. It is mistakenly called a *bodhisattva* by the excavators.

80. Sahni, *Catalogue,* 91–92.

81. M. A. [Madhusudan Amilal] Dhaky, *Encyclopaedia of Indian Temple Architecture,* vol. 2, part 3 (New Delhi: American Institute of Indian Studies, 1998), pl. 162.

82. Dhaky, *Encyclopaedia,* pl. 246.

83. That date assigned on the museum label is especially odd since Sahni, *Catalogue,* 319, dates it to the Gupta period.

84. Sahni, *Catalogue,* 165, identifies the Shiva as spearing Tripura.

85. Two of these figures are in the Archaeological Museum Sarnath, accession numbers 6686 and 6638; both have museum labels indicating a twelfth-century date. The seated Buddha image, with the hand in bhumisparsha mudra, is in the National Museum of India, accession number 49.121, and is labeled as dating to the ninth century.

86. The inscription was first published by Jonathan Duncan, "An Account of the Discovery of Two Urns in the Vicinity of Benares," *Asiatic Researches* 5 (1799): 133; and then properly by E. Hultzsch, "The Sarnath Inscription of Mahipala," *Indian Antiquary* 14 (1885): 139–40.

87. There is much discussion about the extent to which this inscription indicates Pala hegemony over this part of India. Suffice it to say that kings (and queens) did not always restrict their largess to the territory over which they ruled. Patronage beyond the fuzzy borders of ancient kingdoms may be seen as an assertion of authority.

88. Marshall and Konow, *ASIAR, 1907–8,* 76. For a discussion of the inscription, including a translation, see Sten Konow, "Sarnath Inscription of Kumaradevi," *Epigraphia Indica* 9 (1907–8): 319–28.

89. Anderson, *Catalogue and Hand-Book,* 16–17.

90. Leoshko, "About Looking at Buddha Images," 77.

91. Gregory Schopen, "Burial 'Ad Sanctos' and the Physical Presence of the Buddha in Early Indian Buddhism: A Study in the Archaeology of Religions," *Religion* 17, no. 3 (July 1987): 193–225.

92. Schopen, "Burial 'Ad Sanctos,'" 120.

93. Shobhana Gokhale, "The Memorial Stūpa Gallery at Kanheri," in *Indian Epigraphy: Its Bearing on the History of Art,* ed. Frederick M. Asher and G. S. Gai (New Delhi: Oxford & IBH, 1985), 55–59.

94. Anderson, *Catalogue and Hand-Book,* 18. That image, S30, is described in the catalog as 3'3.5." The image in the Bangkok Museum is 119 cm high (measurement thanks to Piriya Krairiskh at the museum), a disparity, however, of about 19 cm.

95. Damrong Rajanubhab, *Nithan Borankadee (Tale of Archaeology),* trans. Padungkiat Tangkamolsuk (Phra Nakhon: Krom Sinlapakon, 1968), 127.

96. National Archive of India, Proceedings of the Home Department, May 1910, Memo from J. H. Marshall, Director General of India, to Secretary, Government of India, Home Department, "Disposal of Buddha Relics Discovered in 1909," Proceeding no. 33.

97. "Disposal of Buddha Relics Discovered in 1909," Proceeding no. 33.

98. "Disposal of Buddha Relics Discovered in 1909," Proceeding no. 33.

99. Damrong Rajanubhab, *A History of Buddhist Monuments in Siam,* trans. S. Sivaraksa (Bangkok: Siam Society, 1962), 35.

100. The Asia Society Museum website, http://museum.asiasociety.org/collection /explore/1979-005-buddha/ gives the provenance as "reportedly from Bodhgaya, perhaps from Nalanda," surely a mistake.

101. For the full text of the Ancient Monuments Preservation Act of 1904, see https://indiaculture.nic.in/sites/default /files/Legislations/5.pdf.

102. Ananda K. Coomaraswamy, "An Approach to Indian Art," *Parnassus* 7, no. 7 (1935): 19.

103. In its presentation of the torso discussed above (see fig. 3.64), the Cleveland Museum of Art website observes that "the Gupta period is known as the renaissance or golden age of Indian art. These terms signify the highest level of accomplishment in the plastic arts, both in physical perfection and in spiritual content." See "India, Sarnath, Gupta Period Standing Buddha, 5th Century," David Rumsey Map Collection, Cartography Associates, http://www .davidrumsey.com/amica/amico1260107 -34483.html#record. What constitutes high accomplishment and physical perfection must be taken as arbitrary criteria without widely accepted definitions.

104. Karl J. Khandalavala, ed., *The Golden Age: Gupta Art—Empire, Province and Influence* (Bombay: Marg, 1991).

CHAPTER 4

Reviving Mrigadava

Among all the sites associated with the life of the Buddha, only Bodhgaya received pilgrims continuously from ancient times to the present day. The other sites, including Sarnath, have yielded no record of either new patronage or Buddhist pilgrims from the late twelfth century to modern times, essentially the nineteenth century, when it became a place of greater interest to archaeologists than to Buddhists. That is, of course, because it was not recognized as the site of the Buddha's first sermon and the founding of the Buddhist order until then.

The identification of Sarnath with ancient Mrigadava or Rishipatana opened the path to an emphasis on the sangha, the Buddhist order. Yet by contrast to Bodhgaya, which today houses some sixty or more modern monasteries, there are only a handful at Sarnath. One might expect that at the very place the Buddhist monastic order was established, there would be a great many modern monasteries. But as Abhishek Amar has explained, monks from around the world, but predominantly from countries with substantial Buddhist populations, come to Bodhgaya in order to replicate the experience of the Buddha himself, to move toward their own personal enlightenment. Sarnath does not have such a draw.[1]

Sarnath did nonetheless attract Buddhists from Burma all the way east to Japan who, in the course of the twentieth century, established national monasteries on the periphery of the excavated site and developed educational institutions there on the assumption that a vihara was tantamount to a university. It also brought the Buddha himself back to Sarnath, though in the form of remains — relics — rather than a living teacher.

A BUDDHIST UNIVERSITY FOR SARNATH

Unofficial plans called for a Buddhist university at Sarnath. The place had, after all, been a center for learning, as an ancient monastic community was imagined to have been, and so with the revival of Sarnath through archaeology, revealing a past, and the creation of a museum, further to present a past, a university was needed, especially one that might balance the Hindu university located in Varanasi since 1916. The idea of a Buddhist university had

FIGURE 4.1
Entrance to Sarnath Railway Station, Sarnath.

been around for some time, promoted heavily by the Maha Bodhi Society in Calcutta. But how to fund such an enterprise, one that would not have central government support in the way that Banaras Hindu University did?

In 1924, D.R. Bhandarkar proposed a solution. In a lecture delivered at Sarnath itself[2]—one essentially directed to the Gaekwad of Baroda, who was in the audience—Bhandarkar noted that the institution would cost "no less than four lacs of rupees [400,000 rupees].... The only question that remains unsolved is the question of funds." He then exclaimed:

> Would that Aśoka would incarnate himself and pour out benefactions to help this cause.... Perhaps Aśoka has already incarnated himself. Is there any ruler round about us who may be rightly regarded as the modern replica of Aśoka?...I am sure you will all agree with me in saying that we have this incarnation of Aśoka not only in this age and in this country but now and here actually before us in the person of the distinguished visitor of this morning.[3]

And yet, it seems, the Gaekwad did resist this extraordinary flattery. Despite the selection of an architect for the institution, Manmohan Ganguly, who had designed the Sri-Dharmarajika Chaitya Vihara at the Maha Bodhi Society in Calcutta and even had, said Bhandarkar, prepared plans and elevations for the university, the institution was never commenced. The idea, however, or at least an idea close to the conception of Bhandarkar and the Maha Bodhi Society, found form in the Central University for Tibetan Studies.

CENTRAL UNIVERSITY FOR TIBETAN STUDIES

The Central University for Tibetan Studies, initially called the Central Institute of Higher Tibetan Studies, was established in 1967 in order to provide higher education primarily for the Tibetan exile community in India. In 1988, it became what is called a "deemed university"—that is, a university officially recognized by the government of India and permitted to award degrees, as it does in the study of Tibet, in Tibetan Buddhism, Tibetan medicine, astrology, and fine arts.[4] Located about two kilometers south of Sarnath's excavated area, the university architecture combines Tibetan forms with styles most familiar to the Indian Public Works Department.

SANCHI AT SARNATH

Sarnath has two emblematic monuments widely used in signage at the site and elsewhere nearby. One is the Dhamekh stupa. As Alexander Cunningham notes, "With the single exception of the Taj Mahal at Agra, there is, perhaps, no Indian building that has been so often described as the [Dhamekh stupa]."[5] The other, of course, is the lion capital. As if, however, those two are not enough, at least three buildings at Sarnath incorporate the Great Stupa at Sanchi into their fabric, perhaps the other most readily recognizable and frequently incorporated Buddhist monument in India. The small railway station at Sarnath, for example, is entered through a gateway with three lintels that are reminiscent of the gateways at Sanchi's Great Stupa (FIGURE 4.1), while the dome over the station building is modeled

FIGURE 4.2
Entrance to Chùa Đại Lộc, Vietnam Pink Temple, Sarnath.

on the Sanchi stupa itself. At the Vietnamese monastery, about a kilometer north of the railway station, the entranceway is clearly modeled on the Sanchi stupa's gateways (FIGURE 4.2). Four addorsed elephants support the horizontal members, as they do on the Sanchi stupa's east and north gateways, and the bracket yakshis are fully intact, even more so than on the Sanchi gateways, where only the right figure of the eastern gateway remains. Instead of guardians at the inward-facing portion of the upright, however, are figures of the Buddha with the hand extended downward in a gift-bestowing gesture (varada mudra), as may be seen on other entranceways—for example, at the entrance to

Cave 19 at Ajanta. And substituting for the scenes
on Sanchi's east gateway are reliefs illustrating other
episodes from the life of the Buddha, episodes that
are illustrated by monuments in their present form.
Among them is the Dhamekh stupa, not to suggest
the Buddha's death, as a stupa would, but rather his
first sermon. An almost identical gateway is placed
adjacent to the Japanese temple (FIGURE 4.3); so sim-
ilar is it to the one at Chùa Đại Lộc, the Vietnamese
monastery, that the two must have been carved at
the same time by the same hands. The primary dif-
ference is the decor of the gateways' uprights.

ANAGARIKA DHARMAPALA COMES TO SARNATH

The story of the Maha Bodhi Society at Sarnath and
the associated temple, the Mulagandhakuti Vihara,
starts with the Sri Lankan monk who took the name
Anagarika Dharmapala (1864–1933). His commit-
ment to Buddhism included the foundation of the
Maha Bodhi Society, initially with headquarters in
Sri Lanka but after just a year, in 1892, moved to
Calcutta, at least in part to lobby the British Indian
government to support transfer of authority over
the Maha Bodhi temple at Bodhgaya, site of the
Buddha's enlightenment, from Hindu authority,
specifically the Shaiva Mahant of Bodhgaya, to Bud-
dhist control. Still today, the Maha Bodhi temple
remains a contested site, as does Sarnath.

Dharmapala's first visit to Sarnath came on 20
January 1890, and the discourse of his description
of the site follows closely his description of Bodh-
gaya, a site in ruins despite its sanctity to Buddhists.
His diary entry for that day reads, "What a pity that

FIGURE 4.3
Gateway adjacent to the Japanese temple, Sarnath.

no Buddhists are occupying the place to preserve them [the stupa and carvings] from the hand of vandals."[6] He notes in an 14 October 1900 letter to the collector of Benares that the site is "in a state of absolute neglect," that "where once the devotees walked within the sacred enclosure now the village pigs roam."[7] His solution: give the land within the enclosure to the Maha Bodhi Society, so, among other things, they could undertake the restoration of the Dhamekh stupa. In this letter, he claimed to be speaking on behalf of 475 million Buddhists. Apparently, the collector did not respond affirmatively to Dharmapala's request because the following year, 1901, Dharmapala, with funds provided by his mother, purchased a plot of land and, with donations from other sources, constructed a small building on the plot. There, apparently in that building, which had been conceived as a Buddhist monastery, Dharmapala started the School of Arts and Agriculture, described as a "nonsectarian institution."[8]

The Maha Bodhi Society implies that Dharmapala's commitment to the site served as the inspiration for F. O. Oertel's 1904–5 excavations at Sarnath.[9] The excavations required taking a portion of the land Dharmapala had purchased and giving, in compensation, another plot. In 1916, the government of India wrote to the Maha Bodhi Society that it would give some relics of the Buddha to the Society if the Society would construct a vihara to house them.[10]

Recognizing the politics of a battle not easily won, Dharmapala moved his attention to Sarnath, spending the last years of his life there, 1931 to 1933. As early as 1904, Dharmapala had constructed a rest house at Sarnath, as he did at Bodhgaya that year, and had sought to construct a vihara, in this case probably meaning a "temple" rather than a "monastery," close to the Dhamekh stupa. Permission to do so was denied by the Archaeological Survey of India (ASI), but a subsequent gift of land just outside the excavated area from the government of India, along with the government's initial cash grant, offered the possibility of constructing a temple. That grant was supplemented by a substantial gift from Mary Foster, an American who was one of Dharmapala's strongest—and wealthiest—supporters. The result was the Mulagandhakuti Vihara (FIGURES 4.4, 4.5), opened 11 November 1931.[11] On that day—very precisely at 2:15 in the afternoon, the Maha Bodhi Society reports—the bone relics of the Buddha that had been discovered at Taxila were presented to the Maha Bodhi Society by the director-general of archaeology, Daya Ram Sahni, with the future prime minister, Jawaharlal Nehru, in attendance.[12] A year later, in 1932, relics from the southern Indian site of Nagarjunakonda were presented to the Mulagandhakuti Vihara; three years after that, on 12 November 1935, relics from Mirpur Khas were presented. That final gift of relics came two years after Dharmapala died at Sarnath, on 29 April 1933. The site of his cremation (FIGURE 4.6) stands on an elevated mound (probably once the site of a stupa) within the small zoo situated between the excavated site and the Mulagandhakuti.

With a personal gift of ten thousand rupees from B. L. Broughton, the vice president of Britain's Maha Bodhi Society, the Japanese artist Kōsetsu

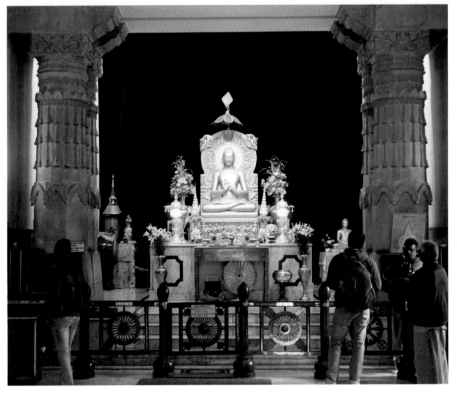

FIGURE 4.4
Mulagandhakuti Vihara, Sarnath.

FIGURE 4.5
Interior of Mulagandhakuti Vihara, Sarnath.

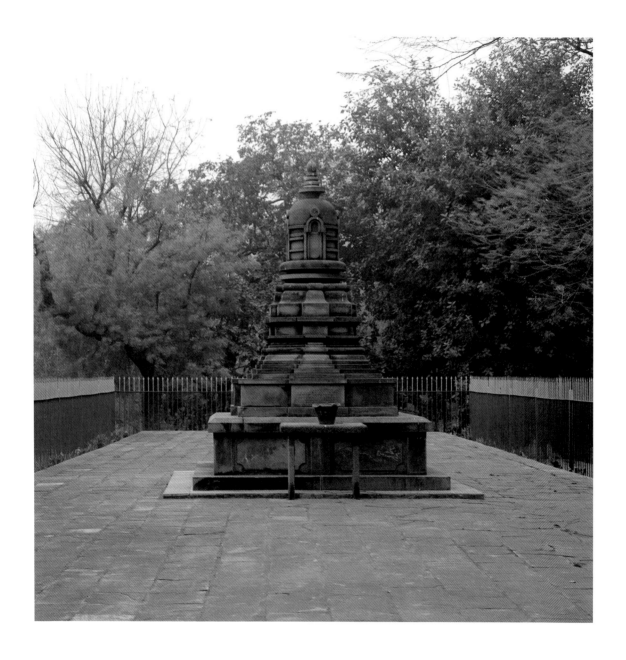

FIGURE 4.6
Samadhi (cremation site) of Dharmapala, Sarnath.

Nosu (1885–1973) was commissioned to decorate the interior of the Mulagandhakuti Vihara with murals depicting the life of the Buddha, a project he executed from 1932 to 1936 (FIGURE 4.7).[13] Although there was some initial Indian criticism of the selection of a Japanese artist for the project, some preferring instead an artist from one of India's art schools, the opposition apparently diminished as the project developed, in part because the famed Indian poet, artist, and composer Rabindranath Tagore supported the selection of Nosu. By 1930, Tagore had had a long association with Japanese artists, starting near the beginning of the twentieth century with Okakura Kakuzō. As part of advocating a pan-Asian visual culture, Japanese artists spent time in India during the first two decades of the twentieth

FIGURE 4.7
The Buddha Overcoming Mara, by Kōsetsu Nosu, mural inside Mulagandhakuti Vihara, Sarnath.

century, while Indian artists—particularly Nandanlal Bose and Benodebihari Mukherji—spent time in Japan. Bose returned to Tagore's Vishva Bharati University, Shantiniketan, to become head of Kala Bhavan, the arts program. His work there is infused with Japanese forms.

While Bose and a few other Bengali artists had been taken with Japanese form, Nosu's copies of the Ajanta paintings clearly served as the inspiration for his visual recounting of the Buddha's life in the murals adorning the walls of the Mulagandhakuti. They are rendered more or less in biographical order, starting above the temple's entrance with the bodhisattva in the Tushita Heaven, indicating that he is ready to descend to the earth, and concluding on the wall to the right of the entrance with his death and attainment of nirvana. But then, immediately following the parinirvana scene, and out of biographical order, is the illustration of the Buddha's conversion of the killer Angulimala, a reference to the possibility of redemption that the faith offers and the Maha Bodhi Society's effort to revive sites associated with the life of the Buddha.[14]

The design of the Mulagandhakuti is curiously never discussed in literature, which instead focuses on the role of Dharmapala in establishing it and on the relics that it now houses. Overlooked is the obvious appearance it shares with the Maha Bodhi temple at Bodhgaya, the temple marking the site of the Buddha's enlightenment. The corner towers above the porchway roof and the towering square-section superstructure crowning the temple all contribute to the resemblance, as if the

intention was to bring Bodhgaya, Dharmapala's first but less successful endeavor, to Sarnath. And with the relics enshrined in the Mulagandhakuti, the site of the Buddha's demise, Kushinagar, is metaphorically brought to Sarnath. Among the four principal pilgrimage places, the site of the Buddha's birth, Lumbini, is the most distant from Sarnath, although even Lumbini is there too, represented by the scene of the Buddha's birth depicted in the murals within the temple.

Beside the temple, an adjacent park was cared for by the Maha Bodhi Society for some time; it belonged to the ASI. As Daya Ram Sahni, the director-general of archaeology, wrote in a memo dated 30 January 1934, the maintenance of the park is "a costly affair and the Archaeological Department has no funds for this purpose." After some two years of exchanging memos and draft agreements, a letter from the director-general dated 1 May 1935 set out an agreement for the transfer of the park to the Maha Bodhi Society.[15] Among the provisions, it required the Society to spend no less than thirty rupees per month (about ten dollars at that time) on maintenance of the park, and it prohibited alterations to the plantings and the removal of valuable fruit-bearing trees. The Society was permitted to use income from the sale of grass and fruit from the park's trees for maintenance of the park. The number of administrators involved in this decision and the significant number of memos and letters exchanged before the final agreement was drafted give some indication of the bureaucracy involved in matters that might seem routine, even trivial.

THE MONASTERIES

Nine years after Bhandarkar's call for the establishment of a university at Sarnath, an effort that seems to have gone nowhere, the Maha Bodhi Society proposed that each Buddhist country provide seven thousand rupees to build a cottage at Sarnath and send two monks who would study Pali, Sanskrit, and other languages, presumably ones related to Buddhism, forming the nucleus of an international Buddhist institute.[16] This 1933 call specified Burma, Ceylon, China, Japan, Nepal, Siam, and Tibet as the Buddhist countries and may have been the stimulus for the national monasteries located in close proximity to Sarnath's excavated site. Well before 1933, in 1910, the Burmese had built a rest house

at Sarnath, though later than the one they established at Bodhgaya in the late nineteenth century in order to accommodate the Burmese who worked on restoration of the Maha Bodhi temple. It is not surprising that the Burmese were the first to have a continuing presence at both these sites. Burma was part of British India from 1886 to 1937, giving Buddhists there much easier and more direct access than Buddhists in other countries had. That initial Burmese presence significantly increased after the Maha Bodhi Society's call for the construction of cottages by Buddhist countries, for in 1934, the Burmese began a much more substantial monastery and library, the basis of a compound immediately north of the excavated site that has continued to

FIGURE 4.8
Entrance to Burmese monastery, Sarnath.

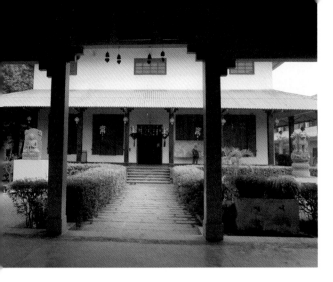

expand—for example, with a monks' residence in 1937 and frequent remodeling of the existing structures (FIGURE 4.8).

Other monasteries followed, but not immediately. Next to be constructed and also close to the excavated site was the Chinese Buddhist temple (FIGURE 4.9), commenced in 1939 and funded by Li Lizhai (Lee Choon Seng, as signage at the temple spells it), a wealthy Chinese businessman

who was committed to the development of Buddhism not only with his provision of this temple but also with the provision of several Buddhist institutions in Singapore, where he settled. The temple courtyard features replicas of the lion capital and the fifth-century seated Buddha as well as a map detailing Xuanzang's travels to India in the seventh century, as if to link this temple with an ancient Chinese presence at Sarnath. It is all the more linked to antiquity because this temple was imagined as a rebuilding of an ancient Chinese temple at Sarnath that is nowhere documented.[17]

Just four years after the Chinese annexation of Tibet in 1950, the Tibetan monastery was begun (FIGURE 4.10).[18] Besides housing Tibetan monks

FIGURE 4.9
Chinese Buddhist monastery, Sarnath.

FIGURE 4.10
Tibetan monastery, Sarnath.

and serving as a link to the Central Institute of Higher Tibetan Studies, it stands in notable contrast to the Chinese temple. A stupa in the monastery erected in 1987 (FIGURE 4.11) commemorates the "courageous men, women and children [who] have [laid] down their lives to defend their freedom and their country."

This was followed by the Thai monastery (Wat Thai Sarnath), begun in 1971. Situated a very short distance from the excavated area on the road leading to the Chaukhandi stupa, the monastery's main attraction for visitors is the Thai-style temple (FIGURE 4.12) completed in 1981 and especially the enormous standing Buddha image (FIGURE 4.13),

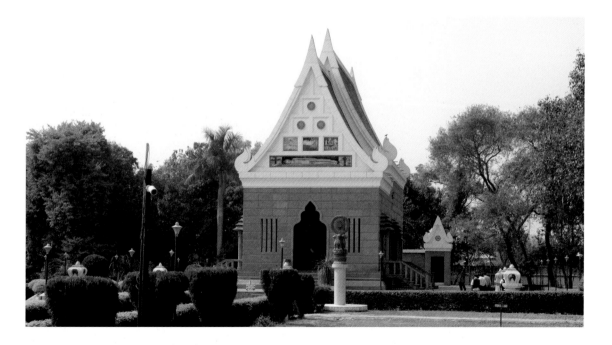

FIGURE 4.11
Stupa in Tibetan monastery, Sarnath.

FIGURE 4.12
Wat Thai, Sarnath.

FIGURE 4.13
Enormous Buddha in Wat Thai, Sarnath.

FIGURE 4.14
Nichigat Suzan Horinji temple, Sarnath.

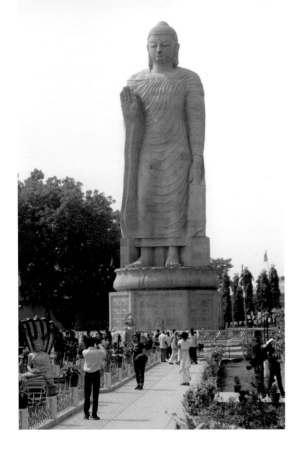

some 26.2 meters high, carved between 1995 and 2005 by an artist of Chunar named Jiut Kushwaha, who based the image on a model created by an artist of Varanasi, Mohan Raut. The erection of the statue, for some reason, took another six years, 2005 to 2011, and was finally dedicated on 16 March 2011. As usual in Indian dedicatory inscriptions, even in antiquity, the patron, Shasan Rashmi Mahastaveer of Wat Thai Sarnath, gets top billing and is identified before the sculptors involved in the project.

The Nichigat Suzan Horinji temple (FIGURE 4.14), commonly called the Japanese temple, was commenced in 1986. It closely follows the form of

temples in Nara, such as the Todaiji, though on a much smaller scale. Enshrined within the temple, in front of the altar, is a large parinirvana Buddha image but no figures of the Buddha in the teaching gesture, as one might expect at Sarnath. Next to the temple is the park, entered via the replica of a Sanchi gateway, that houses the Vishwa Shanti stupa (FIG-URE 4.15) inaugurated in 2010, joining some eighty other peace stupas worldwide. They are the conception of Nichidatsu Fujii, a Buddhist monk who was deeply inspired by Mahatma Gandhi.

About a kilometer north of the excavated area is the Nok Yawon Korean temple, whose foundation stone was put in place on 21 February 1995 by the district magistrate of Varanasi and dedicated almost a year later, on 1 February 1996. The interior of the temple features a sort of diorama of the Buddha preaching to the five ascetics who had been his companions. These are represented sculpturally. The deer grazing peacefully in the background (a sort that never appears in the Varanasi area), shown against autumn-colored trees, are represented in mural.

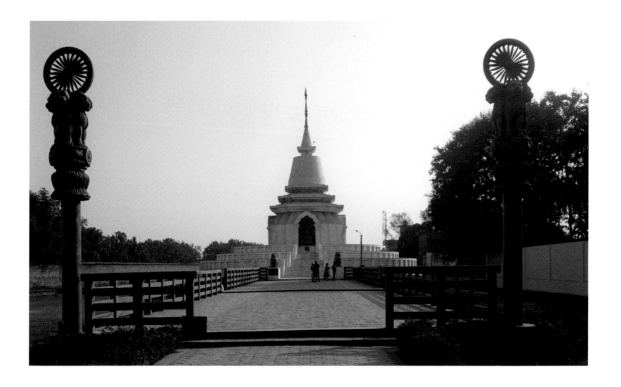

FIGURE 4.15
Vishwa Shanti stupa, Sarnath.

Finally, among the monasteries is the so-called Pink Temple, the Vietnamese monastery and temple commenced in 2009, situated, like the nearby Korean temple, about a kilometer from the excavated site. Formally called Chùa Đại Lộc Vietnam Pink Temple—or, in Hindi, the Gulabi Mandir (literally, "rose[-colored] temple")—the structure is entered through a replica of one of the Sanchi gateways. Beyond the gateway is an enormous image of the seated Buddha (FIGURE 4.16), approximately 21 meters high, his hands in dharmachakra mudra, the teaching gesture appropriate to Sarnath. Visible from a considerable distance, this figure appears to rival the Thai standing Buddha. Also within the temple and monastery compound is a statue depicting Ashoka (see FIGURE 8), which, like the Sanchi gateway, clearly links this monastery with India's antiquity. Most remarkably, this figure, representing the person so widely accepted as a propagator of Buddhism and identifier of sites associated with the life of the Buddha, is holding a mace that is given the form of the pillar he erected at Sarnath, even showing as its summit the four addorsed lions that were originally at the summit of the Sarnath pillar.

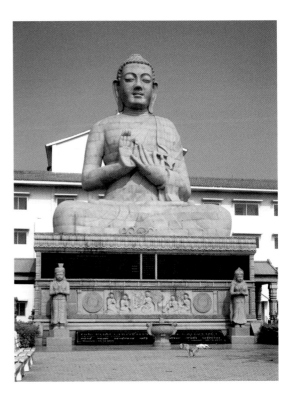

THE ASHOKAN PILLAR REVIVED

The first monument discussed in this book is the pillar erected by Ashoka and its capital with four addorsed lions standing on a tall abacus carved with four animals, each separated from the other by a wheel. It thus seems a good bookend to look at the continuing life of that monument. The Constitution of the Republic of India is not only the world's

FIGURE 4.16
Enormous seated Buddha, Chùa Đại Lộc, Vietnam Pink Temple, Sarnath.

longest constitution but also the only one in the world that is illustrated. At the urging of Jawaharlal Nehru, so committed to linking India's present and future with the past, Nandalal Bose was commissioned to create paintings that would adorn the new constitution. The first two of these twenty-two paintings (FIGURES 4.17, 4.18) show the addorsed lions that compose the Sarnath capital. That emblem, together with the legend *satyameva jayate* (truth triumphs), serves as the seal of the Republic of India, which is emblazoned on currency, passports, and just about all other government documents.[19] So, too, the Indian flag draws on Sarnath imagery with the wheel from the Sarnath abacus rendered against the flag's central white stripe. This replaced the Gandhian spinning wheel that had been the central emblem of the flag of the Indian National Congress, the new emblem being one imagined to carry no communal sense. It was understood as an emblem that was not Buddhist—even though B. R. Ambedkar, who subsequently became a Buddhist, was on the committee that selected the new flag's design—but rather one that represented righteous law (*dharma*). As Himanshu Prabha Ray notes, Nehru, in a speech delivered on the occasion of the re-enshrinement of the Buddha's relics at Sanchi in 1952, said, "The selection of the Ashoka cakra (wheel) for the National Flag and the adoption of the Ashoka Lions for the National Emblem was not merely a matter of chance. It was deliberately done because these signs denoted a sincere desire for peace and would work as a constant reminder to the people to continue to make incessant efforts in that direction."[20]

FIGURE 4.17
Cover of the Constitution of India (original calligraphed and illuminated version), 1949. Illustrated by Nandanlal Bose et al.

FIGURE 4.18
First page of the Constitution of India (original calligraphed and illuminated version), 1949. Illustrated by Nandanlal Bose et al.

WHOSE SARNATH?

An appropriate place to conclude this book would be with recognition that Sarnath is a place in flux and that like any monument or place, its life cannot be associated exclusively with a particular moment in time. The excavated site and the Archaeological Museum Sarnath are under the authority of the ASI. The ASI does not, however, control all the many unexcavated mounds that lie within two kilometers of the site and are ripe for plunder. Even the ASI's control of the excavated site is not without controversy. In 2007, a petition was launched that sought shared control of the site through a drive headed "Liberate the Sacred Buddhist Site at Sarnath." Much of the petition seeks free admission to Sarnath for Buddhist devotees, who presently pay the same admission as tourists do[21] and permission to conduct Buddhist worship within the site. Today, there is little restriction on the conduct of ritual within the excavated site. I have never failed to see groups of devotees chanting, usually in front of the Dhamekh stupa or sitting in meditation before the remains of the Ashokan column. The signs requesting worshippers not to place gold foil on the Main Shrine may seem a reasonable measure to protect an ancient monument, but they are routinely ignored, as perhaps they should be, in recognition that even an ancient structure must have a life today and that just as the Mulagandhakuti was once experienced by fragrance, so other senses, even tactile ones, might effectively be invoked by those engaged in ritual. The stone will be more damaged by rain and pollution than by gold foil. But the petitioners'

demand that control of the site be shared with the ASI and that the "Government reconsider its total dominance on the site and share administration by way of creating a Managing Committee comprising of Indian Buddhists"[22] is not very likely to happen even though stakeholders, not only at Sarnath but also at protected sites everywhere, in every country, need to feel engaged in the preservation, promotion, and protection of their heritage.

NOTES

1. Abhishek Amar, response to a question at the panel "Reconfiguring a Buddhist Homeland" (Association for Asian Studies Annual Meeting, Toronto, ON, 18 March 2017).

2. D. R. [Devadatta Ramakrishna] Bhandarkar, "Sarnath—A Site for a Buddhist Vihara and University," in *Maha Bodhi* 32, no. 1 (January 1924): 239–47.

3. Bhandarkar, "Sarnath," 247.

4. The history of the institution is presented in the *Memorandum of Association, Rules and Bye-laws* [sic] *of the Institute* (Sarnath: Central Institute of Higher Tibetan Studies, 1988).

5. Alexander Cunningham, *Four Reports Made during the Years 1862-63-64-65 (Archaeological Survey of India Report)* (Simla: The Government Central Press, 1871), 1:110.

6. Quoted by Sangharakshita [Dennis Philip Edward Lingwood], *Anagarika Dharmapala: A Biographical Sketch and Other* Maha Bodhi *Writings* (Cambridge: Windhorse, 2014), 34.

7. Quoted by Dodangoda Rewata, "Sarnath and the Maha Bodhi Centre," in *The Maha Bodhi Centenary Volume, 1891–1991* (Calcutta: Maha Bodhi Society, 1991), 133–34.

8. Nalinaksha Dutt, "The Maha Bodhi Society, Its History and Influence," in *Maha Bodhi Society of India Diamond Jubilee Souvenir* (Calcutta: Maha Bodhi Society, 1952), 81.

9. Rewata, "Sarnath and the Maha Bodhi Centre," 135.

10. Rewata reports that the government of India through the government of Bengal informed the Maha Bodhi Society that the government of India was prepared to present a relic of the Shakyamuni Buddha to the Society, if the Society would erect a suitable building for a temple at Sarnath. Rewata, "Sarnath and the Maha Bodhi Centre," 135. This is essentially confirmed by a letter from the director-general of archaeology dated 4 April 1931, in which he urges that relics unearthed at Taxila in 1912–13 be given "for enshrinement in the Sarnath vihara … because it was decided in 1916 that the Buddha relic which had been discovered at Bhattiprolu in 1891 should be given to the Maha Bodhi Society for enshrinement at Sarnath." See National Archive of India Education Department file 22-23 of 1931 containing Letter no. 124/15-20. That Bhattiprolu relic was enshrined instead at the Maha Bodhi Society's vihara in Calcutta.

11. Himanshu Prabha Ray, *The Return of the Buddha: Ancient Symbols for a New Nation* (New Delhi: Routledge, 2014), 115–19. Ray effectively documents the opening of the Mulagandhakuti with contemporary newspaper reports.

12. Rewata, "Sarnath and the Maha Bodhi Centre," 138. Upinder Singh very effectively discusses the politics of these relics in *The Idea of Ancient India: Essays on Religion, Politics, and Archaeology* (New Delhi: Sage, 2016), 191–221.

13. Dinah Zank, "Painting the Life of Buddha at Sarnath: Transculturality, Patronage and an Artist's Vision" (conference paper presented at "Continuities and Ruptures of Modernization," Berlin, sponsored by the Freie Universität Berlin and the University of Tsukuba, 28–29 May 2016). Paper accessed at https://www.academia.edu/28100361/Painting_the_Life_of_Buddha_at_Sarnath_Transculturality_Patronage_and_an_Artists_Vision.

14. Kōsetsu Nosu, *Life of the Buddha in Frescoes* (Sarnath: Maha Bodhi Society, 1953), reproduces most of the murals—they are not frescoes—with an accompanying narrative describing the events illustrated in the paintings.

15. For the memos dated 30 January 1934 and 1 May 1935, see Director-General of Archaeology, No. 15–3842, in National Archive of India file 115/2/33/F, titled "Transfer of Park to Maha Bodhi Society."

16. Rewata, "Sarnath and the Maha Bodhi Centre," 139.

17. Zhang Xing, "Buddhist Practices and Institutions," in *Buddhism across Asia: Networks of Material, Intellectual, and Cultural Exchange,* ed. Tansen Sen (Singapore: Institute of Southeast Asian Studies, 2014), 454n21.

18. This is the date provided by the staff at the monastery. A gateway serving as the monastery's entrance bears the date 1965, but that probably records the year the gateway was constructed.

19. Himanshu Prabha Ray notes that this visual symbol and the legend from *Mundaka Upanishad* draw upon "a non-sectarian past to suit national expediencies, particularly after the Partition of India along religious lines on August 15, 1947." Ray, *The Return of the Buddha*, 209.

20. Ray, *The Return of the Buddha*, 219.

21. The Indian entrance rate is charged to visitors from Afghanistan, Bangladesh, Bhutan, Burma, Maldives, Nepal, Pakistan, Sri Lanka, and Thailand. Others pay twenty times the Indian rate.

22. Dr. Suresh Bhatia, "Liberate the Sacred Buddhist Site at Sarnath," https://www.gopetition.com/petitions/liberate-the-sacred-buddhist-site-at-sarnath.html. See also Rana B. P. Singh, "Politics and Pilgrimage in North India: Varanasi between *Communitas* and Contestation," *Tourism: An International Interdisciplinary Journal* 59, no. 3 (2011): 287–304.

Bibliography

Agrawala, V. S. [Vasudeva Saran]. *Sārnāth.* New Delhi: Director General of Archaeology, 1956.

Anderson, John. *Catalogue and Hand-Book of the Archaeological Collections in the Indian Museum, Part II.* Calcutta: Printed by the Order of the Trustees, 1883.

Basham, A. L. [Arthur Llewellyn], ed. *Papers on the Date of Kanishka.* Leiden: E. J. Brill, 1968.

Beglar [Melik-Beglaroff], J. D. [Joseph Daviditch]. "A Tour through the Bengal Provinces in 1872–73." *Archaeological Survey of India Report.* Calcutta: Superintendent of Government Printing, 1878.

Bhandarkar, D. R. [Devadatta Ramakrishna]. "Sarnath—A Site for a Buddhist Vihara and University." *Maha Bodhi* 32, no. 1 (January 1924): 239–47.

Bhattacharyya, Benoytosh. *The Indian Buddhist Iconography.* Calcutta: K. L. Mukhopadhyay, 1958.

Bloch, Theodor. "Two Inscriptions on Buddhist Images." *Epigraphia Indica* 8 (1905–6): 180–81.

Brown, Robert L. "The Feminization of the Sārnāth Gupta-Period Buddha Images." *Bulletin of the Asia Institute,* n.s., 16 (2002): 165–79.

Chandra, Pramod. *The Sculpture of India, 3000 B.C.–1300 A.D.* Washington, D.C.: National Gallery of Art, 1985.

Cohn, Bernard. *Colonialism and Its Forms of Knowledge: The British in India.* Princeton: Princeton University Press, 1996.

Coningham, R. A. E., et al. "The Earliest Buddhist Shrine: Excavating the Birthplace of the Buddha, Lumbini (Nepal)." *Antiquity* 87, no. 338 (December 2013): 1104–23.

Coomaraswamy, Ananda K. "An Approach to Indian Art." *Parnassus* 7, no. 7 (1935): 17–20.

——. "The Origin of the Buddha Image." *Art Bulletin* 9 (1926–27): 287–329.

Cunningham, Alexander. "Colonel Cunningham's Archaeological Survey Report for 1861–62." Supplement, *Journal of the Asiatic Society of Bengal* 32 (1864): i–cxix.

——. *Four Reports Made during the Years 1862-63-64-65 (Archaeological Survey of India Report).* Simla: The Government Central Press, 1871.

——. *Mahabodhi; or, the Great Buddhist Temple under the Bodhi Tree at Buddha-Gaya.* London: W. H. Allen, 1892.

Damrong Rajanubhab. *A History of Buddhist Monuments in Siam.* Translated by S. Sivaraksa. Bangkok: Siam Society, 1962.

——. *Nithan Borankadee (Tale of Archaeology).* Translated by Padungkiat Tangkamolsuk. Phra Nakhon: Krom Sinlapakon, 1968.

DeCaroli, Robert. *Image Problems: The Origin and Development of the Buddha's Image in Early South Asia.* Seattle: University of Washington Press, 2015.

Dhaky, M. A. [Madhusudan Amilal]. *Encyclopaedia of Indian Temple Architecture.* Vol. 2, part 3. New Delhi: American Institute of Indian Studies, 1998.

Dialogues of the Buddha. Translated by T. W. [Thomas William] Rhys Davids and Caroline A. F. Rhys Davids. London: H. Frowde, 1910.

Duncan, Jonathan. "An Account of the Discovery of Two Urns in the Vicinity of Benares." *Asiatic Researches* 5 (1799): 131–33.

Dutt, Nalinaksha. "The Maha Bodhi Society, Its History and Influence." *Maha Bodhi Society of India Diamond Jubilee Souvenir.* Calcutta: Maha Bodhi Society, 1952: 62–132.

Dutt, Sukumar. *Buddhist Monks and Monasteries of India.* London: George Allen & Unwin, 1962.

Falk, Harry. *Aśokan Sites and Artefacts: A Source-Book with Bibliography.* Mainz: Von Zabern, 2006.

Falser, Michael. "The Graeco-Buddhist Style of Gandhara—a 'Storia Ideologica,' or: How a Discourse Makes a Global History of Art." *Journal of Art Historiography* 13 (2015). Online publication, https://arthistoriography.files.wordpress.com/2015/11/falser.pdf.

Fleet, J. F. [John Faithful]. "The Tradition about the Corporeal Relics of Buddha." *Journal of the Royal Asiatic Society of Great Britain and Ireland* (April 1907): 341–63.

Fogelin, Lars. *An Archaeological History of Indian Buddhism.* Oxford: Oxford University Press, 2015.

Foucher, Alfred. "The Greek Origin of the Image of Buddha." *The Beginning of Buddhist Art and Other Essays.* Translated by L. A. Thomas and F. W. Thomas. London: Humphrey Milford, 1918.

——. *The Life of the Buddha, according to the Texts and Monuments of India.* Translated by Simone Brangier Boas. Middletown, CT: Wesleyan University Press, 1963.

Freemantle, Francesca. *A Critical Study of the Guhyasamāja Tantra.* PhD diss., University of London, 1971.

Geary, David, and Sraman Mukherjee. "Buddhism in Contemporary India." In *The Oxford Handbook of Contemporary Buddhism,* edited by Michael Jerryson. Oxford: Oxford University Press, 2017.

Gokhale, Shobhana. "The Memorial Stūpa Gallery at Kanheri." In *Indian Epigraphy: Its Bearing on the History of Art,* edited by Frederick M. Asher and G. S. Gai. New Delhi: Oxford & IBH, 1985.

Guha, Sudeshna, ed. *The Marshall Albums: Photography and Archaeology.* New Delhi: Mapin and Alkazi Collection of Photography, 2010.

Guha-Thakurta, Tapati. *Monuments, Objects, Histories: Institutions of Art in Colonial and Postcolonial India.* New York: Columbia University Press, 2004.

Hargreaves, H. [Harold]. "Excavations at Sārnāth." *Archaeological Survey of India, Annual Report, 1914–15.* Calcutta: Superintendent of Government Printing, India, 1920.

Härtel, Herbert. "Archaeological Research on Ancient Buddhist Sites." In *The Dating of the Historical Buddha = Die Datierung des historischen Buddha,* Part 1, edited by Heinz Bechert. Göttingen: Vandenhoeck & Ruprecht, 1991.

Huber, Toni. *The Holy Land Reborn: Pilgrimage and the Tibetan Reinvention of Buddhist India.* Chicago: University of Chicago Press, 2008.

Hultzsch, E. [Eugen Julius Theodor]. *Inscriptions of Asoka,* Corpus Inscriptionum Indicarum. Vol. 1. Oxford: Clarendon, 1925.

———. "The Sarnath Inscription of Mahipala." *Indian Antiquary* 14 (1885): 139–40.

Huntington, John C. "Sowing the Seeds of the Lotus: A Journey to the Great Pilgrimage Sites of Buddhism, Part II: The Ṛṣipatana Mṛgadāva ('Deer Park') Near Vārāṇasī." *Orientations* 17, no. 2 (1986): 28–43.

———. "Understanding the 5th Century Buddhas of Sarnath: A Newly Identified Mudra and a New Comprehension of the Dharmachakra Mudra." *Orientations* 40, no. 2 (2009): 84–93.

Jayaswal, Vidula. *The Buddhist Landscape of Varanasi.* New Delhi: Aryan Books, 2015.

———. *From Stone Quarry to Sculpturing Workshop: A Report on Archaeological Investigations around Chunar, Varanasi & Sarnath.* Delhi: Agam Kala Prakashan, 1998.

Kang, Heejung. "The Spread of Sarnath-Style Buddha Images in Southeast Asia and Shandong, China by Sea Route." *Kemanusiaan* 20, no. 2 (2013): 39–60.

Karetzky, Patricia Eichenbaum. "The Act of Pilgrimage and Guptan Steles with Scenes from the Life of the Buddha." *Oriental Art,* n.s., 33, no. 3 (1987): 268–74.

Khandalavala, Karl J., ed. *The Golden Age: Gupta Art—Empire, Province and Influence.* Bombay: Marg, 1991.

Konow, Sten. "Sarnath Inscription of Kumaradevi." *Epigraphia Indica* 9 (1907–8): 319–28.

Kumar, Ajit, and Sachin Kumar Tiwari. "A Rare Composite Sūrya Image from Sārnāth: A Note." *Kalā* 39 (2013–14): 104–6.

Kumar, Krishna. "A Circular Caitya-Gṛha at Sarnath." *Journal of the Indian Society of Oriental Art,* n.s., 11 (1980): 63–70.

———. "Date and Significance of a Stupa-Shrine at Sarnath." *Journal of the Indian Society of Oriental Art,* n.s., 15 (1985–86): 8–15.

———. "The Evidence of White-Wash, Plaster and Pigment on North Indian Sculpture, with Special Reference to Sarnath." *Artibus Asiae* 42, nos. 2/3 (1984): 199–206.

———. "On the Identification of Buddhist Monuments Noticed by Fa-Hsien at Sarnath." *Journal of Indian History* 59, nos. 1–3 (1981): 87–96.

Lahiri, Nayanjot. "Coming to Grips with the Indian Past: John Marshall's Early Years as Lord Curzon's Director-General of Archaeology in India—Part I." *South Asian Studies* 14, no. 1 (1998): 1–23.

———. "John Marshall's Appointment as Director-General of the Archaeological Survey of India: A Survey of the Papers Pertaining to His Selection." *South Asian Studies* 13, no. 1 (1997): 127–39.

Lalitavistara. Translated by Bijoya Goswami. Kolkata: Asiatic Society, 2001.

Lam, Raymond. "Kuṣāṇa Emperors and Indian Buddhism: Political, Economic and Cultural Factors Responsible for the Spread of Buddhism through Eurasia, South Asia." *Journal of South Asian Studies* 36, no. 3 (2013): 434–48.

Legge, James. *A Record of Buddhistic Kingdoms.* Oxford: Clarendon, 1886.

Leoshko, Janice. "About Looking at Buddha Images in Eastern India." *Archives of Asian Art* 52 (2000–2001): 63–82.

———. "Scenes of the Buddha's Life in Pāla-Period Art." *Silk Road Art and Archaeology* 3 (1993–94): 251–76.

Mahaparinibbana Sutta. *Dialogues of the Buddha.* Translated by T. W. [Thomas William] Rhys Davids and Caroline A. F. Rhys Davids. London: H. Frowde, 1910.

Majumdar, B. [Bhavatosh]. *A Guide to Sarnath.* Delhi: Manager of Publications, 1937.

Mani, B. R. [Braj Ranjan]. *Sarnath: Archaeology, Art & Architecture.* New Delhi: Archaeological Survey of India, 2006.

Mani, B. R., Sachin Kr. Tiwari, and S. Krishnamurthy. "Evidence of Stone Sculpturing Workshop at Sarnath in the Light of Recent Archaeological Investigations." *Puratattva,* no. 45 (2015): 197–203.

Markel, Stephen. "Reattribution of an Important Early India Buddha Image in the Los Angeles County Museum of Art." In *Temple Architecture and Imagery in South and Southeast Asia,* edited by Parul Pandy Dhar and Gerd J. R. Mevissen. New Delhi: Aryan Books International, 2016.

Marshall, J. H. [John Hubert] and Sten Konow. "Excavations at Sārnāth, 1908." *Archaeological Survey of India, Annual Report, 1907–8.* Calcutta: Superintendent of Government Printing, India, 1911.

———. "Sārnāth." *Archaeological Survey of India, Annual Report, 1906–7.* Calcutta: Superintendent of Government Printing, India, 1909.

Martin, Robert Montgomery. *The Indian Empire: Its History, Topography, Government, Finance, Commerce, and Staple Products.* 3 vols. London: London Printing and Publishing Co., 1858–60.

Morris, Rekha. "The Early Sculptures from Sarnath." *Indologica Taurinensia* 10 (1982): 155–68.

Müller, Max, ed. *The Buddha-karita of Asvaghosha.* Translated by E. B. Cowell. Buddhist Mahâyâna Texts. Sacred Books of the East, vol. XLIX. Oxford: Clarendon, 1894.

Mus, Paul. *Barabudur: Esquisse d'une histoire du Bouddhisme fondée sur la critique archéologique des texts.* Hanoi: Imprimerie d'Extrême-Orient, 1935; reprint, New York: Arno, 1978.

Nosu, Kōsetsu. *Life of the Buddha in Frescoes.* Sarnath: Maha Bodhi Society, 1953.

Oertel, F. O. [Friedrich Oscar]. "Excavations at Sārnāth." *Archaeological Survey of India, Annual Report, 1904–5.* Calcutta: Superintendent of Government Printing, India, 1908.

———. "Some Remarks on the Excavations at Sarnath Carried Out in the Year 1904–5." *Indian Antiquary* 37 (1908): 277–80.

Orland, Brian, and Vincent J. Bellafiore. "Development Directions for a Sacred Site in India." *Landscape and Urban Planning* 19 (1990): 181–96.

Prain, D. "A Sketch in the Life of Francis Hamilton (Once Buchanan) Sometime Superintendent of the Honourable Company's Botanic Garden, Calcutta." *Annals of the Royal Botanic Garden, Calcutta* 10 (1905): i–lxxv.

Przyluski, Jean. "Le symbolisme du pilier de Sarnath." *Etudes d'orientalisme à la mémoire de Raymonde Linossier.* Vol. 2. Paris: Musée Guimet, 1932.

Ray, Himanshu Prabha. *The Return of the Buddha: Ancient Symbols for a New Nation.* New Delhi: Routledge, 2014.

Rewata, Dodangoda. "Sarnath and the Maha Bodhi Centre." *The Maha Bodhi Centenary Volume, 1891–1991.* Calcutta: Maha Bodhi Society, 1991.

Rhi, Ju-Hyung. "From Bodhisattva to Buddha: The Beginning of Iconic Representation in Buddhist Art." *Artibus Asiae* 54, no. 3/4 (1994): 207–25.

Rosenfield, John M. "On the Dated Carvings of Sarnath." *Artibus Asiae* 26, no. 1 (1963): 10–26.

Sahni, Daya Ram. *Catalogue of the Museum of Archaeology at Sārnāth.* Calcutta: Superintendent of Government Printing of India, 1914.

———. "Exploration and Excavation: Sarnath." *Archaeological Survey of India, Annual Report, 1921–22.* Simla: Government of India Press, 1924.

———. *Guide to the Buddhist Ruins of Sarnath.* Calcutta: Superintendent of Government Printing, 1911.

Sangharakshita [Dennis Philip Edward Lingwood]. *Anagarika Dharmapala: A Biographical Sketch and Other* Maha Bodhi *Writings.* Cambridge: Windhorse, 2014.

Schopen, Gregory. "The Buddha as an Owner of Property and Permanent Resident in Medieval Indian Monasteries." *Journal of Indian Philosophy* 18, no. 3 (1990): 181–217.

———. "The Buddhist 'Monastery' and Indian Garden: Aesthetics, Assimilations, and the Siting of Monastic Establishments." *Journal of the American Oriental Society* 126, no. 4 (2006): 487–505.

———. "Burial 'Ad Sanctos' and the Physical Presence of the Buddha in Early Indian Buddhism: A Study in the Archaeology of Religions." *Religion* 17, no. 3 (July 1987): 193–225. Reprinted in *Bones, Stones, and Buddhist Monks: Collected Papers on the Archeology, Epigraphy, and Texts of Monastic Buddhism in India.* Honolulu: University of Hawai'i Press, 1997.

———. "On Monks, Nuns, and 'Vulgar' Practices: The Introduction of the Image Cult into Early Buddhism." *Artibus Asiae* 49, no. 1/2 (1988–89): 153–68.

Sharma, Shankar, and Sachin Kr. Tiwari. "Buddha's Route from the Enlightenment to First Sermon: In the Light of New Evidences." *Humanities India: Journal of the Indian Conclave of Humanities and Social Science* 1, no. 1 (2011): 1–12.

Sherring, M. A. [Matthew Atmore]. *The Sacred City of the Hindus: An Account of Benares in Ancient and Modern Times.* London: Trübner, 1868.

Singh, Anand. *Buddhism at Sārnāth.* Delhi: Primus, 2019.

Singh, Rana P. B. "Politics and Pilgrimage in North India: Varanasi between *Communitas* and Contestation." *Tourism: An International Interdisciplinary Journal* 59, no. 3 (2011): 287–304.

Singh, Upinder. *The Idea of Ancient India: Essays on Religion, Politics, and Archaeology.* New Delhi: Sage, 2016.

Strong, John S. *The Legend of King Aśoka: A Study and Translation of the Aśokāvadāna.* Princeton: Princeton University Press, 1983.

Sykes, William Henry. "On the Miniature Chaityas and Inscriptions of the Buddhist Religious Dogma, Found in the Ruins of the Temple of Sarnath, Near Benares." *Journal of the Royal Asiatic Society* 16 (1856): 37–53.

Thaplyal, K. K. "The Symbolism in Sarnath Lion Capital and Its Purpose." *Journal of the U.P. Historical Society* 8, no. 2 (1960): 11–19.

Thomas, Edward. "Note on the Present State of the Excavations at Sarnath." *Journal of the Asiatic Society of Bengal* 23 (1854): 469–77.

Venis, Arthur. "Some Notes on the Maurya Inscription at Sarnath." *Journal of the Asiatic Society of Bengal,* n.s., 3 (1907): 1–7.

———. "Some Notes on the So-Called Mahipala Inscription of Sarnath." *Journal and Proceedings of the Asiatic Society of Bengal* 2 (1906): 445–47.

Vikrama, Bhuvan. "Preservation of Excavated Remains—Some Issues of Reference at Sarnath." ACCU Nara International Correspondent, The Tenth Regular Report. http://www.nara.accu.or.jp/img/dissemination/10th.pdf.

Vogel, Jean Ph. "Buddhist Sculptures from Benares." *Archaeological Survey of India, Annual Report, 1903–4.* Calcutta: Superintendent of Government Printing, India, 1906: 212–26.

———. "Epigraphical Discoveries at Sarnath." *Epigraphia Indica* 8 (1905–6): 166–79.

———. "Note on Excavations at Kasia." *Archaeological Survey of India, Annual Report, 1904–5.* Calcutta: Superintendent of Government Printing, India, 1908.

Williams, Joanna G. *The Art of Gupta India: Empire and Province.* Princeton: Princeton University Press, 1982.

———. "Sārnāth Gupta Steles of the Buddha's Life." *Ars Orientalis* 10 (1975): 171–92.

Willis, Michael. "Markham Kittoe and Sculpture from Sārnāth in the British Museum." *Journal of Inner Asian Art and Archaeology,* forthcoming.

Woodward, Hiram W. "Queen Kumaradevi and Twelfth-Century Sarnath." *Journal of the Indian Society of Oriental Art,* n.s., 12–13 (1981–83): 7–24.

Xuanzang. *The Great Tang Dynasty Record of the Western Regions.* Translated by Roingxi Li. Berkeley, CA: Numata Center, 1996.

———. *Mémoires sur les contrées occidentales.* Translated by Stanislas Julien. Paris: L'imprimerie impériale, 1857–58.

———. *Si-yu-ki: Buddhist Records of the Western World.* Translated by Samuel Beal. London: K. Paul, Trench, Trübner, 1906.

Illustration Credits

Every effort has been made to identify and contact the copyright holders of images published in this book. Should you discover what you consider to be a photo by a known photographer, please contact the publisher. The following sources have granted additional permission to reproduce illustrations in this volume.

Photos are by Frederick M. Asher when not otherwise credited.

COVER: *The Samaudh of Rajah Booth-Sain at Sara-Naat near Benares* (detail). Watercolor copied by Sheik Abdulla, April 1819, copy after sketch of January 1814. London, British Library. © British Library Board, WD698.

BACK COVER: Standing Buddha image. Excavated by Markham Kittoe. Findspot unrecorded. London, British Museum. © The Trustees of the British Museum, acc. no. 1880.6. See fig. 3.22, p. 94.

PAGES II–III: The Buddha overcoming Mara (detail). Findspot not recorded. London, British Museum. © The Trustees of the British Museum, acc. no. 1880.111. See fig. 3.41, p. 112.

PAGE V: Relief depicting scenes from the Buddha's life (detail). Findspot not recorded. Kolkata, Indian Museum, acc. no. S2/A25100. Courtesy Indian Museum, Kolkata. See fig. 3.30, p. 101.

INTRODUCTION

FIG. 1. IMAGE: Google Earth CNES/Airbus, 20 January 2017.

FIG. 2. © British Library Board, Shelfmark: Photo 17/3 (41).

FIG. 3. Wikimedia Commons/CC BY-SA 4.

FIG. 7. Sarnath Museum, acc. no. 33.

FIG. 9. © British Library Board, 4369.

FIG. 10. © British Library Board, 171.1 MSS. EUR. D. 95. Foll. 249.

FIG. 11. Chronicle/Alamy Stock Photo.

CHAPTER 1

FIG. 1.1. Historic Images/Alamy Stock Photo.

FIG. 1.3. By kind permission of the Victoria Memorial Hall, Kolkata.

FIG. 1.4. © British Library Board, WD2876.

FIG. 1.8. Friends of the Kem Institute and University Library, Leiden University, IIAS, South Asian Studies. Shelfmark P-037129.

CHAPTER 2

FIG. 2.1. Map prepared by M. B. Rajani and Sonia Das, National Institute of Advanced Studies, Bangalore. Image: Google Earth Digital Globe, 21 April 2009.

FIG. 2.7. Archaeological Museum Sarnath, acc. no. 6636.

FIG. 2.8. Archaeological Museum Sarnath, acc. no. 6638.

FIG. 2.9. Image courtesy of National Museum of India, acc. no. 49.121.

FIG. 2.13. Latitude Images/Nicolas Chorier.

CHAPTER 3

FIG. 3.1. Archaeological Museum Sarnath, acc. no. 355.

FIG. 3.2. Friends of the Kern Institute and University Library, Leiden University, IIAS, South Asian Studies. Shelfmark P-036174.

FIG. 3.4. Archaeological Museum Sarnath, acc. nos. 483, 373.

FIG. 3.5. Archaeological Museum Sarnath, acc. no. 420. Courtesy American Institute of Indian Studies Center for Art and Archaeology, acc. no. 25680, negative no. A27.69B.

FIG. 3.6. Archaeological Museum Sarnath, acc. nos. 418, 420, 423.

FIG. 3.7. Archaeological Museum Sarnath, courtesy Archaeological Survey of India.

FIG. 3.8. Archaeological Museum Sarnath, acc. no. 527.

FIG. 3.9. Archaeological Museum Sarnath, acc. no. 356.

FIG. 3.10. Archaeological Museum Sarnath, acc. no. 348.

FIG. 3.12. Archaeological Museum Sarnath, acc. no. 349.

FIG. 3.13. Archaeological Museum Sarnath, acc. no. 352.

FIG. 3.14. Archaeological Museum Sarnath, acc. no. 342.

FIG. 3.15. Archaeological Museum Sarnath, acc. no. 341.

FIG. 3.16. Archaeological Museum Sarnath, acc. no. 343.

FIG. 3.17. Archaeological Museum Sarnath, acc. no. 346.

FIG. 3.18. Courtesy Indian Museum, Kolkata, acc. no. S21/25084.

FIG. 3.19. Courtesy Indian Museum, Kolkata, acc. no. S15/25089.

FIG. 3.20. Archaeological Museum Sarnath, acc. no. 514.

FIG. 3.21. Archaeological Museum Sarnath, acc. no. 252.

FIG. 3.22. © The Trustees of the British Museum, acc. no. 1880.6.

FIG. 3.23. © The Trustees of the British Museum, acc. no. 1880.7.

FIG. 3.24. Image courtesy of National Museum of India, acc. no. 59.527/2.

FIG. 3.25. Digital Image © 2020 Museum Associates/LACMA. Licensed by Art Resource, NY.

FIG. 3.26. Archaeological Museum Sarnath, acc. no. 340.

FIG. 3.27. Archaeological Museum Sarnath, acc. no. 223. Image courtesy American Institute of Indian Studies Center for Art and Archaeology, acc. no. 1720, negative no. 6.68.

FIG. 3.28. Archaeological Museum Sarnath, acc. no. 237. Image courtesy American Institute of Indian Studies Center for Art and Archaeology, acc. no. 1729, negative no. 199.92.

FIG. 3.29. Archaeological Museum Sarnath, acc. no. 256.

FIG. 3.30. Indian Museum, acc. no. S2/A25100. Courtesy Indian Museum, Kolkata.

FIG. 3.31. Archaeological Museum Sarnath, acc. no. 261.

FIG. 3.32. Mathura Museum, acc. no. H1.

FIG. 3.33. Archaeological Museum Sarnath, acc. no. 260.

FIG. 3.34. Courtesy Indian Museum, Kolkata, acc. no. S5/A25099.

FIG. 3.35. Image courtesy of National Museum of India, acc. no. 49.113.

FIG. 3.36. Courtesy Indian Museum, Kolkata, acc. no. S37/A25082.

FIG. 3.37. Courtesy Indian Museum, Kolkata, acc. no. S17/A25092.

FIG. 3.38. Archaeological Museum Sarnath, acc. no. 6683.

FIG. 3.39. Archaeological Museum Sarnath, acc. no. 6812

FIG. 3.40. Archaeological Museum Sarnath, acc. no. 697.

FIG. 3.41. © The Trustees of the British Museum, acc. no. 1880.11.

FIG. 3.42. Archaeological Museum Sarnath, acc. no. 351.

FIG. 3.43. Archaeological Museum Sarnath, acc. no. 250.

FIG. 3.44. Archaeological Museum Sarnath, acc. no. 251.

FIG. 3.45. Archaeological Museum Sarnath, acc. no. 6697.

FIG. 3.46. Archaeological Museum Sarnath, acc. no. 59. Image courtesy American Institute of Indian Studies, Center for Art and Archaeology, acc. no. 5747, negative no. 7.56.

FIG. 3.47. Archaeological Museum Sarnath, acc. no. 30.

FIG. 3.48. Archaeological Museum Sarnath, acc. no. 621.

FIG. 3.49. Archaeological Museum Sarnath, acc. no. 610.

FIG. 3.50. Archaeological Museum Sarnath, acc. no. 535.

FIG. 3.51. Archaeological Museum Sarnath, acc. no. 236.

FIG. 3.52. Archaeological Museum Sarnath, acc. no. 39.

FIG. 3.53. Archaeological Museum Sarnath, acc. no. 615.

FIG. 3.54. Archaeological Museum Sarnath, acc. no. 32. Courtesy American Institute of Indian Studies Center for Art and Archaeology, acc. no. 5753, negative no. 6.8.

FIG. 3.55. Courtesy Indian Museum, Kolkata, acc. no. S26/A25127.

FIG. 3.59. Varendra Research Museum and Center for Heritage Education, Bangladesh, Accession number A-217. Photo courtesy of Sikder Md Zulkernine.

FIG. 3.60. © The Trustees of the British Museum, acc. no. 1880.15.

FIG. 3.61. National Museum Bangkok, Fine Arts Department.

FIG. 3.62. © British Library Board, acc. no. WD2876.

FIG. 3.63. Asia Society/Art Resource, NY.

FIG. 3.64. The Cleveland Museum of Art, Purchase from the J. H. Wade Fund, 1943.278.

FIG. 3.65. The Cleveland Museum of Art, Gift of the John Huntington Art and Polytechnic Trust, 1946.492.

FIG. 3.66. Photo courtesy Nelson-Atkins Media Services/Jamison Miller.

FIG. 3.67. Photograph © 2020 Museum of Fine Arts, Boston.

FIG. 3.68. Photograph © Staatliche Museen zu Berlin, Museum für Asiatische Kunst/Iris Papadopoulos, acc. no. 43.905.

FIG. 3.69. Philadelphia Museum of Art, Stella Kramrisch Collection, acc. no. 1994-148-1.

CHAPTER 4

FIG. 4.17. World Digital Library/Wikimedia Commons.

FIG. 4.18. World Digital Library/Wikimedia Commons.

PAGE 162: Buddha head. Cleveland, The Cleveland Museum of Art, Gift of the John Huntington Art and Polytechnic Trust, 1946.492. See fig. 3.65, p. 133.

PAGE 163: Standing Buddha (detail), probably from Sarnath. Los Angeles, Los Angeles County Museum of Art. Digital Image © 2020 Museum Associates/LACMA. Licensed by Art Resource, NY. See fig. 3.25, p. 96.

Index

NOTE: Page numbers in italics refer to figures; those followed by *n* refer to notes, with note number.

About the Author

Frederick M. Asher is professor emeritus of art history at the University of Minnesota. His books include *Nalanda: Situating the Great Monastery* (2015), a study of what is probably India's most important monastery until the twelfth century, and *Bodhgaya* (2007), an examination of the site where the Buddha achieved enlightenment. He has held various offices for the American Institute of Indian Studies and the National Committee for the History of Art. In 2006, he received the Horace T. Morse–Minnesota Alumni Association Award for Outstanding Contributions to Undergraduate Education from the University of Minnesota, and in 2015 he was granted the Distinguished Contributions to Asian Studies Award from the Association for Asian Studies. His current research examines the visual culture of Indian Ocean trade, extending from the South China Sea to East Africa.